PRO TIPS & TECHNIQUES FOR
DRAWING ANIMALS

Michiyo Miyanaga

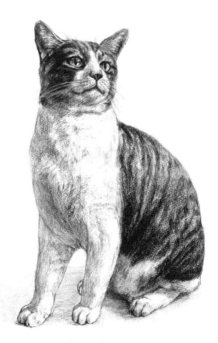

TUTTLE Publishing

Tokyo | Rutland, Vermont | Singapore

Contents

Why I Wrote This Book 7

Let's Draw & Paint Animals!

❶ Tutorial: Draw & Paint a Tiger 8
❷ Tutorial: Paint a Giraffe's Head 10
❸ Tutorial: Paint an Entire Giraffe 11
❹ Tutorial: Draw & Paint a Cat 12
❺ Tutorial: Draw & Paint Dogs 14

Drawing Animals from Anatomy by Ingo Garschke

❶ *Cormorant 2 (2008)* 15
❷ *Crow 2 (2005)* 16
❸ *Wild Rabbit 1 (2008)* 17

Prologue

❶ Tools Required for Pencil Drawing 18
❷ How to Sharpen a Pencil 19
❸ Basic Drawing Knowledge 20
❹ Basic Drawing Techniques 24
❺ The Basic Structure of Animal Bodies 26

❻ The Movement Modes of Animals 34
❼ Biological Diversification 36
❽ The Evolutionary Tree 38
❾ About the Colors and Sizes of Mammals 40

Animal Drawing Index

Part 1

Mammals

30 Types

① Human.............. 42
② Dog.................. 50
③ Hyena 56
④ Cat.................. 58
⑤ Gorilla.............. 66
⑥ Orangutan 68
⑦ Chimpanzee 70

⑧ Squirrel and Chipmunk72

⑨ Giraffe 74

⑩ Rhinoceros 76

⑪ Lion and Tiger 78

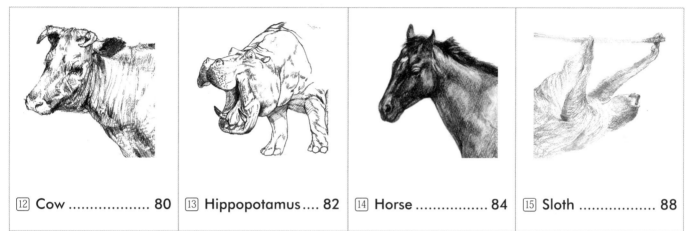

⑫ Cow 80

⑬ Hippopotamus 82

⑭ Horse 84

⑮ Sloth 88

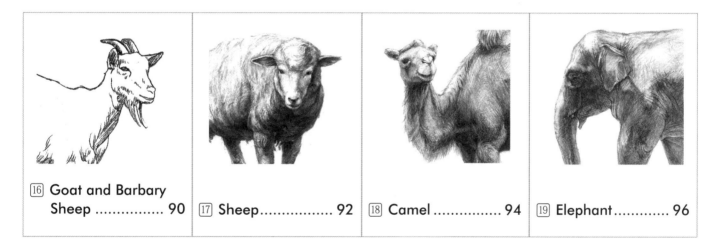

⑯ Goat and Barbary Sheep 90

⑰ Sheep 92

⑱ Camel 94

⑲ Elephant 96

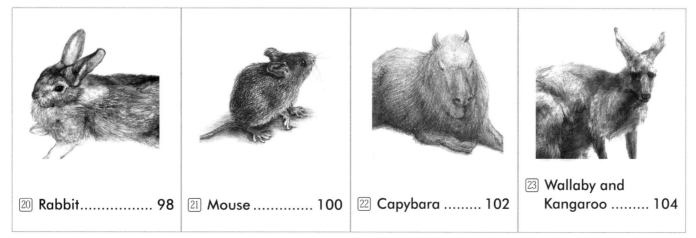

⑳ Rabbit 98

㉑ Mouse 100

㉒ Capybara 102

㉓ Wallaby and Kangaroo 104

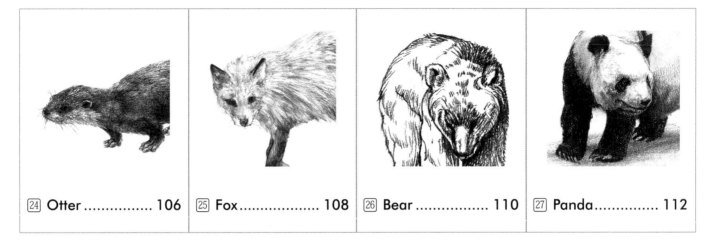

24 Otter 106 25 Fox 108 26 Bear 110 27 Panda 112

28 Armadillo 114 29 Pangolin 116 30 Deer 118

Part 2

Amphibians & Reptiles

6 Types

1 Snake 120 2 Lizard 122 3 Turtle 124

4 Chameleon 126 5 Frog 128 6 Giant Salamander 130

Part 3

Aquatic & Waterside Animals

7 Types

1 Crocodile and Alligator 132

2 Koi 134

3 Octopus and Squid 136

4 Dolphin138

5 Harbor Seal and Fur Seal 140

6 Penguin 142

7 Whale 144

Part 4

Flying Animals

7 Types

1 Dove and Pigeon.............150

2 Crow 152

3 Sparrow........... 154

4 Owl 156

5 Chicken 158

6 Cockatiel 162

7 Bat 164

Part 5

Insects & Arthropods

7 Types

[1] Rhinoceros Beetle and Stag Beetle........ 168

[2] Ant 170

[3] Praying Mantis.... 172

[4] Ladybug 174

[5] Butterfly............ 178

[6] Spider 180

[7] Dragonfly 182

Sidebars

❶ Environment... 146

❷ Animal Droppings .. 148

❸ An Animal's Vision and Expressions 166

Bibliography... 184

List of Artists Whose Drawings Appear in This Book 185

How to Use This Book

- At the introduction of each new animal, you will find the name and classification of the animal, such as kingdom, phylum, class, order, family, genus and species.

- For each animal, there are skeletal, musculature and finished drawings. Compare the skeletal diagram against the finished drawing. Do the same with the musculature drawing and the finished drawing.

- Some animals include a drawing process. The steps are easier to understand if you study each drawing with its accompanying caption individually.

- The "Notes" section for each animal is packed with useful information for sketching, such as drawing tips, descriptions of animal parts, animal ecology and behavior, and so on.

Why I Wrote This Book

Why is it necessary to understand the skeleton and other body structures in order to draw an animal?

Most mammals have thick fur, so if you draw fluffy wool, you can make a sheep look more or less like a sheep. However, even if you capture a horse's long legs in your drawing, you may still be under the impression that the horse's knees and ankles bend in the opposite direction to ours. In such cases, the impact of poor or insufficient understanding is more obvious to the viewer.

Art anatomy is the study of the internal structure (skeleton and musculature) and its relationship to the external form of the body. It is anatomy that is learned for the sake of art. Although the discussion is usually focused on the human body, the comparative view of the human and animal body is actually very important. This is called "comparative anatomy."

Humans are one species of mammal. Other animals that seem very different from humans once evolved from a common ancestor. In the continuity of the history of life that began 3.6 billion years ago, and 500 million years of phylogenetic development as vertebrates, we can see differences in habitat and diet, how organisms survived past climate changes, how they adapted to various environments and the long history of adaptation that lies behind the animals that we see before us today.

When you pick up a dog or cat, you can quickly ascertain if it is overweight, of average build or emaciated. When expressing an animal's form, I think it is important to look closely at the animal and, if possible (and prudent), to handle it. In addition, learn about the structure of the animal's body and think about how each animal has adapted to its environment.

The study of the animal body promotes an understanding of our own body forms. It will help us to understand how we ourselves live in the grand continuum of biological history.

The classifications in this book are as up to date as possible. Animal kinship has been classified based on anatomical traits and ecology, such as teeth, skeleton, and external appearance, but new genetic findings have been uncovered in recent times, and science is still being gradually written. Terminology was difficult to unify, as there are different terms used in each specialty of animal research. In this book, the terminology for analogous parts of the human body have been used for the sake of simplicity.

The drawings presented here were created by active artists who are junior faculty members of the Art Education Laboratory at Tokyo University of the Arts as well as graduate and undergraduate students, many of whom have attended my lectures on art anatomy. The most important aspect of drawing animals is the love for the animals that form the motif, and this is expressed beautifully in each of the drawings.

There is more than one way to execute a drawing. In this book, I have presented the basics of capturing and detailing shapes and shading for beginners. There is no better way to learn than to emulate the work of artists demonstrating proper techniques. But there is more than one way to look at things. In this sense, I think one of the appeals of this book is that you can see the variations in expression by many different artists.

I had been working on the idea of a book on animal anatomy for some time, but it was an exchange with the now late German sculptor and art anatomist Ingo Garschke that gave me the impetus I needed. Thanks to him, I became more deeply convinced of the importance of comparative anatomy, which was already present in Japanese art anatomy. I would also like to thank the Department of Anatomy at Tokyo Medical University, the Graduate School of Art Education at Tokyo University of the Arts and my friends in Germany for their help in compiling this book.

I dedicate this book to the memory of Ingo Garschke.

Michiyo Miyanaga
June 2020

Tutorial: Draw & Paint a Tiger ★ Pencil & Watercolor ★

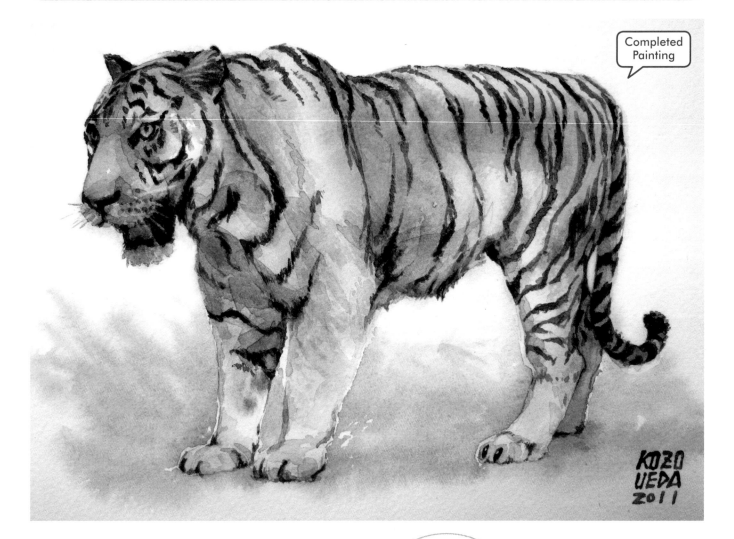

Completed Painting

KOZO UEDA 2011

Make the most of drawing and watercolor expression

A tiger appears to stand in steamy air in what hints at being a meadow. In this painting, the pencil drawing showing the three-dimensionality and skeletal structure of the animal has been erased after completion, leaving the large outlines which have been painted over with watercolors.

In the middle of the production process, a new sheet of paper has been substituted, on which the shadows and volume of the animal have been painted with watercolors. The continual pencil development of the tiger's three-dimensionality and grasp of the tiger's skeletal structure are fresh in the artist's mind, and the result is an accurate-looking tiger that makes the most of the watercolor technique.

Drawing a tiger ➔ page 78

By drawing the stripes of the tiger, you can show its three-dimensionality. The key point is to express where the stripes disappear as they pass to the far side of the tiger.

The Drawing and Painting Process

1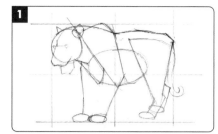

Capture the form

Draw a rough form in pencil to capture the scale of the tiger on the paper. Rough out the head, back, forelimbs and hind limbs on the paper to mark the front, back, top and bottom. By repeating these trial drawings several times, you will develop an eye for the form and the characteristics of the movement of the animal.

2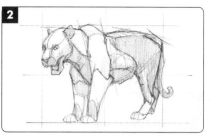

Express the three-dimensional structure

Flesh in the head, neck and forelimbs with a pencil, being aware of the planes and volumes to see how to express them with three-dimensional depth. Deepen your understanding of the animal's form by measuring the height of the joints (the elbows and knees), the size, height, depth and proportions of the head and forelimbs using a knitting needle (or similar tool) held at arm's length.

3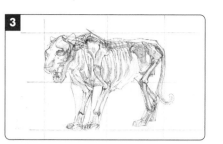

Envision the internal structure via the whole skeleton

Develop an image of the pose as you draw the skeletal structure of the tiger while looking at a photo or a specimen. Considering the internal structure, especially the position and structure of the moving joints, is important for a drawing with realism and presence.

4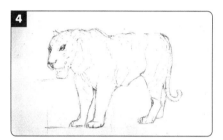

Return the ground paper to white

This piece will be finished with watercolors and we will be attempting to express the volume and depth, so at this point the internal structure or three-dimensional form of the tiger, which has been layered in with pencil, is removed with an eraser. The outline is also largely erased, leaving only traces. Remove just enough of the pencil lines to prepare the surface to show off the beauty of the watercolor paint colors.

5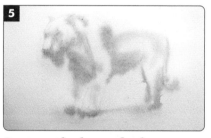

Capture the large shadows

Using a flat bristle brush, spread a thin layer of water over the entire paper. Squint and place a pale shade of mauve in the areas that should be in shadow. This is where the results of our three-dimensional analysis and skeletal structure analysis, which has brought us familiarity with the animal, come to life. This now looks like an image seen through frosted glass.

6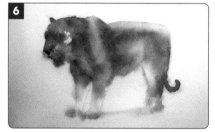

Add colors specific to a tiger

Tiger-specific colors are represented by layering yellow ochre and brown. Putting the color on the paper while it is still wet will create a blurry or blotchy effect. Moisten the areas where you want this effect with the flat brush in advance. The tail should not bleed, so the wet brush has not been used in that area.

7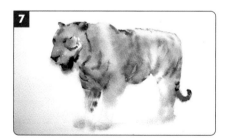

Rough in the stripes of the tiger

For the sake of clarity, I have made the color a little darker than necessary in step **6**. I then painted another version of the same process on another piece of paper, and once I reached step **6** I waited until the paper was completely dry and painted the tiger stripe pattern, this time with shading. Once your paper has dried, add the shapes of the nose, eyes and mouth, which should not bleed.

8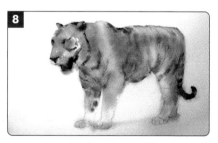

Draw the feet

After repeated trial and error, as watercolors are laid down in layers, the figure of the tiger has emerged as if from a cloud of smoke.

9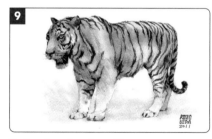

Paint in the details

By painting the detailed pattern of the stripes, the three-dimensionality of its body can be expressed. The roundness of the back, the transition from one plane to another, and the bulge in the abdomen can be depicted with the stripe pattern. It is very important to depict the parts where the stripes disappear to the other side. Observe carefully to express this.

Tutorial: Paint a Giraffe's Head ★ Watercolor ★

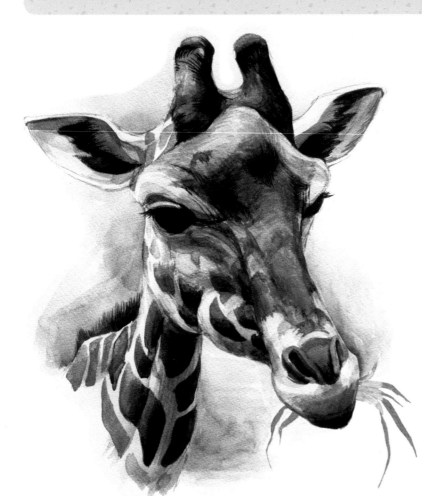

Completed Painting

The action of chewing the grass is depicted with the bulge of the right cheek and the lower jaw

This is a giraffe munching on grass. Because we are viewing the animal nearly head-on, the long neck is foreshortened. The right cheek of the giraffe is bulging, and it looks as if it is moving its lower jaw back and forth as it eats the grass. The key points are its ossicones (horns) made of bone and its long eyelashes.

The Drawing and Painting Process

1

Apply color to the dark areas

After roughing out the overall shape, erase most of the pencil lines, just leaving a few. Paint on layers of burnt sienna and cobalt blue that have been thinned out with water in the shaded and dark areas. The shadows that are formed in natural light have a blue tinge to them because they reflect the blue of the sky.

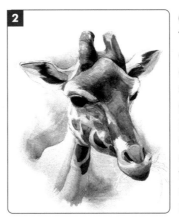

2

Connect the patterns

To depict the giraffe's craggy head, ossicones and long snout, mix brown and green together on the palette, and look for dark areas to layer on the colors. With the overall form in mind, occasionally use light blues and browns to connect the free-floating spots in a three-dimensional manner. The entity and the space are in a figure to ground relationship, and although viewers tend to focus only on the figure, train yourself to invert the figure and the ground as needed. You will become able to clearly see anything that is wrong with the form in this way.

Tutorial: Paint an Entire Giraffe ★ Watercolor ★

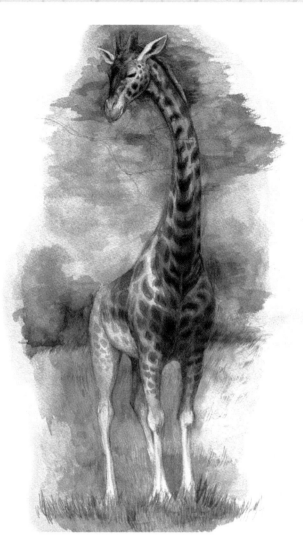

Completed Painting

Create a sense of depth by creating light and dark lines in the foreground of the painting

Depict a long-necked giraffe eating leaves from an acacia tree on the savanna. Instead of a partial closeup, try depicting the whole giraffe from approximately the front.

Drawing a giraffe ➔ page 74

The Drawing and Painting Process

1

Lay down the colors

The outline has been put in with pencil, so start laying down the distinctive colors of the giraffe with chrome yellow (a bright yellow) along the neck and front limbs. Leave the fore- and back limbs of the giraffe white, and lay down the green grass background of the savanna to depict the shapes around the limbs. Utilize the white of the paper for the color of the limbs, leaving them unpainted.

2

Paint the pattern

Paint the pattern from the neck to the chest. The head, neck, and forelimbs in the foreground have stronger and clearer shapes than the hind limbs in the background, so observe them well and paint them in as you proceed.

Tutorial: Paint an Entire Giraffe **11**

Tutorial: Draw & Paint a Cat ★ Pencil & Watercolor ★

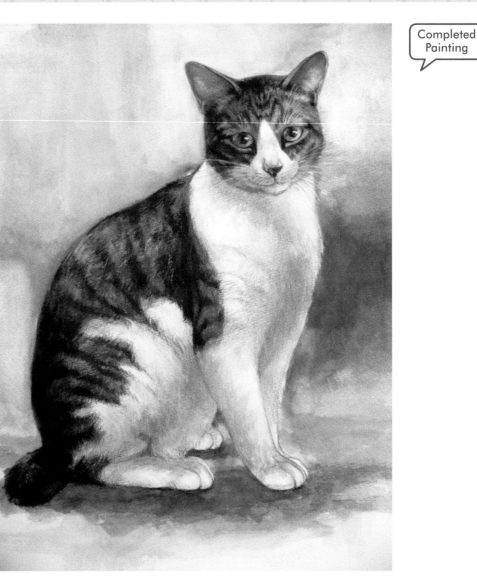

Completed Painting

If you can depict the surroundings, the realism of the animal is increased

Cats or dogs that you have in your home are ideal models that you can observe to the fullest. Here a sitting cat has been drawn with care, and watercolors have been layered on top. The piece is completed about 80% of the way with the drawing, and then fully completed with watercolors on top of that. The stripe pattern on the back and the strokes of the flow of the fur are depicted in the same direction. Several colors can be perceived on the back such as brown, black, gray, beige and orange. In addition, if you use a little bit of the blue used for the background in the color of the fur, the background will not contrast so strongly with the foreground. To make the fur on the chest and stomach brighter, white paint is layered on in the direction in which the fur grows.

Finally, the fine facial features, such as the whiskers on the muzzle and above the eyes, are painted in white using a thin brush.

If you can depict the surroundings around the animal, the realism of the animal will be heightened. Simply applying solid color will result in a flat, dull background. The dark cobalt blue beside the chest contrasts well with the whiteness of the fur, and the rest of the background is filled with watered-down blues and greens for a nuanced look. The strong blue color is not placed around the face, which is the centerpiece of the image. That leads the viewer's eye naturally to the cat's face.

The Drawing and Painting Process

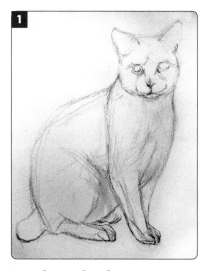

1

Rough out the shape
Think about how you want to put the whole image on the paper, and then make a large shape with a 2B pencil, taking into account the relationship with the negative space. The lines become heavier in the areas where the shape has been decided. Squint at the object to identify the transitions from light to shadow.

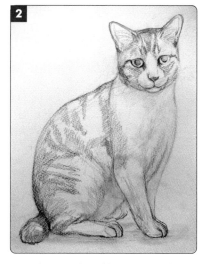

2

Conduct a detailed analysis of the form
Analyze the shape in detail. If the form is not right, correct it. After refining the shape in detail, squint again and pay attention to the overall volume. In this way, the dark areas gradually become more saturated. A little shadow on the surface of the ground where the cat is sitting has also been drawn in.

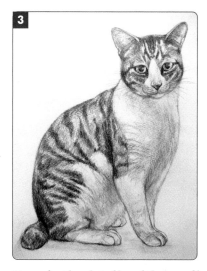

3

Draw in the details with pencil
Draw in the flow of the fur, the striped pattern and the details of the head. The pencil strokes are aligned to express the uniform alignment of the hairs. Facial details and expressions can change dramatically with the slightest pencil stroke, so look carefully while drawing. Because this piece will be continued with watercolors, the dark areas will not be overly developed with pencil strokes, but do analyze the form carefully.

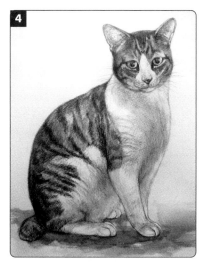

4

Lay down the colors
Lay down colors with watercolor paints. Start with the browns on the back and the face. The ground has been painted the same color. If you are layering on the watercolors, let the paper dry between layers before putting down more paint. Squint occasionally and compare the subject and the painting alternately to see if you are capturing a good impression of the subject.

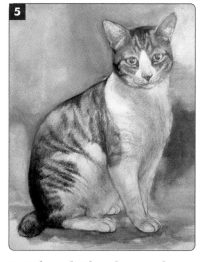

5

Continue laying down colors
Keep on laying down watercolor paint. Here a sense of atmosphere has been suggested by using shades of blue. Some ochre and lightly watered-down brown has been layered on the cat, but it may have turned a little too yellow around the chest and belly area. However, this cat looks as if it could walk off the paper.

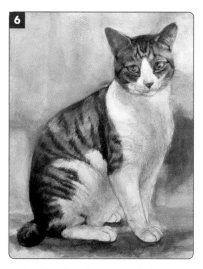

6

Paint in the details with watercolors
Squint and quickly place the colors in the dark or deeply colored areas. The red tint used on the ears is also placed around the eyes and on the back where the color is strongest. The green color of the eyes and the translucent pink color of the ears are mixed on the palette and carefully applied. The stripes on the back are also placed with strokes of the brush in the growth direction of the fur. The whitest part of the chest fur is brightened with white paint.

Tutorial: Draw & Paint Dogs ★ Pencil & Watercolor ★

● Draw and Paint a Brown Dog

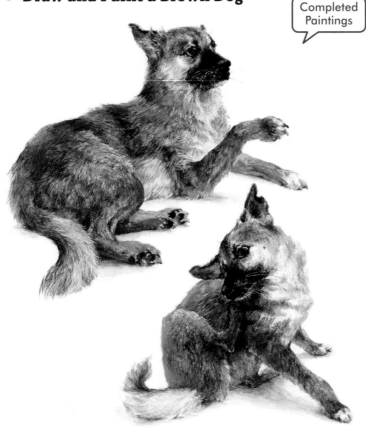

Completed Paintings

The Drawing and Painting Process

① Start by completing the piece about 70% with pencil, and then add layers of watercolor.

② The brown dog is painted in light yellow and dull reddish yellow, and the black color of the muzzle is darkened in stages.

③ The difference between the highlights and shadowed parts of the fur are depicted by mixing white and gray on the palette, and layering the colors on following the growth direction of the fur.

④ For shading use blue-gray with blue or violet tints, as natural light gives a bluish tint.
The brown of the back of the dog is slightly subdued so that its muzzle in the foreground is emphasized.

⑤ The fur on the white parts of the chest, belly and tail are also lightly shaded, and then layered with light bluish and reddish colors. Use a stiff, fine brush to paint the hairs in the foreground with white paint.

⑥ Last, paint the whiskers on the muzzle. The hair can shine white or be black, depending on the colors of the background.

→ See page 51 for the detailed pencil drawing process

● Draw and Paint a White Dog

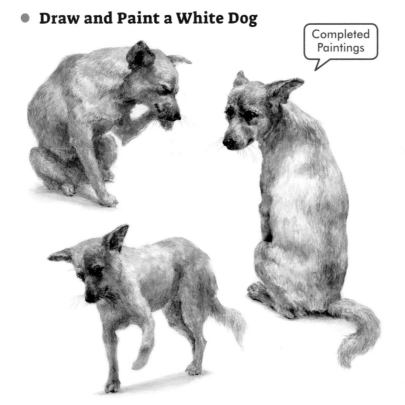

Completed Paintings

The Drawing and Painting Process

① Start by completing the piece, such as the head and paws, about 70% with pencil, and then add layers of watercolor.

② You can see a variety of colors even on a white body. These include reds, blues and greens. And the color of the shadow is a bluish violet in natural light. If you use black or dark brown for the shadows it tends to give an aged, smoke-stained look. Here, a reddish violet color has been used. For a white body color, the range of shading used should be relatively light.

③ The nose and eyes are darkened, but because there is a hint of purple or brown in the shadows, no black paint has been placed there. The color is mixed on the palette. Even the darkest areas are about 3 steps removed from solid black.

→ See page 52 for the detailed pencil drawing process

Cormorant 2 (2008) (Ingo Garschke, 1965–2010) Tempera / 12 x 16 in (30 x 40.5 cm)

©Ingo Garschke

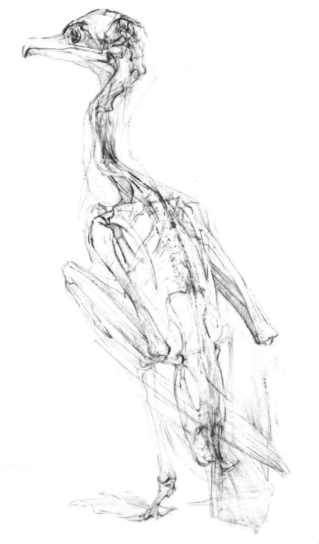

Kormoran

The structures of the long folded wings, the scapulae that support them, the anterior coracoid and sternum are visible as if the bird was transparent. The cormorant's interlocking skeleton seen from the back reminds us of its relationship to all vertebrates.

Ingo Garschke, the artist of this painting, graduated with a degree in sculpture from Dresden University of the Arts in 1992, and commenced serious research into the anatomy of mammals and birds. From 1998 he taught anatomy and drawing at the Hochschule für Grafik und Buchkunst (Academy of Fine Arts, Leipzig). His deep interest in animal anatomy led him to create many skeletal specimens of animals, which he then assembled into his own interlocking skeletons.

This X-ray view of the cormorant comes from the experience gained from working with them and from tireless observation as an artist. In 2002 he dissected an orca and used it as a skeletal specimen. He later became interested in geology and collecting fossils, but sadly passed away in 2010.

Crow 2 (2005) (Ingo Garschke, 1965–2010) Tempera / 16 x 12 in (40.5 x 30 cm)

The artist does not just depict what can be seen, but also explores the relationship to the invisible parts in his drawings, such as the trachea at the throat and the keel of the sternum. The external shape is formed as an outline over the bones and joints of the skeleton.

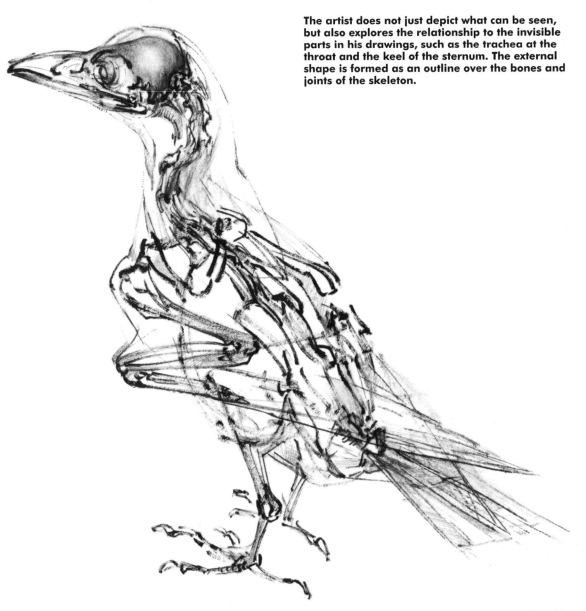

©Ingo Garschke

Garschke stated that on frigid mornings unfortunate crows could be found frozen on the ground. He picked up those birds, dissected them in the lab, and carefully posed the skeletons to create reference forms. Based on these experiences and knowledge, the animals lived again through the drawings.

The bones of the wings and the lower limbs, painted in a fluid brushstroke, and the light ink outline of the exterior create a brisk zigzag rhythm.

Wild Rabbit 1 (2008) (Ingo Garschke, 1965–2010) Tempera / 16 x 12 in (40.5 x 30 cm)

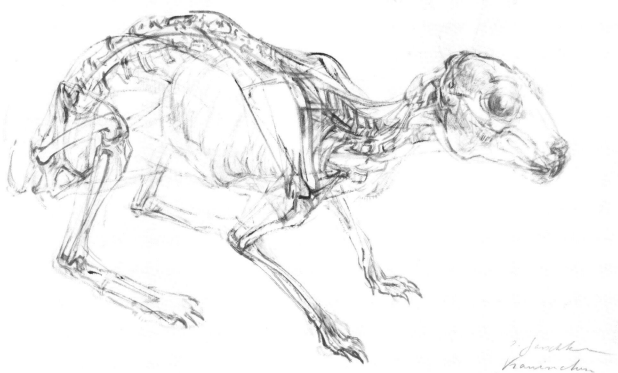

©Ingo Garschke

The roundness of the lightly drawn eyeballs, the multilayered musculature supporting the neck, the spine and shoulder blade ridges that create the rounded back, and the depth and three-dimensionality of the animal's body are all beautifully captured in this work.

The rabbit's most distinctive feature is its long ears. But even without ears, this rabbit can still be experienced by us as a vibrant image. The rabbit-like appearance of the bones is due to the artist's mastery of anatomy and his knowledge of the rabbit's structure, which cannot be captured without making several study sketches.

It is important to understand that the depth and volume of the animal's body is not only depicted by what can be seen, but also by providing a sense of the far side of the body which cannot be seen from the viewer's perspective in a life drawing.

Tools Required for Pencil Drawing

Although the tools used differ by the individual, here I will introduce you to the basic tools needed for pencil drawing. For pencil drawing, drawing paper or Bristol paper are used.

Tool ❶: Pencils

Drawing pencils are made by many manufacturers, and their colors and textures are subtly different. Start by putting together a set of a few pencils each of HB, B, 2B and 4B pencils. When the pencils get short, use a pencil holder (Tool 3) to use them up without waste.

> When you have use a kneaded eraser for a while and it starts to contain a lot of oil from your hands, it will no longer erase pencil lines and the paper will get dirty, so pay attention to that.

Tool ❷: Kneaded eraser

A kneaded eraser is used while drawing to correct lines and colors. It can also thin out the pencil markings or be used to reveal white areas when finishing your drawing, so it is convenient to have. Rip off a piece that is about the size of a stick of gum from the block and knead it with your fingers, and use it to remove pencil marks. It is also useful for when you want to create lighter areas in your drawing.

Tool ❸: Pencil holder

You can put short pencils in pencil holders to make them easier to hold.

> After erasing, be sure to tidy up the edges of the areas you have erased with a pencil.

Tool ❹: Plastic eraser

As with the kneaded eraser, a plastic eraser is used to erase extraneous lines. It is also used when you want to return the paper to a pristine state, or to add fine highlights using the sharp corners and edges. Do not overuse either a kneaded eraser or a plastic eraser; wait to use them until you're midway through your drawing, and use them as little as possible.

Tool ❺: Utility knife

Pencils are sharpened with a utility knife. H pencils as well as softer pencils—including HB, 2B and 3B—should always be kept sharp. The use of the pencil and the expression of the pencil line are affected by how sharp the pencil is.

Tool ❻: Fixative

The finished drawing is sprayed with fixative spray so that it does not get smudged and dirty or faded. The spray adheres the pencil particles to the paper. Fixative can be used to affix pencil, charcoal, pastel and so on.

How to Sharpen a Pencil

The ease with which pencils can be sharpened depends upon the texture of the wood and the hardness of the lead. Here, I will explain how to sharpen a pencil using HB and 2B pencils as the examples.

Basic knowledge of pencils

Pencils range from B pencils, which have soft, dark leads, to H pencils, which have hard leads that produce light lines. Soft lead pencils range from B to 10B; in the middle are F and HB pencils; and hard pencils range from H to 10H. (Note: a U.S. no. 2 pencil is equivalent to an HB pencil.) In general, hard materials such as glass and metal and delicate, thin lines are usually drawn with H pencils, and soft materials are often drawn with B pencils. I think that pencils softer than HB are more appropriate for beginners.

Use the range of pencils freely depending on how you want to express yourself.

How to sharpen a pencil

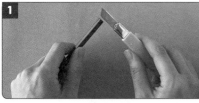

1

The length of the utility knife
When sharpening a pencil, if you let the blade of the utility knife emerge too far it may break, so retract it to a little more than an inch (3 cm).

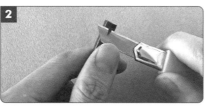

2

Start by shaving off the corners of the pencil
Start by shaving off the hexagonal corners of the pencil. Press on the back of the knife blade steadily with your thumb as you shave off the corners.

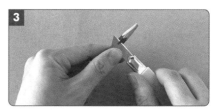

3

Shave the wood
When all the corners have been shaved off, place the blade of the knife behind the edge of the painted area and shave it off thinly. Be careful not to dig your blade in too deeply.

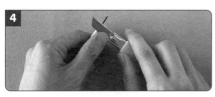

4

Sharpen the lead of the pencil
After shaping the wood part of the pencil, start sharpening the lead. Shave it off little by little so that the end becomes thin. Make sure that the wood and the lead are at the same angle, forming a cone.

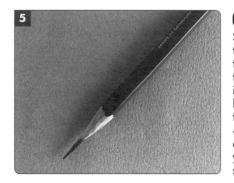

5

Finished

Sharpen your pencil lead to the length that suits your needs. In general, pencils that are harder than 2B are sharpened to be long and thin. A sharpened pencil is like a well-honed knife. When it becomes blunt through use, sharpen up the lead part. Pencils that are softer than 4B may become easy to break if they are made too long and sharp, but all of your pencils should always be kept well sharpened.

Know about the characteristics of pencils

The harder the pencil, the lighter the color, and the more suitable it becomes to drawing delicate lines. When paper is covered using a hard pencil, the texture of the paper is flattened, and it becomes easier to express hard textures—but hard pencils also have the tendency to tear the fiber the paper. In contrast, the softer the pencil, the darker it is, and the more you can see the texture of the paper—so you can use it to create a soft impression. Soft pencil marks can be smudged with your fingers or a piece of cheesecloth to widen your scope of expression too. For drawing animals, I recommend using HB, 2B and 4B pencils. Try seeing how many steps from light to dark you can draw on a piece of drawing paper. The broader the range you can show in these lights and darks, the more expressive your drawings will be.

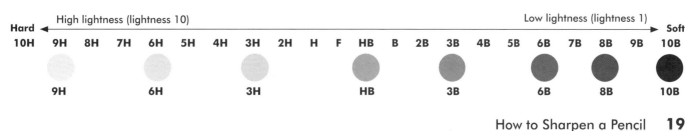

Basic Drawing Knowledge

Here, I will explain the basics of pencil drawing. In order for beginners to more easily capture animal forms, I will go over the problems they are likely to encounter along with their reasons, and describe in detail what you will want to be aware of as you draw.

The process of drawing an animal

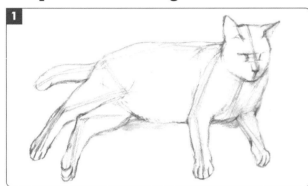

1

Capture the shape
Look at the overall balance as you decide how to fit in the overall shape. This is called "roughing out."
See **Basic Knowledge 2** ➜ page 21

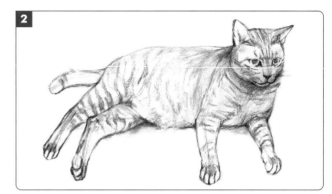

2

Analyze the shape
Don't just look at the outline, but analyze the inner contours also. Be aware of the vertical and horizontal length ratios. (See Note, below.)
See **Basic Knowledge 3** ➜ page 22

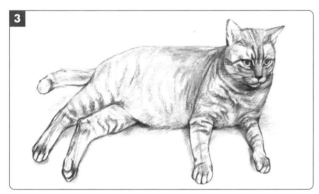

3

Lay down the shading
Squint occasionally to comprehend the large shaded areas, and add shading to the drawing. Be careful with the orientation of the hatching you draw as you begin to give the form a three-dimensional appearance.
See **Basic Knowledge 4** ➜ page 22

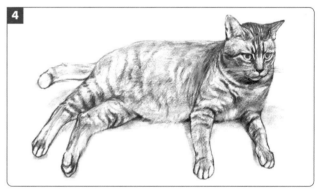

4

Draw in the details and bring out the volume at the same time
Draw the shapes of the details. Follow the striped pattern carefully. Occasionally narrow your eyes and just gaze at the drawing to see the three-dimensional "big picture." Alternate the time you spend looking at the details and the whole image as you draw, and work towards completion.
See **Basic Knowledge 5 – 6** ➜ page 23

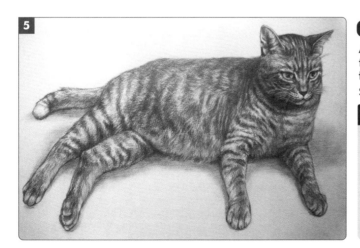

5

Finish

Add hatching lines (page 22) following the direction in which the fur grows. The paws in the front become the key points to finishing.
See **Basic Knowledge 7** ➜ page 23

Note

Vertical-Horizontal Illusion

One of the ways in which we see things includes the "vertical-horizontal illusion." This is where the vertical direction appears longer than it really is. Check the vertical and horizontal ratios using a pencil or knitting needle.
See **Illustration** ➜ page 21

Begin with Observation and Sketching

It is important to make several quick sketches before you start your main drawing, using a 4B pencil. Once you have all your drawing materials together, sit in front of your motif (the animal you are drawing) and carefully observe the subject. Study the whole form to determine approximately how you will position it within your frame, and how the motif fits vertically and horizontally. The first step of sketching out the outline of the subject is called "roughing it out". If the motif will become too small by including the tail, you may leave some parts of it out, but aim to fill up your paper freely with the subject. It is very important to observe your subject carefully and study it well.

Plan to spend 80 percent of your time while you are drawing an animal observing it, and 20 percent of the time actually putting pencil to paper—in other words, take a lot of time to observe.

The pencil can be best controlled if you hold it in the same way that you do when writing with it. Use an HB to 2B pencil and make thin, sketchy lines in straight strokes to sketch the outline. Curved areas are best defined at this stage using short, straight strokes that are connected.

Capture the Shape Accurately

When you are drawing, it is important to frequently observe the shape of the negative space around your subject. If you get too hung up on the object you are drawing, you will become unable to see errors in its shape. The object you are drawing has a shape, but at the same time the space around it has a shape too. These are the positive and the negative shapes. If you keep this in mind and occasionally draw while being conscious of the negative space, I think you will be able to create shapes that are just right.

There is an illustration where the shape of a vase can look like the subject itself, or the background between two faces—a popular optical illusion (see the right bottom illustration). When you look for the faces, they become the "subject" and the white area become the "background." On the other hand, if you look at the vase as the "subject," the black areas become the "background." In the same way, when you are drawing a motif, try occasionally trading the motif and the space around it as the subject and the background. When you are looking at an animal, switch between the actual subject and the shape of the space around it. Even when you are in the middle of your drawing, occasionally switch the subject and the background and compare them to correct errors in the shape.

The mistakes that beginners are liable to make are that they look too much at the picture they are drawing rather than the subject, and that they get too caught up in the details (the facial expressions for example). Take your time to observe your subject well.

In order to capture the shape well, study it thoroughly, and sketch it several times—that's what it really boils down to. It is really hard work to get to an accurate shape. Correct mistakes in the shape as soon as you discover them, and repeat that as you keep drawing. Always compare the motif and your drawing as you work, with an eye toward catching and correcting errors.

● **Illustration: Vertical-Horizontal Illusion**

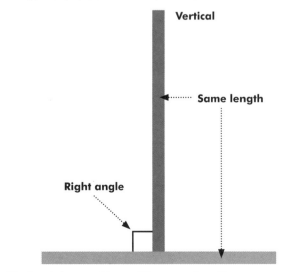

Vertical

Same length

Right angle

Horizontal Lines of the same length

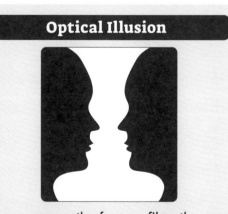

Optical Illusion

When you can see the face profiles, the vase is hidden. When you can see the vase, the faces are hidden. We are unable to see both the subject and the background as being the background or subject at the same time.

Basic Knowledge 3 **Analyze the Shape**

Once the overall shape has been captured, analyze the shapes of the interior of the subject. Define the dark parts and the light parts of the inner parts of the subject—the areas with essentially the same amount of lightness—with wavy lines. The reason you use wavy lines is because the transition between shades is rarely sharp. Straight, solid lines will be too strong and the tone will have too much contrast. What is useful when analyzing the shape is to squint a bit while referring to the subject. By narrowing your eyes, the details of the subject become blurred and hard to see, and you can comprehend the whole volume and large areas of lights and darks without being distracted by details. Let's refer to the task of defining light areas and dark areas with outlines as "analyzing the shape." Shadows have several levels of darkness, so outline the ones with the same degree of lightness and darkness and keep on analyzing the shape.

● **Take Time to Capture the Shapes**

Take plenty of time to capture the shape. This is because once you start to lay down shading, even if you realize there are mistakes in the shape, it becomes more and more difficult to correct them. In addition, if the shapes are properly analyzed, the shading can be applied smoothly. But no matter what stage you are at in the drawing process, when you realize there is a mistake in the shape, correct it without hesitation. Use a knitting needle or similar

tool to measure the proportions and compare it to your subject so you can identify what is wrong and correct the shape. Avoid vigorously erasing with your plastic eraser or kneaded eraser when doing this. Even if you think the overall shape is wrong, the interior contours you have already analyzed can occasionally be useful, so leave them be until you really need to erase them.

The work of observing the subject while searching for the correct shapes is a process. Once you have captured the shapes, the shading (hatching applied with pencil) is laid down.

Partition both the subject and the negative space with straight lines using a pencil or knitting needle to measure, and verify if the shapes of the spaces of the subject (the cat) and the paper are similar. Use a knitting needle to measure and mark horizontal and vertical lines, and check how the shape changes. Horizontal and vertical lines are easy to recognize, but the differences in angles of diagonals are more challenging. Whenever you are checking the shapes of spaces or measuring the proportions, it is a good idea to use a knitting needle or similar tool in horizontal, vertical and various angled orientations.

Basic Knowledge 4 **Lay Down the Shading**

Up until now we have analyzed the shapes according to their shading levels, but now we will lay down the shading with B to 2B pencils using a technique called "hatching." Hatching is a technique where even lines are aligned together to express a surface. The lines are laid down as parallel to each other as possible. They do not have to be long lines. When the area to cover is large, connect areas of hatched lines. The hatch lines are laid down in such a way as to reflect the orientations of the surfaces of the subject. It's especially important for beginners to put down straight hatch lines, not curved ones. Be aware that even curved surfaces are indicated by arranging short, straight lines. The reason for this is that straight lines are easy to put down and can be easily repeated, but repeating curved lines requires a high level of expertise.

In addition, curved hatch lines make previously analyzed shape lines hard to see.

● **Make the Shading Darker with Cross Hatching**

Make dark parts dark by layering hatching lines. Vary the direction (the angle) of the layered lines a little bit, while being aware of the surface at the same time as you lay down shading. Be careful not to lay down the hatch lines at right angles. Unless you have a lot of skill, right-angled hatch lines tend to look like a screen and do not look attractive, and more than anything it is difficult to express shading with them. When varying your hatching lines, make the angle changes small (for example from 20 to 50 degrees).

You might think that if you lay on shading with hatching, the shape-defining outlines you made will disappear. However, if you use those shape-defining lines as guides, and fashion your hatch lines in different directions from them with sensitivity to the surface of the subject, the undulating transitions you defined while sketching will not be lost.

Incidentally, lightness 10 is white, and lightness 1 is black. Study how richly you can express the steps between those two extremes.

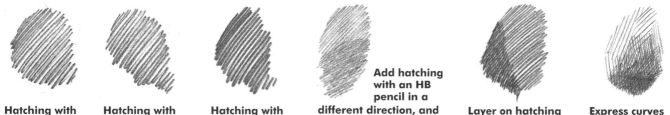

Hatching with an H pencil

Hatching with an HB pencil

Hatching with a 2B pencil

Add hatching with an HB pencil in a different direction, and reduce the lightness by one level with each pass

Layer on hatching with a 2B pencil

Express curves by layering on hatching

Basic Knowledge 5 ## Draw the Details

To express the fur of mammals, after applying shading to the entire drawing with the various pencils and balancing out the whole well, apply strokes following the direction of the growth of the hair. Black fur, white fur and everything in-between; there are lots of fur colors. There's a difference in texture between stiff short fur and silky long fur too. You will be substituting lightness for different shades, and expressing them all with monochromatic pencils. The stiff hair on the back of an animal versus the white, soft fur on their bellies, the difference between the fur on the outer part of the ear versus the inner part of the ear—ask yourself how you can differentiate these as you observe the subject, and improvise as you work. If you think you have laid down too much tone at this time, you can wipe some of it away with a cloth or press on it lightly with a kneaded eraser.

Basic Knowledge 6 ## Capture the Volume

Narrow your eyes and compare the subject to your drawing. Are the areas of volume that you can see on the subject properly depicted in your drawing? If your drawing looks monotonous and lacking contrast or weak, narrow your eyes and look at the subject as one large three-dimensional object, and add a little extra shading.

In Japanese and other East Asian cultures, there is a strong propensity to capture the outlines of subjects, without much attention being paid to shading. But with that aesthetic it is difficult to see the depth that a three-dimensional object has.

Basic Knowledge 7 ## Finish

Finish up the details. If you draw in the parts that are closer to you finely at this time, they will become emphasized and look even closer. If you think you have drawn in the parts in the back too strongly, use methods such as adding more pencil lines to diffuse the details, or weakening the lines by pressing on your kneaded eraser. On an animal, the head and face, and the positions of the legs are very important. If the animal is in a standing position, make sure the legs are positioned properly.

For the head, observe the eyes, nose and ears well. Beginners often inject their own image of what the eyes, nose and mouth should be. However, the ears, mouth and eyes of an animal have very different shapes than those of a human. Don't get hung up on the thought that you're drawing an eye, or a nose, or a mouth, but rather look at the spaces surrounding them. In addition, measure the proportions of the animal or the positions of the parts you are drawing carefully as you draw them.

Have you captured the shapes properly? Is the animal posed naturally? Draw a lifelike representation that faithfully expresses the "animal-ness" of your subject.

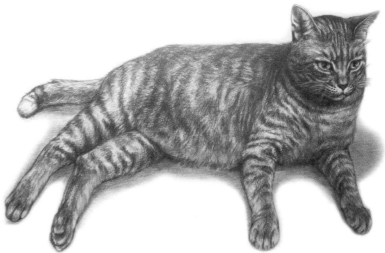

Basic Drawing Techniques

Here are 7 basic techniques you can use to create lively animal drawings.

Basic Technique 1 Stroke

Stroke refers to the way you use your drawing implement when drawing. There are a lot of ways of expressing yourself, such as layering lines to show three-dimensionality and using strong and weak lines flexibly when showing shadows.

◀ An example of using straight-line strokes to express curves. The changes in the surfaces are expressed by changing the directions of the parallel lines.

Move the pencil in one direction, and put down parallel lines densely. By changing the angle little by little, you can express the changing angles of the surface. Use the appropriate orientation of lines to show the direction of each surface.

Basic Technique 2 Black Out

This means to completely fill up an area with your pencil. This is a technique that is often used for very dark areas or when expressing hard surfaces.

◀ This method is used to express the blackness of the wings of a beetle, or the luster of shiny objects. The white high-lights are smaller than they actually appear, so make them intentionally smaller. In addition, the lightness of the areas adjacent to the shiny areas is extremely low (dark).

Don't make it very dark from the outset. Start with a lightness of 1 or 2, and make it gradually darker with uniform strokes. Do not overlook the fact that even very dark areas have tonal variation. Use 3B and 4B pencils while staying aware of the areas of varying tonal values, and darken them carefully.

Basic Technique 3 Shading

Shading is how you express three-dimensionality through lights and darks. The transition between light and dark (gradation) is expressed with line strokes, and they are used to show the direction of the light and its depth, and the volume of the subject.

◀ Richly express the movement of shading from the back of the animal where the light hits to the belly, which is in shadow.

To express the volume and weight of massive bodies and the texture of the hide, layer pencil strokes on densely. The objective is to show the variety of lights and darknesses effectively. Occasionally smudge the carbon particles using a soft cloth or tissue to blend them.

Basic Technique 4 Hatching

This is the method of putting down multiple small parallel lines to express the character of surfaces. It is used to for a variety of purposes, such as to express volume, shadows, and light and dark surfaces.

◀ Follow the contour and layer on shad-ing as you add the strokes. Layering on hatching that goes in different direc-tions is called "cross hatching."

For animals with fur, pay attention the direction in which that fur grows, and express the stiffness or softness of that fur in tandem with the flow.

Basic Technique 5 — "Draw" With White—Use the Kneaded Eraser

Use a shaped kneaded eraser to remove shading to reveal lighter areas.

◀ The direction in which the fur grows was expressed with the pencil, but afterwards the highlights of the fur were pulled out with a kneaded eraser formed into a point as if to draw in white. We tend to see white parts as larger than they actually are. White parts are actually much smaller than they may appear, so after whiting out areas, clean up their edges with a pencil, and consciously make the white areas smaller.

If you gently press the kneaded eraser onto the surface of the drawing, you can express a softer, diffused lightness too.

Basic Technique 6 — Pull Out More White—Use the Plastic Eraser

With a plastic eraser, you can create sharp whiteness as opposed to the kneaded eraser's softer effect. Using the edge of the eraser, you can bring out whiteness in one pass.

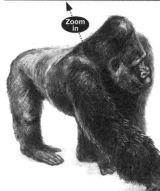

◀ Use a kneaded eraser and a plastic eraser together to express the contrast between the strong strokes with presence in the foreground, and the fur upon which the light is shining in the more distant parts depicted in the drawing.

After using a kneaded eraser, check to see if the contrast between light and dark is apparent, and always clean up the edges of the erased areas with a pencil.

Basic Technique 7 — Bring Out the Whites / Leave the Whites

This is a method where you leave areas that you want to be white untouched.

◀ The lightest parts of the motif (the parts that face upward or the light areas that are in the front and so on) are the parts where the white of the paper will be left untouched. Here, we will surround those areas with irregular lines.

As the drawing nears completion, reduce and refine the number of very light areas, and adjust the overall tonal balance.

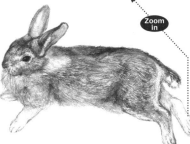

The Basic Structure of Animal Bodies

Before you learn about bone structure, understand the basic structure of an animal's body. Here, we have used a vertebrate animal, in particular a human, as the base, and explained the structures of other animals by comparing them with that.

The Bilateral Symmetry of Animal Bodies and Their Bipolarity

Plants have radial symmetry. When you look at them from above, just like a round cake, each part that you might cut out from the center is symmetrical.

On the other hand, the outer appearance of most animals has bilateral symmetry. Animals developed a front and back side to facilitate mobility. For animals, the functional differences between front and back are critical.

The earliest organisms were essentially a sac with one "mouth" to take in food, absorb and digest it, and also eliminate. Then, a tube (the digestive system) developed, containing a distinct entrance and exit, becoming the mouth and the anus. The digestive system was surrounded by nerves, specialized by body part, and the homeostatic functions became ever more complex. At this point in evolution, no brains or eyes had yet been formed. Afterward, the nervous system became interconnected and the spinal cord was developed. Eventually, the end of the spinal cord became enlarged, developed complexity and became the brain. Appearing at the forward end of the direction in which an animal advances, the head contains sensory organs like the mouth, nose, eyes and ears.

Comparing the parts of a human to those of a cat

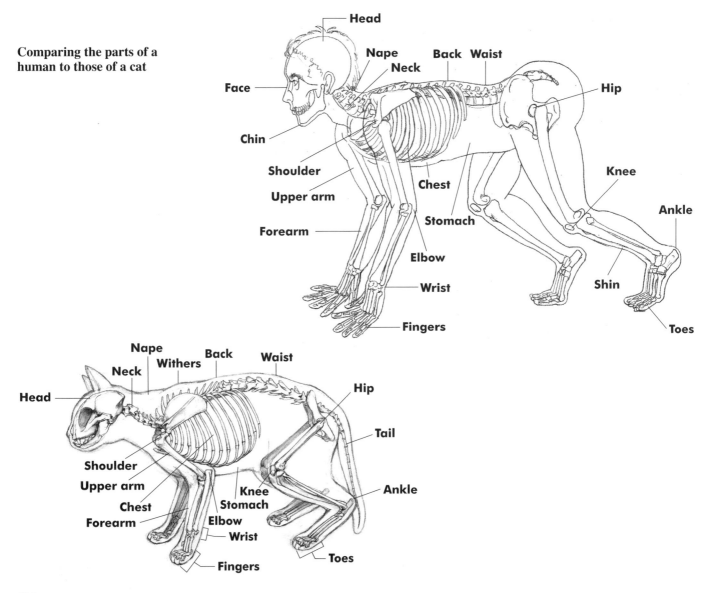

What is the Body Axis?

The body axis is an imaginary line that connects the head and the tail. Bipedal animals like humans have a vertical body axis, and quadrupedal animals have horizontal axis. Humans, who share the same ancestors as monkeys, acquired the ability to walk on two legs, and their lumbar spines strongly bend forward, and their upper bodies shifted 90 degrees, resulting in a body axis that became vertical. For this reason, the front and back limbs of an animal are analogous to the upper and lower limbs on a human.

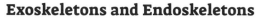

Exoskeletons and Endoskeletons

Insects possess hard shells on their exteriors, and their soft innards inside them. This kind of structure is called an *exoskeleton*. In addition to insects and arachnids, marine animals such as shrimp, crabs, shellfish and many other exoskeletal animals exist.

On the other hand, vertebrates such as humans possess bones inside that support them, and have soft tissue such as the muscles and skin surrounding the bones. This type of structure is called an endoskeleton. A large group within the endoskeletal group is the vertebrates. Exoskeletal creatures are limited in size by their outer structures, but endoskeletal creatures can keep on adding soft tissue outside of their inner structures and keep growing bigger. Endoskeletal beings include large animals such as elephants and whales. Humans can also be classified as large-scale endoskeletal beings.

Motor Systems

The bones and muscles used to move the body are called the *motor systems*. The bones form the structure of the body, and are passive motor systems. The muscles control movement through nerves called *motor neurons*. The ends of muscles go over the joints and are adhered to the bones. By contracting the muscles, they become shorter, and they move depending on the structure of the joints. The muscles are active motor systems.

I have not touched on the subject of tendons here because it is beyond the scope of this discussion.

Axial Skeletons and Appendicular Skeletons

The entire skeletons of vertebrates, including humans, can be divided into axial skeletons and appendicular skeletons.

Axial skeletons are the ones at the core such as the skull, the spine and the rib cage. The appendicular skeletons are comprised of the bones of the upper (or frontal) and lower (or back) limbs. The upper limb bones (the forelimb bones) are made up of the upper limb girdle (the shoulder girdle) and the free limb upper bone (the forelimb bone) and the lower limb bones (the back limb bones) are made up of the lower limb girdle (the hip girdle) and the free limb lower bone (the lower limb bone).

The upper and lower limbs on a human are the fore- and back limbs on an animal. In addition, as far as animals are concerned, the forelimb girdle is often included in the forelimb bone, and the back limb girdle is often included in the back limb bone.

From here, I will explain the bones, focusing on the human form.

The Spine

The spine refers to the "backbone" that stretches along the back side of an animal from the head to the tail. The parts of bone that make up the spine are called the vertebrae. The spine can be divided up starting from the part closest to the head into the cervical spine, the thoracic spine, the lumbar spine, the sacrum (the sacral vertebra) and the coccyx (tail vertebra). The number of vertebrae differs by the animal, but the cervical spines of mammals are fixed at 7 vertebrae.

Incidentally, humans have 7 cervical vertebrae, 12 thoracic vertebrae, 5 lumbar vertebrae, 1 sacrum vertebra (the 5 sacral vertebrae fused together to become one) and 1 coccyx vertebra (3 to 5 tail vertebrae fused together to become one). Although humans lost external tails, they still have the bones of a small tail located internally.

A lot of animals have long tails and a large number of tail vertebrae. For instance, a cow has 7 cervical vertebrae, 18 thoracic vertebrae, 5 to 6 lumbar vertebrae, 5 sacrum vertebrae and 15 to 19 tail vertebrae.

The Rib Cage

The rib cage is a bird-cage-like bone structure made up of the thoracic spine, which is part of the spine, the 12 pairs of ribs and one sternum. The heart and the lungs are housed within this structure. The diaphragm, which is at the bottom of the rib cage, divides the thoracic cavity and the abdominal cavity.

In humans, the rib cage is vertically oriented, but this is a unique structure; in most mammals it is horizontally oriented. The human sternum is a bone in the solar plexus, but in other animals a column-like structure of several bones can be seen here.

In addition, the sternum in birds is enormous, with a keel that projects prominently to the front, on which large pectoral muscles that pull down the wings when they are flapped are attached.

Cross Sections of Rib Cages

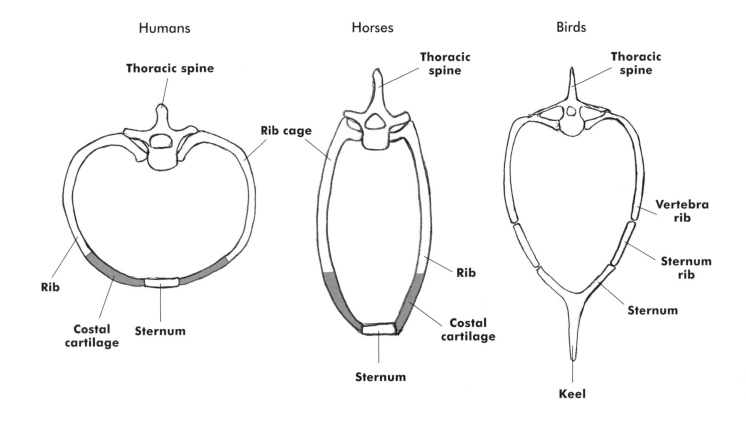

Humans — Thoracic spine, Rib, Costal cartilage, Sternum

Horses — Thoracic spine, Rib cage, Rib, Costal cartilage, Sternum

Birds — Thoracic spine, Vertebra rib, Sternum rib, Sternum, Keel

Skull

The bone of the head is called the skull. The skull can be roughly divided into the neurocranium and the facial skeleton (the visceral skull). The neurocranium contains the brain, and the facial skeleton contains sensory organs such as the eyes, nose, mouth and ears, and has many openings to hold them and through which they are connected to the brain.

The neurocranium is made up of the frontal bone, the parietal bone, the occipital bone, the temporal bone, the petrosal bone, and the sphenoid bone. On the other hand the facial skeleton is made up of the mandible, the maxilla, the palatine bone, the nasal bone, the cheekbones, the lacrimal bone and so on.

If we compare the volume of the neurocranium and the facial skeleton, in animals except for humans the facial skeleton is much larger. In animals with the exception of humans the masticatory bones (the maxilla and the mandible) are large, and the muzzle projects forward. On the other hand, while the masticatory bones have become weaker and have regressed in humans, the neurocranium is characterized by its forward projection and having become large and roughly spherical. The nasal bone and chin of the human are the parts that have remained after the proboscis regressed.

If you become used to looking at the skulls of various animals, you will come to realize that the human skull is comparatively very unique.

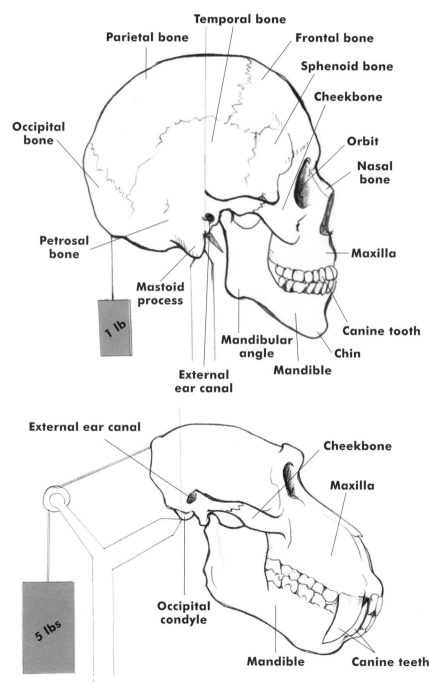

The Balance of the Human Skull

If we balance the front and back of the skull with the occipital condyle (the joint side with the spine) as the fulcrum, we can balance it with a small amount of tension at the back, and there is little load on the nuchal ligament and posterior platysma that connect the occipital bone and the spinous process of the cervical spine. In other words, the large neurocraniums of upright walking humans are on fairly short necks, and are well balanced.

The Balance of the Orangutan Skull

If we balance the front and back of the skull with the occipital condyle as the fulcrum, orangutans and other mammals need a large amount of tension at the back. The nuchal ligament that supports the heads of mammals at the nape projects prominently from each cervical spine protrusion and the occipital bone to support the head and the long neck. Animals with long necks, such as horses and giraffes, have thick, strong nuchal ligaments.

The Teeth and Jaws of Various Mammals

A dental formula is where the incisors, canines, premolars (anterior molars) and molars (posterior molars) of the upper or lower jaw appear on the left or right side. The upper teeth are expressed as the numerator and the lower teeth as the denominator of a fraction, and each mammal has different characteristics. The teeth of mammals are a key to understanding their phylogenetic relationships as eating habits.

The Dental Formula for Mammals

$$\frac{3 \cdot 1 \cdot 4 \cdot 3}{3 \cdot 1 \cdot 4 \cdot 3} = 44 \quad \left\langle \frac{\text{(Upper jaw) Incisors} \cdot \text{Canine} \cdot \text{Premolars} \cdot \text{Molars}}{\text{(Lower jaw) Incisors} \cdot \text{Canine} \cdot \text{Premolars} \cdot \text{Molars}} = \frac{\text{The total of the number of upper and lower and left to right teeth}}{} \right\rangle$$

Lions

Lions are carnivores that have sharp, developed canines on both their upper and lower jaws. Where the jaws come together, pay attention to the way that the lower jaw is to the front of the upper jaw. This is not limited to just lions; many carnivores share this trait, and the canines of the lower jaw are in the front of the ones on the upper jaw. The molars of carnivores are called carnassials and are shaped like knives to rip apart flesh, and are not shaped like grinding stones in the way molars in herbivores or omnivores are.

The dental formula for lions

$$\frac{3 \cdot 1 \cdot 3 \cdot 1}{3 \cdot 1 \cdot 2 \cdot 1} = 30$$

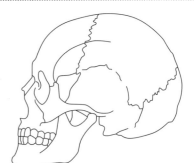

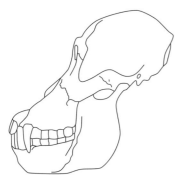

Orangutans

Japanese macaques as well as orangutans, gorillas and chimpanzees all have the same dental formula as humans, They are omnivores with a good balance of incisors, canines and molars.

The dental formula for orangutans

$$\frac{2 \cdot 1 \cdot 2 \cdot 3}{2 \cdot 1 \cdot 2 \cdot 3} = 32$$

Humans

Humans are omnivores. Due to using fire to cook foods until they were tender, the capabilities of their jaws decreased, and the jawbone regressed. The teeth may be decreasing in number too, a bit behind the regression of the jawbone. It is not unusual for some humans to not have the third molar.

The dental formula for humans

$$\frac{2 \cdot 1 \cdot 2 \cdot 3}{2 \cdot 1 \cdot 2 \cdot 3} = 32$$

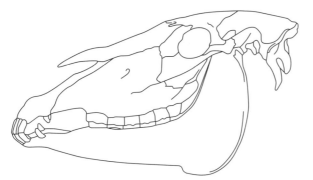

Horses

In herbivores like horses, the molars that grind up difficult-to-digest grasses are well developed. Other things that characterize a horse's teeth are that there are incisors on the upper jaw and that they have canine teeth. Cows do not have upper-jaw incisors or canines.

The dental formula for horses

$$\frac{3 \cdot 1 \cdot 3 \cdot 3}{3 \cdot 1 \cdot 3 \cdot 3} = 40$$

Dolphins

The skulls of dolphins are shaped so that the rounded protruding part is largely split into two. This contains an organ called the "melon" for echolocation, which emits sound waves that bounce back from its targets and are picked up as vibrations registered by the lower jaw, to measure the distance between the target and the dolphin. When dissected, the melon looks like a mass of connective tissue. A dolphin's teeth are comprised of many similar cone-shaped structures; they capture and swallow fish in one motion.

The Bones of the Skull

The figure below shows the bones that make up the skulls of orangutans, humans, dogs and horses juxtaposed for comparison.

In horses, the maxilla, mandible, nasal bone, lacrimal bones and cheekbones make up most of the skull. On the other hand, the proportions of the frontal, parietal, occipital, and temporal bones that make up the cerebral cranium (neurocranium) are small, and the volume ratio between the facial and cerebral craniums appears to be about 7:1.

Looking at dogs, we can see that the facial skull is larger than the cerebral skull, with a volume ratio of about 5:1. The orangutan, which is closely related to humans, has a large facial skull with a volume ratio of about 3:1 between the facial skull and the cerebral skull.

However, in humans, the ratio of facial and cerebral cranium volumes is reversed to about 3:7, and the cerebral cranium is markedly larger. Humans are the only mammals with such a large cerebral cranium. Humans are characterized by a large and rounded cerebral cranium and a marked posterior retraction of the facial cranium (proboscis). Comparisons with animals show that the human nasal bone and chin are not protruding forward, but are rather simply remaining in place following the regression of the other features.

How to Look at Bones

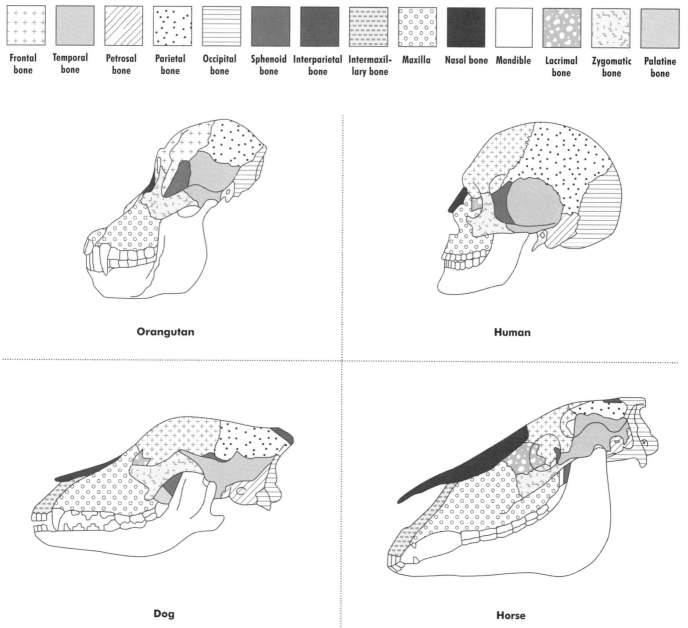

Frontal bone · Temporal bone · Petrosal bone · Parietal bone · Occipital bone · Sphenoid bone · Interparietal bone · Intermaxillary bone · Maxilla · Nasal bone · Mandible · Lacrimal bone · Zygomatic bone · Palatine bone

Orangutan

Human

Dog

Horse

Pectoral Girdle (Shoulder Girdle)

The pectoral girdle (shoulder girdle) is made up of the scapula and the clavicle. Horses, which are odd-toed ungulates, do not have clavicles. The clavicle is degenerative, and has been lost during evolution in many mammals. In carnivorous cats a small remnant of the clavicle is seen within the ligaments that connect the scapula and sternum.

The illustrations below show the chests of a human (viewed from above), lion and horse. In humans, the clavicle is on the front side, the scapula is on the back side, and the acromioclavicular joint (the joint between the scapula and the clavicle)

projects to each side. For this reason, the human chest, which is narrower from front to back, looks even wider from side to side.

The clavicle is a bone that connects the upper limbs (the front limbs) and the trunk, and supports the movement of the upper limbs crossing. Because horses do not have clavicles, there is no skeletal connection between the forelimbs and the trunk, so they are supported by muscles only. In humans the pectoral girdle aids the movement of the upper limbs, and so we have a large range of movement.

The Rib Cage and the Shoulder Girdle

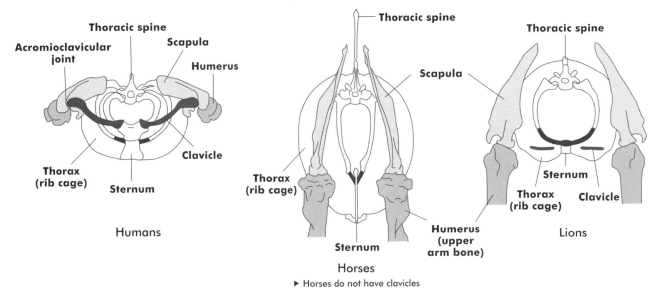

► Horses do not have clavicles

Bones of the Free Upper Limbs (Front Limb Bones)

In four legged animals, the front limbs support the body with the back limbs, and participate in the animal's locomotion. On the other hand humans stand upright, so the upper limbs have been freed from this task. Monkeys were able to achieve the skill of grasping, and their hands were able to act as tools, and humans made tools, their brains developed, and their hands became ever more dexterous. Although the upper limbs of a human and the front limbs of an animal may look different, they have the same relationship. Many animals other than humans have developed front limbs that are specialized by the way they eat.

For example, the "hands" of a mole are like shovels, and the "hands" of pandas have a sixth finger-like appendage. This is not a finger, but a result of the carpal bones becoming deformed, and they are utilized in the process of eating bamboo. The bones of the free upper limbs (the front limb bones) are made up of the upper arm bones, the forearm bones (the ulna and the radius) and the bones of the hand.

The forelimbs of a mammal are capable to some extent of being rotated to the inside and outside (the rotational motion of the forearm axis), in most animals they are limited to rotating to the inside.

Lower Pelvic Girdle (Hind Pelvic Girdle)

The lower pelvic girdle of humans is called the hind pelvic girdle in animals, or just "the pelvic girdle." The part that connects the lower pelvic girdle (hip bone) to the sacrum part of the spine, sandwiching it from the left and right, is called the pelvis. Because humans stand upright, the pelvis is shaped like a basin that supports the inner organs from the bottom, but in four-legged animals this specialization of the hip bone is not seen.

In addition, the hip bone is made up of the ilium, the pubis and the ischium. The pubis on both sides create a pubic connection on the stomach side. Because the lower pelvic girdle makes up the pelvis, it does not move much.

Free Lower Limb Bones (Hind Limb Bones)

The free lower limb bones (the hind limb bones) are made up of the thigh bones, the lower leg bones and the bones of the foot. Although the thigh bones project to the sides of amphibians and reptiles, in mammals the thigh bones run along the trunk, and are bent in relation to the long axis of the hip bone.

The lower leg bones have two bones, the tibia and the fibula. In some animals the tibia and fibula are fused together, while in some animals such as the horse the fibula has degenerated.

The top of the knee has the patella. This is a sesamoid bone that rises from the tendon of the quadriceps, and occurs in an area that is exposed to the stress of the muscle flexing.

The bones of the foot are made up of the tarsus, the metatarsal bones and the phalanges.

The Bones of the Hind Limbs

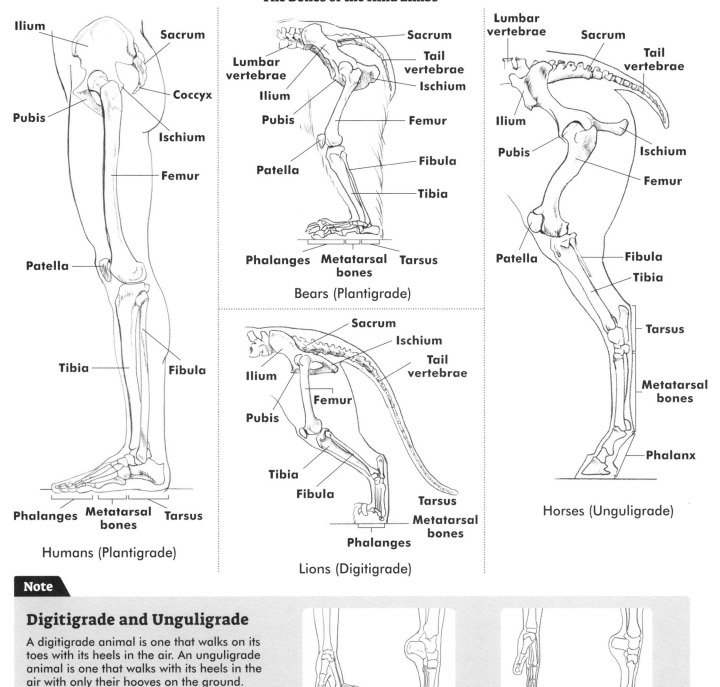

Humans (Plantigrade)

Bears (Plantigrade)

Lions (Digitigrade)

Horses (Unguligrade)

Note

Digitigrade and Unguligrade

A digitigrade animal is one that walks on its toes with its heels in the air. An unguligrade animal is one that walks with its heels in the air with only their hooves on the ground.

Digitigrade configuration shown with the human hand and foot.

Unguligrade configuration shown with the human hand and foot.

PROLOGUE 6 The Movement Modes of Animals

It is the task of the limbs to support the weight and move, but the spine is also involved, creating a movement that is unique to the animal.

The Movement of the Spine is Critical for Propulsion

The locomotion of reptiles and that of mammals differs greatly due to the movement of the spine.

A snake's locomotion is achieved by slithering across the ground. By twisting its body from left to right, it catches its belly scales on the bumps on the ground and pushes against them as it advances. Although lizards possess limbs, the front limbs and the thighs extend out to the sides, and repeatedly bend to the sides as the lizard progresses. This type of movement can be seen in amphibians too, and it can be seen among fish also. Fish achieve propulsion by moving their tail fins from side to side (see page 134).

On the other hand, the locomotion of mammals is achieved with the front and back limbs where the upper arms and the thighs are both elongated, but the spine makes a large wave-like movement up and down. The spines of running cats and cheetahs bend up and down in a flexible motion. This can be seen in underwater mammals too; dolphins and whales also move by bending their spines back and forth.

In this way, locomotion is not just achieved by moving the limbs—the fluid movement of the spine is critical for forward motion. If you can understand the repeated side-to-side movements of the locomotion of fish, amphibians and reptiles, and the up-and-down flexing movements of the locomotion of mammals, your expression of them will become more realistic.

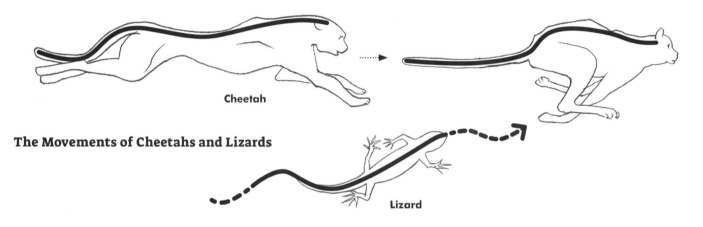

Cheetah

The Movements of Cheetahs and Lizards

Lizard

There are Three Types of Gaits in Mammals: Plantigrade, Digitigrade and Unguligrade

Humans walk by transferring their weight from their heels to their toes as they move forward. As they take a step, their foot lands on its heel, their weight gradually moves to the front, and in the end they kick the ground with their first and second toe tips before they repeat the process with the next step. We are not very speedy, but the amount of ground we can cover is large, and our gait is stable. This type of walking mode is called *plantigrade*. Besides us humans, monkeys, porcupines, beavers and rabbits can walk like this.

The normal stance for dogs and cats is to be standing with their heels raised. This type of gait, which has a small amount of contact with the ground, leads to fast running speeds. In addition, it is easy to change directions while running with this gait. This type of walking mode is called *digitigrade*, and most carnivorous animals such as dogs, cats, foxes, weasels and hyenas move like this.

Cows and horses are animals that are most suited to long-distance running. Their legs have become long and slender, their toes have been covered with thick hooves, and they run rhythmically. This type of walking mode is called *unguligrade*. Herbivorous prey animals such as horses, camels, cows and goats fit into this category.

Incidentally, horses originally had 5 toes. As they evolved they lost their first and fifth digits, then their second and fourth digits. Modern horses stand on their third toes (they are classified as *perissodactyla*, or odd-toed ungulates). On the other hand, cows and pigs stand on their third and fourth toes (they are classified as *cetartiodactyla*, or even-toed ungulates).

Plantigrade Animals

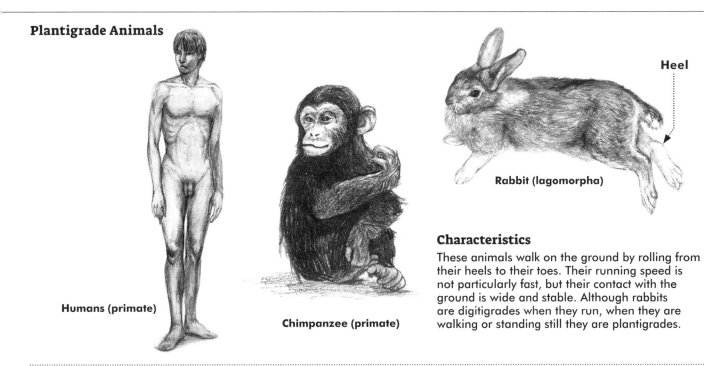

Humans (primate)

Chimpanzee (primate)

Rabbit (lagomorpha)

Heel

Characteristics

These animals walk on the ground by rolling from their heels to their toes. Their running speed is not particularly fast, but their contact with the ground is wide and stable. Although rabbits are digitigrades when they run, when they are walking or standing still they are plantigrades.

Digitigrade Animals

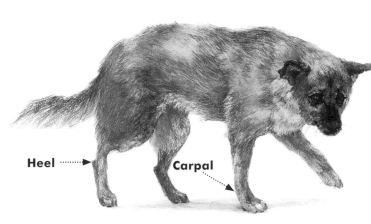

Heel

Carpal

Dog (carnivore)

Cat (carnivore)

Heel

Carpal

Characteristics

The heels never touch the ground, and the metatarsophalangeal joints are prominent and used along with the toes to stand up. The points upon which they are in contact with the ground are small, so their running speed is fast, and they can turn easily while running.

Unguligrade Animals

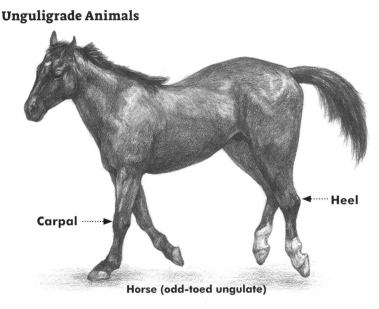

Carpal

Heel

Horse (odd-toed ungulate)

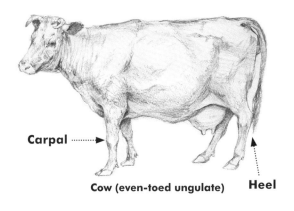

Carpal

Cow (even-toed ungulate)

Heel

Characteristics

The distal phalanges of the toes of these animals have thickened, a thick hoof wraps around, and they stand on their toes. Horses stand on their third toes, and cows and pigs stand on their third and fourth toes.

PROLOGUE 7　Biological Diversification

The bodies of organisms have adapted to their environments and can be seen in various forms. How has biological diversification been classified by science?

The Classification of Organisms

The ancient Greek philosopher Aristotle (fourth century BCE) divided living organisms into animals and plants. This classification was very easy to understand, and is still used today. In the eighteenth century the Swedish scientist Linne proposed the "binomial nomenclature" where organisms are listed by their genus name and species name. Taxonomy started, and microscopic organisms that could not be seen by the naked eye were added, and since then organisms have been categorized into the 5 levels: kingdom, phylum or division, class, order, and family in addition to genus and species. Presently the results of changes in DNA sequencing have been added, and these classifications are frequently being rewritten.

The acceptance of biological evolution is regarded to have started with the publication of *On the Origin of Species* by the scientist Charles Darwin in 1859. This book posited that all living organisms on Earth had ancestors that differed from their current species, and it also discussed natural selection. Natural selection occurs when an individual possessing a particular advantageous attribute produces more offspring than other individuals who lack that characteristic, as the generations progress the more successful offspring proliferate and the group evolves. It was proposed that as a result of natural selection, living organisms adapt in order to survive and to reproduce.

In actuality, before Darwin in 1809, the French naturalist Jean-Baptiste Lamarck had published *Philosophie Zoologique* (*Zoological Philosophy, or Exposition with Regard to the Natural History of Animals*) and had listed the evolution of each type of organism, from old fossils to primitive species

in chronological order, and had discovered the changes that had occurred in each system.

In addition, Lamarck proposed "use/disuse theory" and the theory of the "inheritance of acquired characteristics." "Use/disuse theory" means that the parts of the body that are often used become large and strong over the course of generations, and the parts that are not used eventually degrade. This theory was contradicted later; currently it is believed that characteristics that are acquired later are not inherited, but there are examples that could only have been inherited, so the theory of gradual evolution of organisms is being re-evaluated.

Humans have selected and bred individual animals and plants over many generations, and changed their shapes and characteristics to fit their needs. This is called artificial selection. The vegetables that grace our tables or the animals that become meat have shapes and characteristics that are a far cry from those of their ancestors. Cats evolved from Libyan mountain cats, and dogs evolved from gray wolves through artificial selection. Nowadays, dogs have various types—from large ones like Saint Bernards and Great Danes to small ones like pugs and chihuahuas, and even within the same types there are many subtle variations.

Generally speaking, domesticated animals tend to have rounder, softer, blunter shapes than those of primitive species. In contrast, native or primitive species have a roughness, hardness and sharpness about them. (Example: contrast the wild hog with the pig.)

Humans are also losing their wild nature (self domestication).

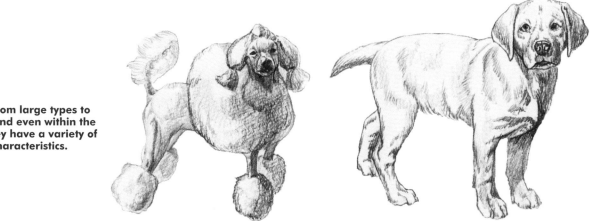

Dogs range from large types to small types, and even within the same type they have a variety of shapes and characteristics.

Animal Organs and Plant Organs

We can divide the organs that make up our bodies into several groups according to their systems. These are the digestive system, the respiratory system, the circulatory systems (vascular system and lymphatic system), the urinary system, the reproductive system, the endocrine system, the sensory system, the nervous system, the skeletal system, the muscular system and so on. Of these, the systems that perform functions that are similar to the ones contained in plants are called plant organs, and the ones that are unique to animals are called animal organs. The plant organs are the respiratory system, the circulatory systems, the reproductive system and the digestive system that absorbs nutrition, and these are equivalent to the respiration of plants, their circulation of nutrients and water, flowering and forming fruit, and absorption of nutrients. These functions are contained within the walls of the muscles and skeleton of the trunk.

Homology

If we trace the history of evolution, ever since life began on Earth some 3.8 billion years ago, we have all evolved from the same ancestors. Embryologically speaking, although the shapes of the upper limbs of a human and the front limbs of a dog and the wings of a bat and the wings of a bird all differ enormously in terms of shape and function, they all started with the same base form. This is called "homology"; the hands of a human and the paws of a dog, and the wings of a bat and those of a bird can be said to be homologous. The shapes that each animal has reached while adapting to their environments during the phylogenetic process is their current form. When comparing humans to animals, understanding the homologous relationship between them requires understanding the animals, and understanding humans too. Knowing animal anatomy leads to a deepening of the understanding of humans.

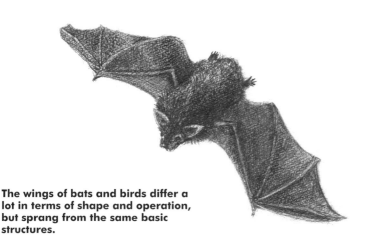

The wings of bats and birds differ a lot in terms of shape and operation, but sprang from the same basic structures.

Biogenesis (Phylogeny and Ontogeny)

The stages of the process by which an egg is fertilized and born is called "biogenesis." With early developmental embryos, all vertebrates (including humans) possess fish-like gills, and are shaped like kidney beans; all embryos look very much alike. On a human, these gills eventually transform into the auricles and the hearing organs, the semicircular canals of the inner ear, the larynx and so on.

In the nineteenth century, the comparative anatomist Ernst Haeckel proposed the "recapitulation theory," which holds that "ontogeny recapitulates phylogeny." It refers to the tracing of history of phylogeny (the evolution of organisms) within the short period of ontogeny (the biogenesis of one egg). Evolution is irreversible, multigenerational change that occurs over a long period of time.

As modern humans, we have discarded the parts that we no longer need and used them for other purposes, changing them into new shapes. Although this means that we have become more complex, that also means many things have been lost too.

For example, humans have lost their tails, and their fur has become a thin covering of hair. These are degradations, but degradation is not the opposite of evolution; degradation is a part of evolution. Evolution means the changes wrought upon organisms as time passes cannot be reversed.

The Evolutionary Tree

If we know the close relationships between animals from the phylogenetic tree of evolution, we can deepen our understanding of them. We can organize the skeletons and body structures of vertebrates using the tree of evolution.

Evolution and Phylogenetic Classification

Phylogenetic classifications have been rewritten again and again. In addition to the study of traits such as the teeth and skeletons, the outer appearance and ecology that already exists, the more recent results of molecular phylogeny reveal some surprisingly close relationships between various organisms.

Vertebrates, who boast a history spanning 500 million years, evolved a long time ago from chordates. Afterward amphibians evolved from fish who possess spines, reptiles evolved from amphibians, and birds and mammals evolved from reptiles.

Mammals Can be Divided Into Three Groups

Mammals can be generally divided into three groups—monotremes, marsupials and eutheria. Monotremes include the platypus and the echidna. Marsupials include the kangaroo and the koala who live in Australia and New Zealand, whose young are born prematurely and are then "brought to term" in stomach pouches.

Eutheria have uteruses that are connected to the mother's body, and whose offspring are born after being nurtured inside the mother's body. Eutheria include groups such as Afrotheria, Edentata, Laurasiatheria, Primates and Rodentia.

Edentata include sloths and anteaters. Afrotheria include elephants, dugongs and aardvarks. Laurasiatheria are divided into Chiroptera, Perissodactyla, Carnivora and Cetartiodactyla.

Whales and Hippopotamuses are Close Relatives!?

In recent years researchers have discovered that whales, hippopotamuses, sheep, goats and pigs are in the same group. It's interesting that the whale and dolphin family, which were previously classified in the cetacean group, are closely related to the Artiodactyla (cloven-hooved animals)—especially hippopotamuses. Carnivora include animals such as the fur seal and the common seal in addition to the cat and dog, fox and wolf. Perissodactyla (odd-toed ungulates) include the horse, the tapirus and the donkey, and Chiroptera include the bat.

The rabbit is not included with rodents such as mice and squirrels, but is in its own group called Lagomorpha. Primates includes mammals who are said to retain primitive characteristics such as tree shrews, Japanese macaques, baboons, as well as apes and humans.

Fish
The lamprey retains the oldest form of currently existing vertebrates. Fish include cartilaginous fish (sharks, rays), ray-finned fish (herrings, trout, tuna, etc.), coelacanths and lungfish.

Amphibians
There are 4,800 varieties of amphibians, and these include salamanders, frogs and caecilians. Many amphibians live both on land and in water: the eggs and larvae live in the water, and when mature they leave the water, and only return to the water to lay eggs.

Reptiles
This group includes animals such as the tuatara, the lizard, the snake, the turtle and the alligator, who split off from the amphibians about 320 million years ago. They are totally adapted to life on land, and lay eggs with hard shells to prevent them from drying out. Most of the offspring of reptiles are hatched from eggs. Present day reptiles that are covered with hard scales cannot breathe through their skins like amphibians, so they perform gas exchange with their lungs.

Birds
There are currently about 8,600 known types of birds. Birds are also thought to be the surviving descendants of dinosaurs. They possess wings, and their bodies are covered with feathers, but those features are made of the protein keratin, just like the scales on reptiles. Their bodies have adapted to make it easier for them to fly by developing hollow bones, among other adaptations.

Mammals
There are currently more than 5,000 types of mammals. "Beasts," or in other words "animals with hair," are mammals. As the name implies, they nourish their offspring with milk, and are characterized by bodies that are covered with hair. In addition, like birds they are warm-blooded animals who generate heat within their bodies.

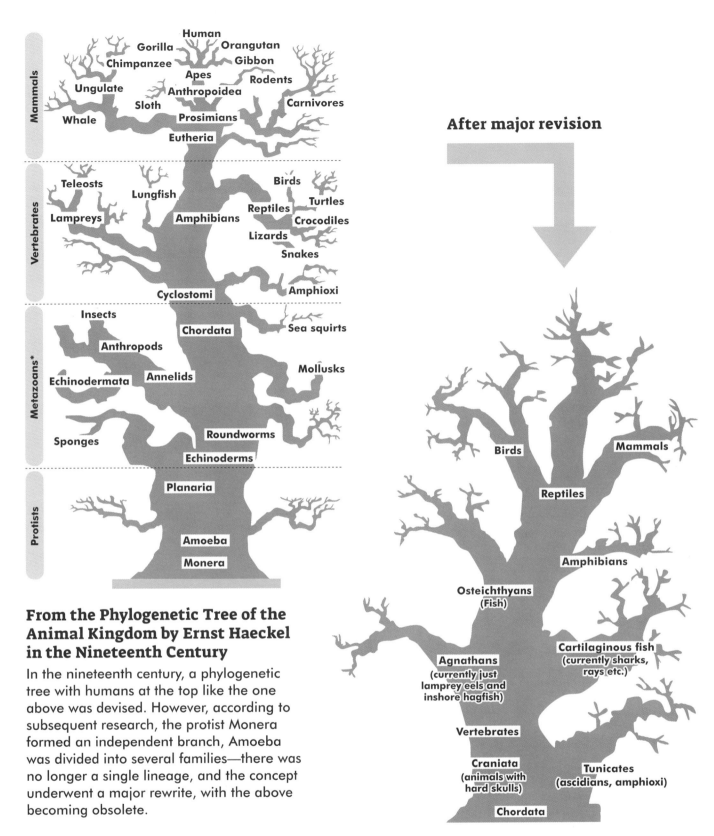

Mammals

Vertebrates

Metazoans*

Protists

Human
Gorilla · Orangutan
Chimpanzee · Gibbon
Apes · Rodents
Ungulate · Anthropoidea
Sloth · Carnivores
Whale · Prosimians
Eutheria

Teleosts · Birds
Lungfish · Turtles
Lampreys · Reptiles · Crocodiles
Amphibians · Lizards
Snakes
Cyclostomi · Amphioxi

Insects · Chordata · Sea squirts
Anthropods
Echinodermata · Annelids · Mollusks
Sponges · Roundworms
Echinoderms

Planaria
Amoeba
Monera

From the Phylogenetic Tree of the Animal Kingdom by Ernst Haeckel in the Nineteenth Century

In the nineteenth century, a phylogenetic tree with humans at the top like the one above was devised. However, according to subsequent research, the protist Monera formed an independent branch, Amoeba was divided into several families—there was no longer a single lineage, and the concept underwent a major rewrite, with the above becoming obsolete.

* Metazoan: a general term for animals other than protozoa.

After major revision

Birds · Mammals
Reptiles
Amphibians
Osteichthyans (Fish)
Agnathans (currently just lamprey eels and inshore hagfish)
Cartilaginous fish (currently sharks, rays etc.)
Vertebrates
Craniata (animals with hard skulls)
Tunicates (ascidians, amphioxi)
Chordata

The Present Abbreviated Phylogenetic Tree of the Chordata by Alfred S. Roemer

I have represented the ancestral lineage of the modern vertebrates, represented by adapting Haeckel's tree. We cannot forget that there have been many more extinct species than there are presently living species. In addition, many species of animals are critically endangered today.

About the Colors and Sizes of Mammals

Since the nineteenth century, several consistent relationships have been noted between the environment in which an animal lives and its body color and shape. Here, I will introduce you to the major ones.

Gloger's Rule (The Relationship Between Body Color and Climate as It Relates to Ultraviolet Light)

The German biologist Constantin Wilhelm Lambert Gloger proposed that "mammals of the same species have darker skin coloration in the tropics and lighter skin coloration in colder climates.

In the case of fur-covered animals, it is body hair rather than skin that exhibits changes in tone, but hair is a variant of skin, so think of it as body color. For example, the body color of bear populations lightens as specimens are observed on a trajectory moving from the tropics to the polar regions, as evidenced in the Malay, black, brown and polar bears. The black hare is widely distributed in the tropics, the brown hare in temperate zones, and

white hares such as the Ezo hare and the Steller's sea hare in cold, snowy regions.

This is deeply related to the strength of ultraviolet rays in a given animal's environment. Bone growth requires a certain amount of ultraviolet light. However, excessive UV rays can be harmful, causing skin cancer. Dark skin and body hair serve as filters for ultraviolet radiation, and dark skin is considered adaptive in tropical zones.

On the other hand, in cold climates, light skin and fur color is more adaptive, allowing the right amount of UV light to penetrate the skin.

Bergmann's Rule (The Relationship Between Body Size and Climate)

The German biologist Carl Bergmann proposed that for the same species of thermostatic animals, those living in cold climates tend to be larger, while those living in tropical regions tend to be smaller. Thermostatic animals include mammals and birds that generate their own body temperature. For example of the bears mentioned above, the farther the observer moves from warmer regions to colder regions, the larger the average body size of local bear populations, ranging from Malay bears to black bears, brown bears and polar bears.

This can be explained by the way that in cold

regions, the smaller ratio of body surface area to volume results in a greater amount of stored heat and less dissipation of body heat, making large animals more suitable for maintaining body temperature. On the other hand, in the tropics, the relatively large surface area to volume allows for more efficient heat dissipation, making smaller animals more adapted to warm climates.

Rabbits also conform to this rule, from the Amami rabbit which is small enough to fit in one's palm, to the great Japanese hare that has adapted to cold climates.

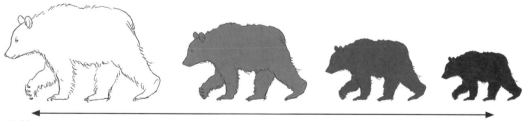

| Cold regions | Temperate regions | Tropical regions |

Allen's Rule (The Relationship Between the Size of Limbs and Appendages and Climate)

Allen's Rule refers to the proposal by the American biologist Joel Asaph Allen that "the same species of thermostatic animals tend to have larger limbs and appendages in tropical regions and smaller limbs and appendages in colder regions." The larger the limbs and appendages, the greater the heat dissipation relative to the conservation of heat.

Conversely, smaller limbs and appendages result in a greater amount of stored heat.

In colder climates, bodies of animals tend to have shorter limbs and small protruding parts such as as tails and ears to prevent the dissipation of heat from the body surface.

Mammals

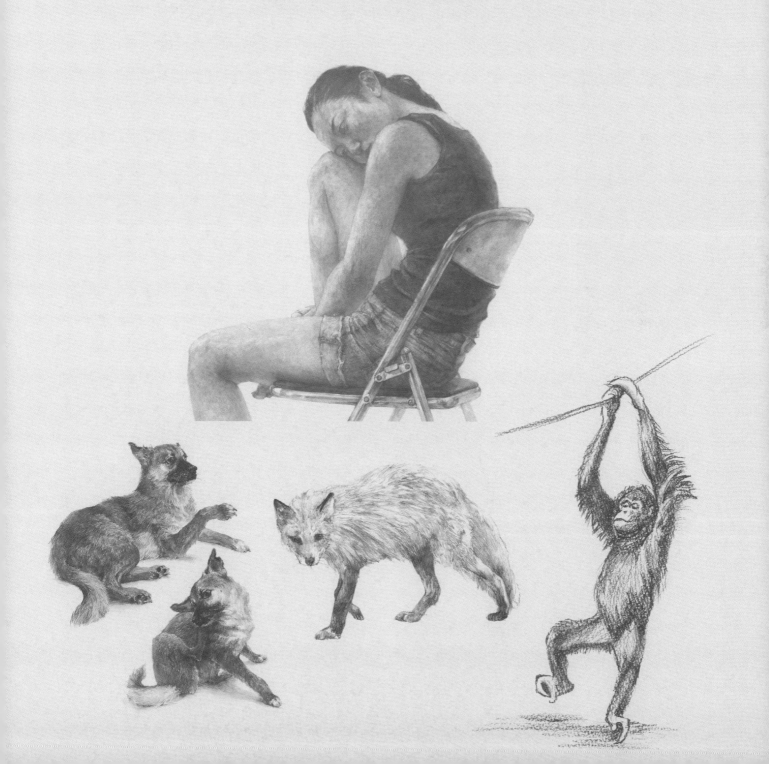

Human

(Animalia/Chordata/Vertebrata/Mammalia/Primates/Hominoidea/ Homo sapiens)

We humans are known by the scientific name (genus and species) Homo sapiens (wise man), a large primate species.

Skeleton • Completed Drawing (Male Frontal View)

The upright human skeleton is characterized by a short cervical vertebrae to support a large head in a balanced manner, a curving lumbar vertebrae, and a pelvis that is sloped down like a basin.

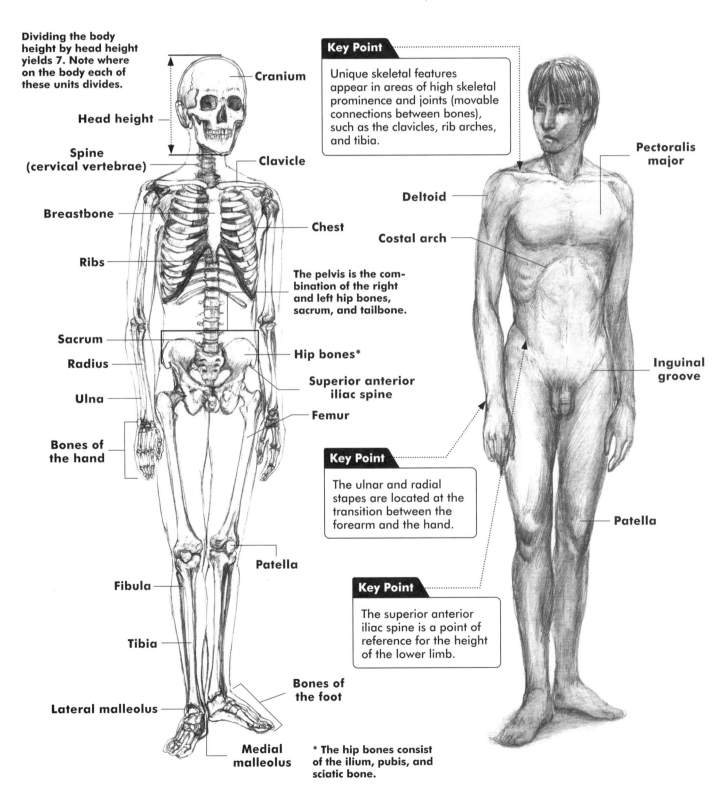

Dividing the body height by head height yields 7. Note where on the body each of these units divides.

Cranium

Head height

Spine (cervical vertebrae)

Breastbone

Ribs

Sacrum

Radius

Ulna

Bones of the hand

Fibula

Tibia

Lateral malleolus

Medial malleolus

Clavicle

Chest

The pelvis is the combination of the right and left hip bones, sacrum, and tailbone.

Hip bones*

Superior anterior iliac spine

Femur

Patella

Bones of the foot

Key Point

Unique skeletal features appear in areas of high skeletal prominence and joints (movable connections between bones), such as the clavicles, rib arches, and tibia.

Key Point

The ulnar and radial stapes are located at the transition between the forearm and the hand.

Key Point

The superior anterior iliac spine is a point of reference for the height of the lower limb.

Pectoralis major

Deltoid

Costal arch

Inguinal groove

Patella

* The hip bones consist of the ilium, pubis, and sciatic bone.

Skeleton • Completed Drawing (Male Back View)

Men generally have a larger overall skeleton and more muscular development than women. For this reason the visible musculature is more angular.

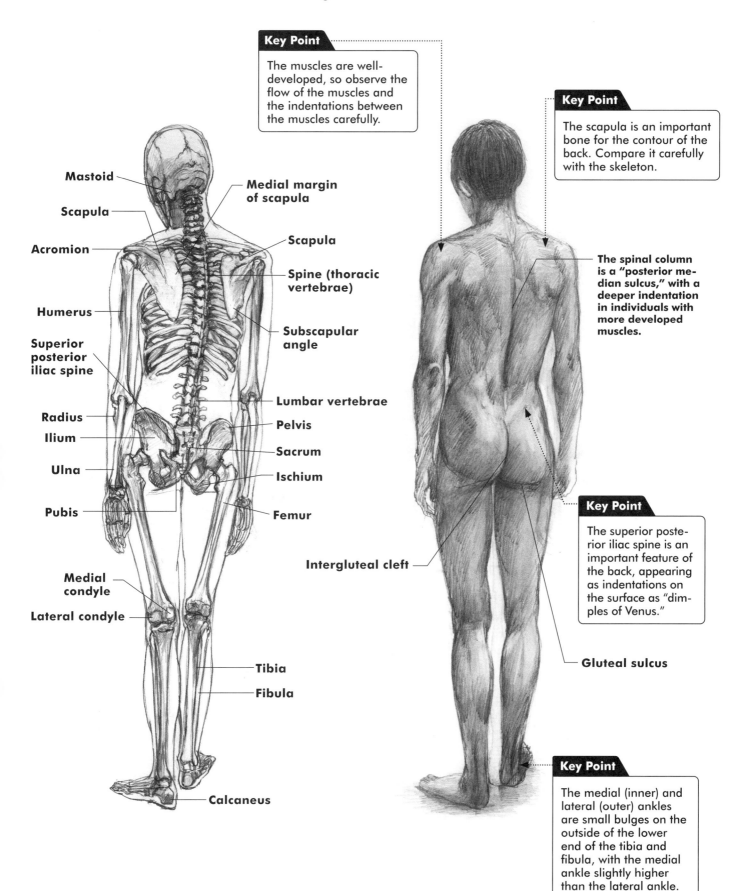

Key Point

The muscles are well-developed, so observe the flow of the muscles and the indentations between the muscles carefully.

Key Point

The scapula is an important bone for the contour of the back. Compare it carefully with the skeleton.

The spinal column is a "posterior median sulcus," with a deeper indentation in individuals with more developed muscles.

Key Point

The superior posterior iliac spine is an important feature of the back, appearing as indentations on the surface as "dimples of Venus."

Key Point

The medial (inner) and lateral (outer) ankles are small bulges on the outside of the lower end of the tibia and fibula, with the medial ankle slightly higher than the lateral ankle.

Mastoid

Scapula

Acromion

Humerus

Superior posterior iliac spine

Radius

Ilium

Ulna

Pubis

Medial condyle

Lateral condyle

Medial margin of scapula

Scapula

Spine (thoracic vertebrae)

Subscapular angle

Lumbar vertebrae

Pelvis

Sacrum

Ischium

Femur

Intergluteal cleft

Gluteal sulcus

Tibia

Fibula

Calcaneus

Skeleton • Completed Drawing (Female Frontal View)

Women's skeletons are generally more slender, smaller, and thinner than those of men, especially in the cranium and pelvis. The skeleton is wider at the ilium.

The concavity created by the right and left clavicles on the sternum is called the jugular fossa (neck cavity).

Key Point

The female body has fat reserves, breasts and a rounder abdomen. The muscles should be less firm and smoother to give them a feminine appearance.

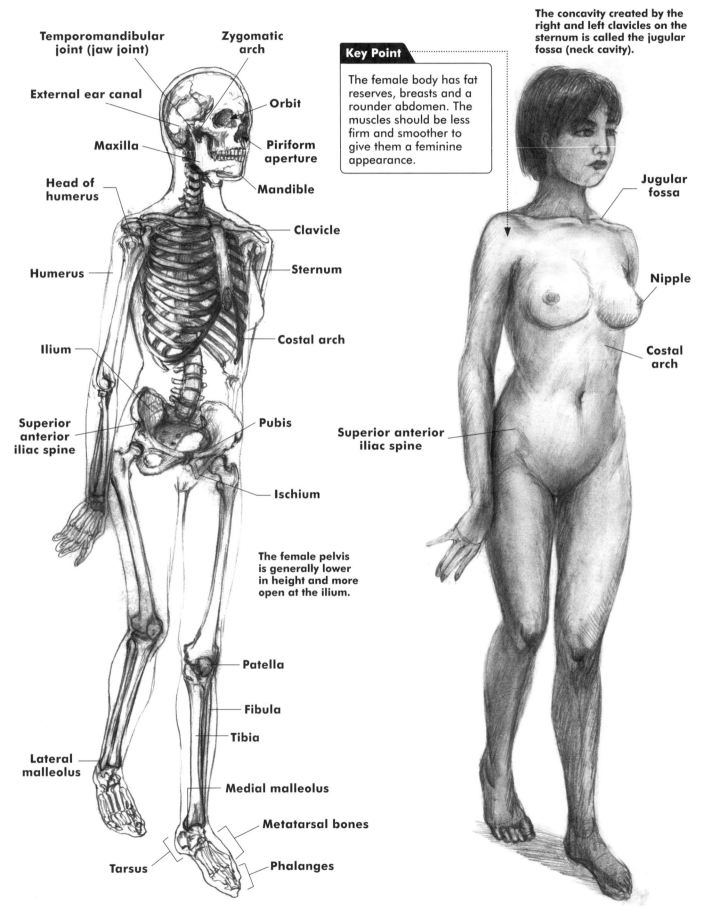

Temporomandibular joint (jaw joint)

Zygomatic arch

External ear canal

Orbit

Maxilla

Piriform aperture

Head of humerus

Mandible

Clavicle

Humerus

Sternum

Costal arch

Ilium

Superior anterior iliac spine

Pubis

Ischium

Jugular fossa

Nipple

Costal arch

Superior anterior iliac spine

The female pelvis is generally lower in height and more open at the ilium.

Patella

Fibula

Tibia

Lateral malleolus

Medial malleolus

Metatarsal bones

Tarsus

Phalanges

Skeleton • Completed Drawing (Female Back View)

Women have less muscle mass and thicker subcutaneous fat than men. The body surface is smooth and curvaceous because the fat fills in the cuts between the muscles.

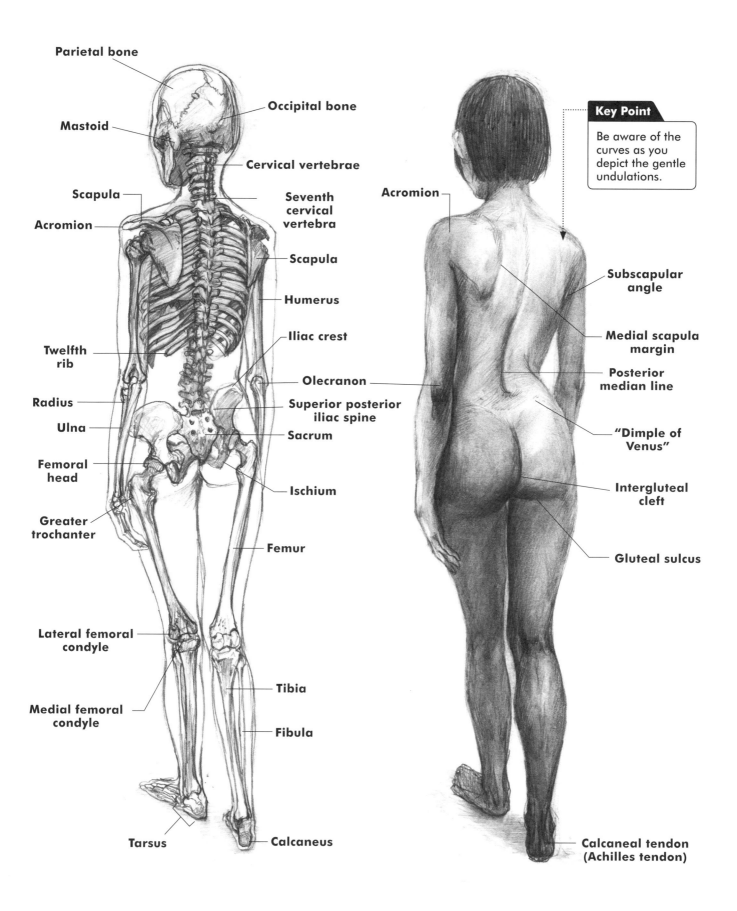

Parietal bone

Occipital bone

Mastoid

Cervical vertebrae

Scapula

Seventh cervical vertebra

Acromion

Scapula

Humerus

Twelfth rib

Iliac crest

Radius

Olecranon

Ulna

Superior posterior iliac spine

Femoral head

Sacrum

Greater trochanter

Ischium

Femur

Lateral femoral condyle

Medial femoral condyle

Tibia

Fibula

Tarsus

Calcaneus

Acromion

Key Point

Be aware of the curves as you depict the gentle undulations.

Subscapular angle

Medial scapula margin

Posterior median line

"Dimple of Venus"

Intergluteal cleft

Gluteal sulcus

Calcaneal tendon (Achilles tendon)

Mammals **45**

Completed Drawing We will draw a person who is posing. We observe the shape and volume of the human body, differences in texture between skin and clothing, joints, etc. as we draw.

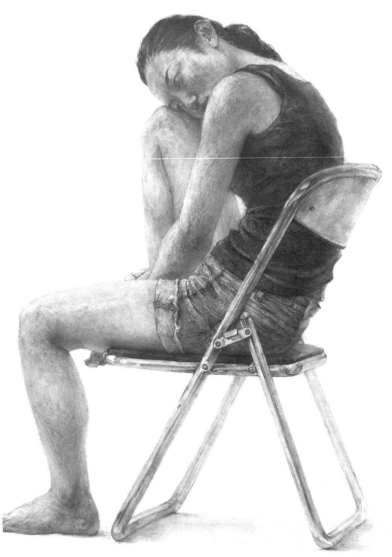

Note

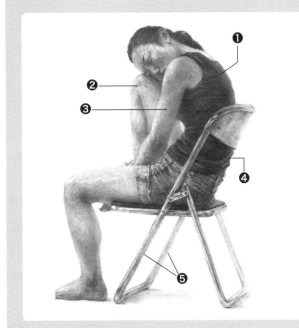

❶ Even within black clothing there are deep shadow tones created by light reflections and wrinkles, so we can find and express changes in color tones within the black.

❷ Draw the knees, elbows and tarsals with the joint structure in mind.

❸ The color of the skin on the upper arm changes slightly depending on how the light hits it. The extensor side is darker than the flexor side, but render the drawing so that the foreground side (the viewer's side) has the strongest tone.

❹ It is important to depict the wrinkles and folds of the garment, but always be aware that the human form is inside the garment.

❺ The near and far sides of the folding chair are rendered in detail, with more contrast and sharpness indicated on the near side. Here, the expression of tonal strength and weakness at the near and far sides of the chair also helps to create a sense of perspective for the human body. Because the subject is the woman, we will refrain from adding too much shiny metallic luster detail to the chair.

Drawing Procedure

In addition to the human body, the artist must be able to depict many other materials such as the wrinkles in the clothing and the texture of the metal of the folding chair.

Decide on the Composition

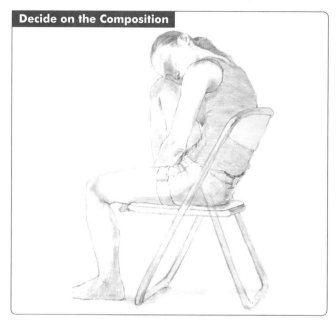

1 Decide on the composition and sketch the whole subject

First, think about how you want the figure to appear in the drawing, and draw the overall large "rough sketch" before you start the detailed drawing. Draw light lines with sharp HB to B pencils. Be aware of the relationship between each body part, and measure and adjust the size and position of each part to reflect accurate proportions. Adjust the body parts by measuring them with a pencil or knitting needle.

Add Tones

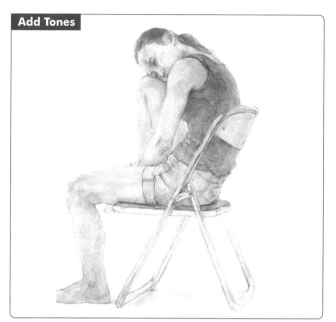

2 Layer tones into the dark areas

Squint to look at the subject in another way to ascertain the overall darkness and lightness of the image. Start with darker areas such as the hair, the tank top, and the seat of the folding chair, and then layer on tones while you keep on looking for the dark areas as you balance the shading. Balance the tones of the face and skin so they don't become too dark as you draw them in. Darken the darkest areas even further. Because tones are relative, this work will bring a sense of radiance back to the skin.

Be Aware of the Weight

3 Develop tones with the overall sense of weight in mind

The tones are layered on by alternately looking at the details and the whole surface, being conscious of the overall weight and whether the ground and the folding chair and foot of the woman are firmly established on the same plane. Squinting at the subject, ascertain if the overall flow of shadows is depicted accurately in the drawing, and adjust the tones as necessary.

Adjust the Shadows

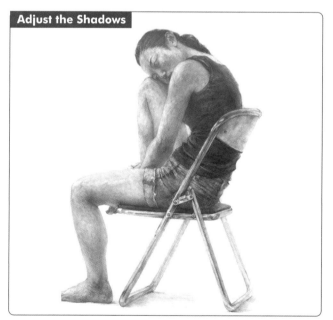

4 Adjust overall tones of the shading and carefully draw in the details

Do the overall tones of lights and darks express the flowing form of the human body well? Be aware of where to place emphasis in the drawing, and finish by drawing in the details in the foreground to tighten up the entire piece.

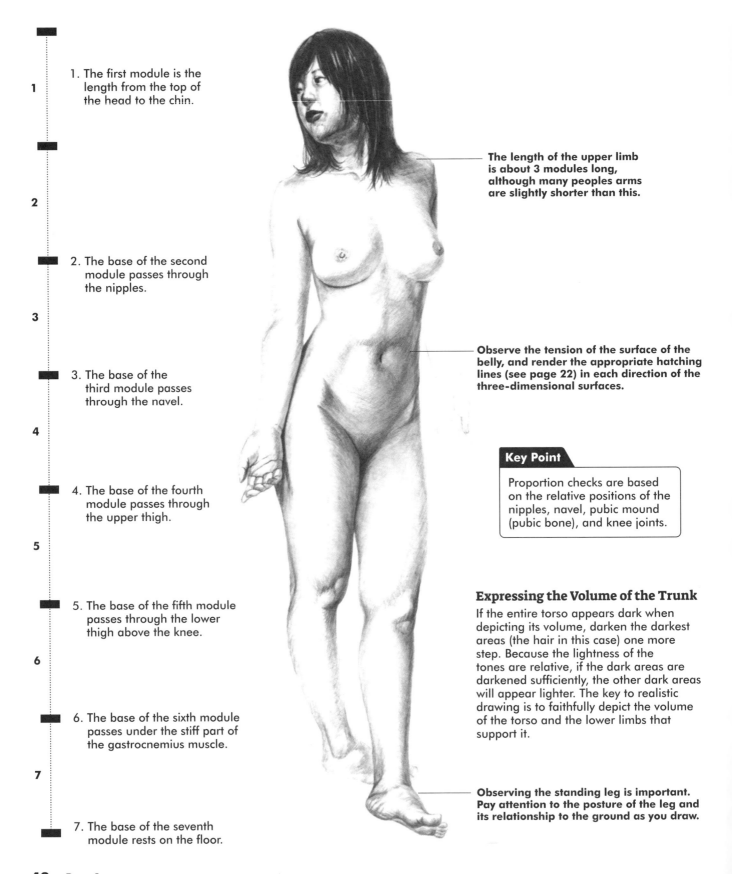

Completed Drawing The height of the human head (the height from the top of the head to the chin) is used as a standard unit to measure by how many heads high the whole body is. Observe the places where each unit passes through. In the case of this person, the head height index is 7, which is the average. Of course these divisions are only a guide, and each person's proportions are unique.

1. The first module is the length from the top of the head to the chin.

2. The base of the second module passes through the nipples.

3. The base of the third module passes through the navel.

4. The base of the fourth module passes through the upper thigh.

5. The base of the fifth module passes through the lower thigh above the knee.

6. The base of the sixth module passes under the stiff part of the gastrocnemius muscle.

7. The base of the seventh module rests on the floor.

The length of the upper limb is about 3 modules long, although many peoples arms are slightly shorter than this.

Observe the tension of the surface of the belly, and render the appropriate hatching lines (see page 22) in each direction of the three-dimensional surfaces.

Key Point

Proportion checks are based on the relative positions of the nipples, navel, pubic mound (pubic bone), and knee joints.

Expressing the Volume of the Trunk

If the entire torso appears dark when depicting its volume, darken the darkest areas (the hair in this case) one more step. Because the lightness of the tones are relative, if the dark areas are darkened sufficiently, the other dark areas will appear lighter. The key to realistic drawing is to faithfully depict the volume of the torso and the lower limbs that support it.

Observing the standing leg is important. Pay attention to the posture of the leg and its relationship to the ground as you draw.

48 Part 1

Here, we will explain how to draw a person after they have been sketched several times in advance, and then drawn based from a photograph.

Draw the Entire Figure

1 Draw the entire outline

The outline is drawn while looking at the overall balance, deciding how to arrange the composition on the paper, and roughing it out (getting an idea of how it should be arranged).

Add Shadows

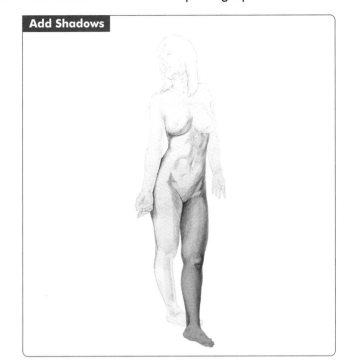

2 Draw the details and add shadows

Once the shape is roughly defined, we can start shading the figure. Layer on tones starting with the torso and the left leg that is in front of the body.

Be Aware of Three Dimensionality

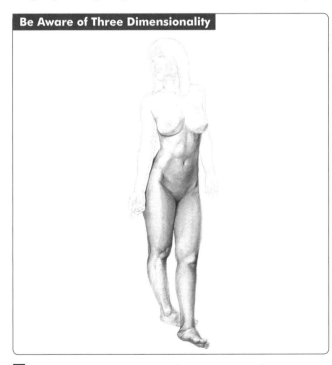

3 Define the shadows, skin texture and three-dimensionality

Be conscious of the shading, skin texture, and three-dimensionality as you draw them in little by little. In addition, render the drawing while keeping in mind the structure of the skeleton and the way the muscles are attached. Line up the hatching lines (see page 22) while being aware of the tautness of the skin of the torso. Even if you think you've gone a little too dark, once you layer color onto darkest part—the hair on the head—you will realize that it's too dark after all.

Draw the Head

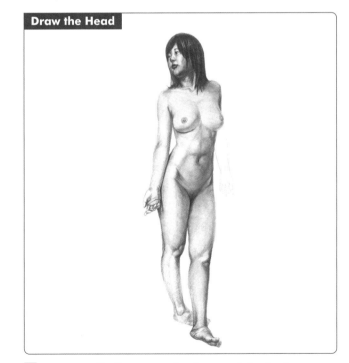

4 Express the luster and volume of the hair

Draw the head. The hair is not solid black—it has a sense of three-dimensionality due to its highlights and shadows. Use a kneaded eraser to lighten the parts that transition to the back and the shiny areas, and express luster and volume. The individual strands are depicted mainly in the foreground and at the tips of the hair, capturing the overall flow of the shading.

Dog

(Animalia/Chordata/Vertebrata/Mammalia/Carnivora/Canidae)

Dogs have been integral to human life since ancient times, and are very familiar animals along with cats (page 58). Get a sense of its features such as its thin limbs in relation to its torso.

Skeletal Diagram Many breeds of dogs have been developed, varying in size and shape. Although there are skeletal differences between the breeds in bone thickness and length, it is helpful to get an understanding of the basic skeletal structure of a medium-size dog.

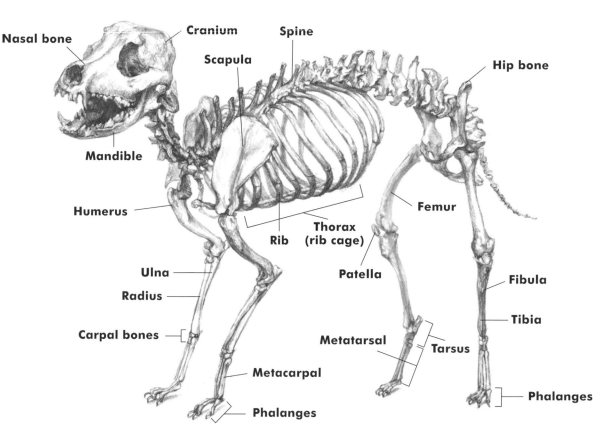

Muscle Diagram Mammals are covered with fur so it is difficult to see their underlying form, but understanding their skeletal structure how the muscles are attached and the flow of their musculature can add more realism to how you draw their poses and expressions.

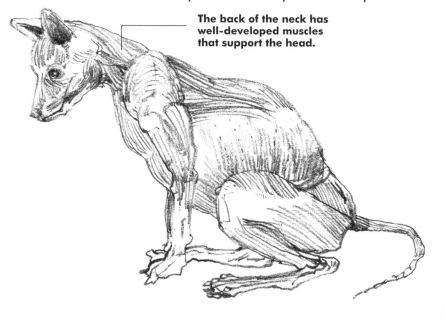

The back of the neck has well-developed muscles that support the head.

Understand the Muscles

Although the proportions of the trunk and limbs vary from breed to breed, the muscles run in much the same way. The tendons that move the fingers and toes run from the elbows and knees, making them thin and sinewy.

▶ Tendons are tough connective tissues that attach muscles to bones.

Here, we have used a shepherd-type dog as the example. Capture the whole as you draw each part.

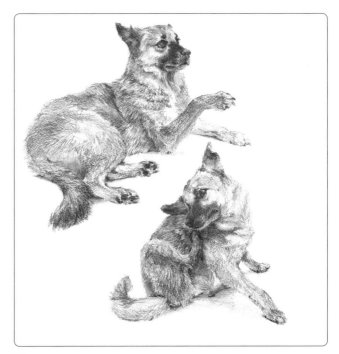

1 Capture the form while looking at the whole

It is important to have a good understanding of the skeleton before capturing the pose. After making a number of sketches, we will capture the characteristics of the movement and gestures. First, we will grasp the overall balance of the whole image and trace the outline. And next, we will layer on pencil starting with the dark, dense areas.

2 Add the flow of the fur and shading

Once you have a good grasp of the three-dimensionality by tracing the general regions of shadow, look carefully at the flow of hair and draw it in. You can also boost the impression of three-dimensionality by adding the shadows that are cast on the ground. After this, the finished drawing is colored with watercolors (see page 14)

Completed Drawing

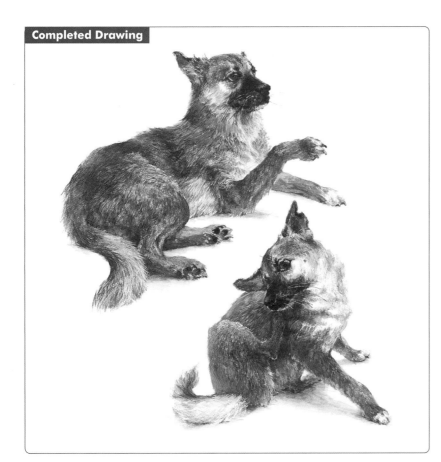

Note

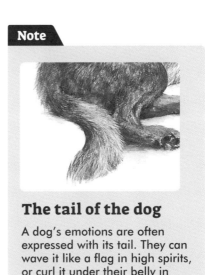

The tail of the dog

A dog's emotions are often expressed with its tail. They can wave it like a flag in high spirits, or curl it under their belly in fear... Observe the tail carefully as you draw it.

Drawing Procedure 2 Here is an example of a drawing that combines three different dog poses. The key is to skillfully capture the different facial expressions that accompany the movement.

Add the Shadows

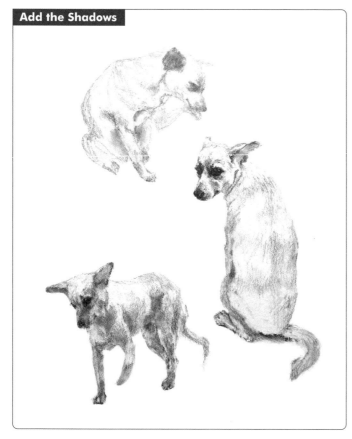

1 Be aware of the shading, and sketch the entire subject

Visualize the skeleton while you add the shading. Once you have outlined the shape, add shading to the darker areas. Add layers of shading colors with a light touch. Line up the hatching lines to follow the growth direction of the fur. On dogs with white fur, the eyes, nose and feet are key points of interest.

Add Grays

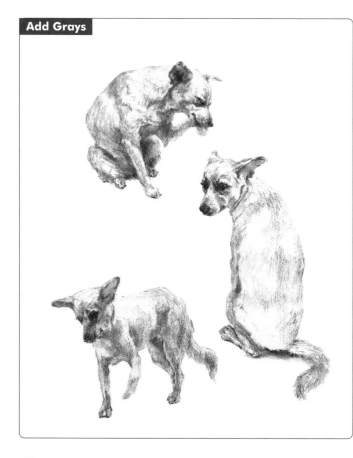

2 Express the subtle light tones

Even when the fur is white, there are many shades of gray within the whiteness. Squint your eyes and apply shading starting with relatively dark grays.

Sometimes when you add shading, it ends up looking like you're depicting dingy fur, but that's because the dark areas aren't really dark enough yet. In this case, further darken the really dark areas, such as the eyes and nose.

Because tones are relative, when the darkest areas become even darker, areas that previously appeared gray appear relatively lighter. The quickest path to improvement is to train yourself to layer on shading judiciously with the pencil rather than overusing the kneaded eraser to remove graphite.

(Tutorial: **Draw & Paint Dogs** ➔ page 14)

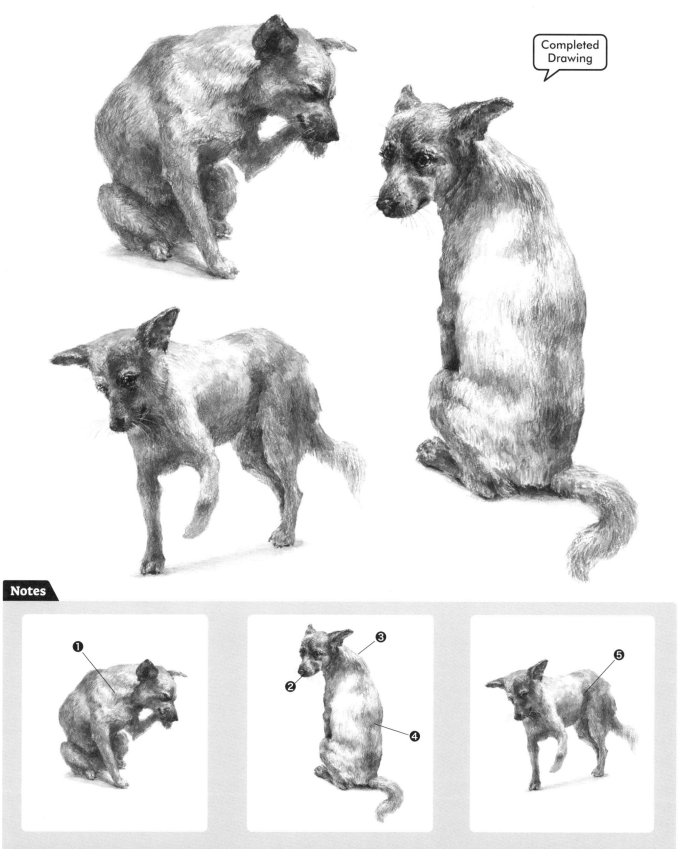

Completed Drawing

Notes

❶ Even when the fur color is white, find the various shades of gray in the whiteness and follow the flow of the fur.

❷ Darken the black areas of the eyes and nose.

❸ Express the flow of fur and the differences in its length and texture on different parts of the body by observing them carefully.

❹ The hairs on the posterior midline are slightly darker in tone. Observe the curvature of the trunk as it rounds out from the front to the far side, using the flow of fur. By drawing shadows, you can create a sense of three-dimensionality.

❺ A close observation reveals that even white dogs have shaded, dark areas. Don't get caught up in the preconception that this dog is "white."

Try depicting the dog while it sleeps, and another one captured in a natural, unposed moment.

Rough out the Drawing

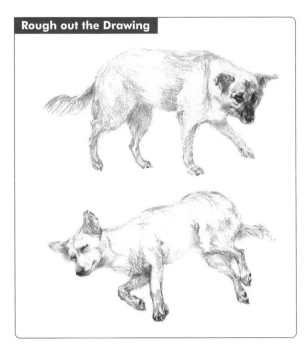

Capture the Shading

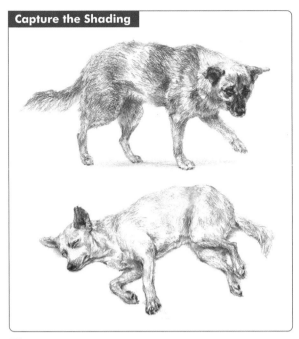

1 Capture the shape with pencil lines

Start with a few sketch lines to get an idea of the subject, and then continue to capture the shape with more and more lines. Look at the shape of the negative space as you correct any deviations in the shape. Once the shapes have been outlined, apply shading with a pencil, starting with the darker areas.

2 Layer on the shading

Squint your eyes and capture the large areas of shadow. Layer the pencil over the darker areas to increase saturation.

Completed Drawing

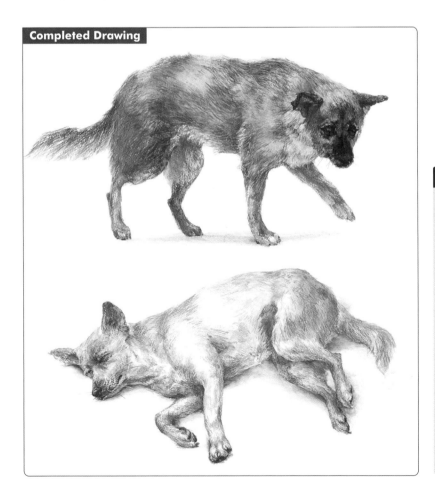

Notes

Pay attention to the positions and angles of the joints

If you have a pet such as a dog or cat to observe, check the position, direction of bending, angle and range of motion of the joints of the limbs by manipulating them while playing with the animal.

If you are aware of the texture of the fur, you can improve your expression

The length and color of the fur hairs vary from location to location on the body. Be aware of the texture of the hair and use F, HB, 2B and 3B pencils according to the softness of the hair and the intensity of the shading to depict the fur.

Variations From large to small dogs, a great many breeds have been developed by selective breeding. Here are a few breeds with some unique characteristics.

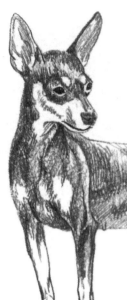

Miniature Pinscher
The miniature pinscher was bred in Germany as a small guard dog. Its velvety black fur and erect ears are its distinctive features. There is no expectation that a "black" dog must be depicted as being solid black. Observe the changes in tone carefully.

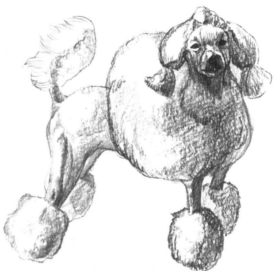

Poodle
The poodle is a long-haired breed. It is a medium-sized dog that looks like it has been dressed in trendy clothes due to artful trimming.

Beagle Puppy
Puppies have larger paws and feet and fuller bellies than adult dogs.

Pugs and Bulldogs
Pugs and bulldogs have wrinkles on their faces that give them a troubled look, which is very endearing.

Labrador Retriever Puppy
Here is a drawing of a labrador retriever puppy, a breed that can be used as a guide dog or police dog as well as being a family dog. They are characterized by their intelligence and gentle nature. Large dogs, even as puppies, have big, sturdy limbs and heavy paws.

Hyena

(Animalia/Chordata/Vertebrata/Mammalia/Carnivora/Feliformia/Hyaenidae)

Hyenas may eat carrion, and have large jaws that crush bones and a strong digestive system. Although they look similar to dogs, hyenas belong to the family Hyaenidae of the suborder Feliformia (the Carnivora suborder that includes cats) and hunt in groups.

Skeletal Diagram The hyena is characterized by its long legs and cervical vertebrae, strong jawbone and lengthy tibia. The back of the head protrudes a little. The back half is on the large side and the hip bone is on the small side. Study the skeleton and check the proportions in your drawing.

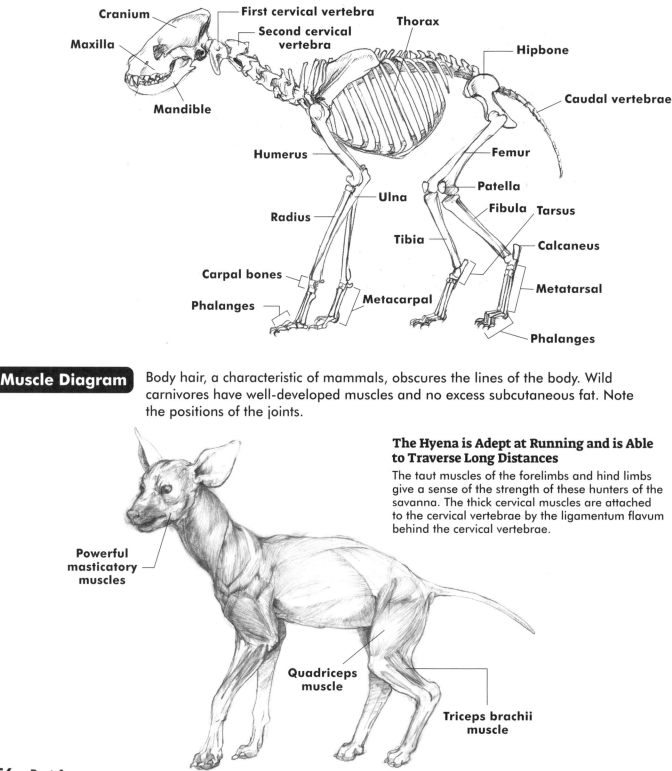

Muscle Diagram Body hair, a characteristic of mammals, obscures the lines of the body. Wild carnivores have well-developed muscles and no excess subcutaneous fat. Note the positions of the joints.

The Hyena is Adept at Running and is Able to Traverse Long Distances

The taut muscles of the forelimbs and hind limbs give a sense of the strength of these hunters of the savanna. The thick cervical muscles are attached to the cervical vertebrae by the ligamentum flavum behind the cervical vertebrae.

Completed Drawing The hair color is darker toward the tips. The mixture of long and short hairs is expressed by using a kneaded eraser to reveal areas of white.

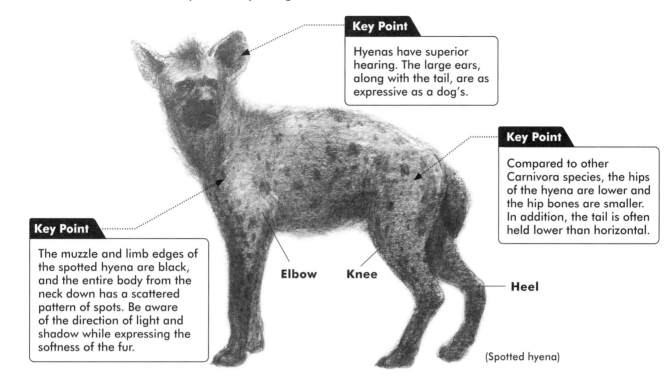

Key Point

Hyenas have superior hearing. The large ears, along with the tail, are as expressive as a dog's.

Key Point

Compared to other Carnivora species, the hips of the hyena are lower and the hip bones are smaller. In addition, the tail is often held lower than horizontal.

Key Point

The muzzle and limb edges of the spotted hyena are black, and the entire body from the neck down has a scattered pattern of spots. Be aware of the direction of light and shadow while expressing the softness of the fur.

Elbow **Knee**

Heel

(Spotted hyena)

Variations Pay attention to the hyena's large ears and the proportions of its fore and hind limbs as you draw it in a variety of poses.

Key Point

Hyenas successfully capture prey by hunting in packs. The brown hyena and the striped hyena scavenge for carrion and often steal prey from cheetahs and other predators.

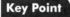

Carefully observe the differences in the length of hairs in the different parts of the fur as you draw.

As a way of expressing a sense of perspective, the foreground is depicted strongly and the background is depicted rather lightly. It is also important to draw the foreground in greater detail than the background.

Hyenas have paws that are _digitate_ (fanned out like fingers) and have claws, but the claws are usually not visible.

Pencil strokes are aligned with the growth direction of the fur.

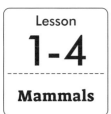

Lesson 1-4 Mammals

Cat

(Animalia/Chordata/Vertebrata/Mammalia/Carnivora/Feliformia/Felidae)

Domestic cats are expressive through their body language. Cats are also frequently anthropomorphized as human females because of their supple forms and slinky movements.

Skeletal Diagram Cats have clavicles, albeit degeneratively, and also exhibit a forelimb crossing motion. If you have a cat, examine it carefully and contrast the skeletal features you can feel with the diagram to verify them.

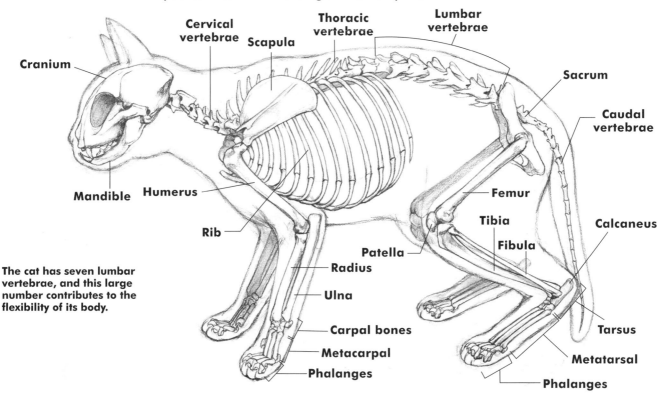

Cervical vertebrae · Scapula · Thoracic vertebrae · Lumbar vertebrae · Sacrum · Cranium · Caudal vertebrae · Mandible · Humerus · Femur · Rib · Tibia · Fibula · Calcaneus · Patella · Radius · Ulna · Tarsus · Carpal bones · Metatarsal · Metacarpal · Phalanges · Phalanges

The cat has seven lumbar vertebrae, and this large number contributes to the flexibility of its body.

Muscle Diagram If we look beyond the fur and skin of the cat, we can see that its muscles are well developed. The hind limb muscles are better developed than the forelimbs, which make high jumps possible.

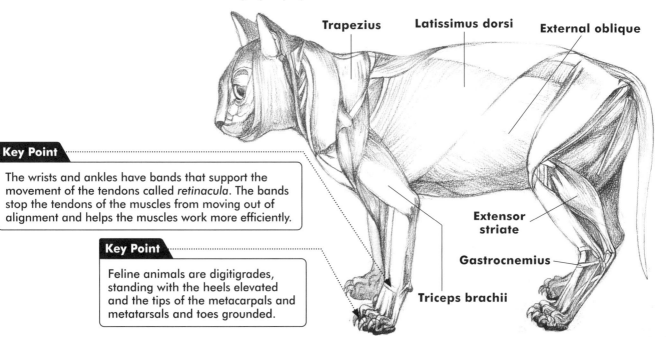

Trapezius · Latissimus dorsi · External oblique · Extensor striate · Gastrocnemius · Triceps brachii

Key Point

The wrists and ankles have bands that support the movement of the tendons called *retinacula*. The bands stop the tendons of the muscles from moving out of alignment and helps the muscles work more efficiently.

Key Point

Feline animals are digitigrades, standing with the heels elevated and the tips of the metacarpals and metatarsals and toes grounded.

As with dogs, household cats make good models. Draw cats in various poses and with various expressions, while being aware of the suppleness of its body.

Soft strokes of the pencil are used to skillfully depict the texture of the fur.

(A kitten that looks like a Munchkin cat)

Key Point

If you want to replicate the look of fine and delicate cat fur, you can use an eraser to remove some of the tone of the hairs instead of just using a pencil. After using a plastic eraser or kneaded eraser, carefully redefine the edges of the erased areas with a pencil.

A cat's mood is often expressed not only in its face, but also in its body shape and movements. Reading the mood of the cat you are observing and quickly drawing a large number of sketches will give the drawing a more realistic feel. The tail also exposes the feelings of the cat.

Here is a cat grooming itself with its front paw. The paw gesture of wiping the face is also unique to the cat family.

Key Point

The cat has a relatively flat face with the mouth and muzzle protruding gently forward and both eyes facing forward.

Key Point

Cats have a variety of eye colors including yellow, green, blue and brown. White cats sometimes have dichromatic eyes, in which the colors of the irises of the left and right eyes are different.

Notes

"The eyes" are especially important for expressions

The cat's eyes, ears, nose, mouth, long whiskers and tail are all important for creating its expression. Special attention should be paid to the shape of the light reflected in the eyeballs and the play of the whiskers and so on in the finishing stages of the drawing.

The pupils of the cat regulate the amount of light that enters the eyes. In bright light the pupils are long and narrow, while in darker conditions they are round and dilated.

Key Point

A gray cat is represented with light and dark tones. Be careful of the flow of fur as you apply the pencil color. If the dark areas are sufficiently darkened and the tones are clarified, the image will not look muddy.

(Russian Blue)

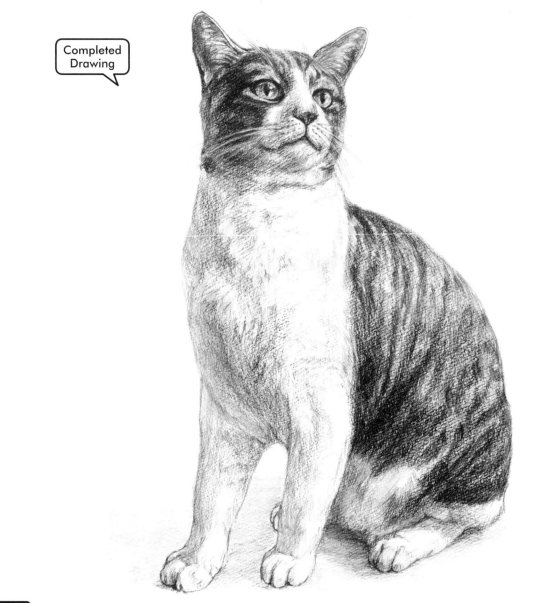

Completed Drawing

Note

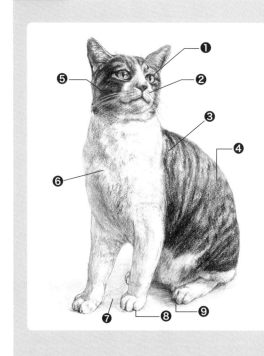

❶ Observe and draw in the eyes, which have a different texture than the body. It's a good idea to make the highlight small, and the darkest areas near the eyes should be darkened well.

❷ Although the muzzle is not as long as that of the dog (page 50), it is still important to capture the depth that is typical of cats. It is especially important to pay attention to the nose and mouth as you draw them.

❸ The same pattern or color can have bright areas on which the light shines and dark areas in shadow. Squint your eyes to see the differences in tonal levels as you draw.

❹ The parts of the rounded back in the background should not be overemphasized, but slightly softened instead.

❺ Before finishing the face, use a kneaded eraser to white out the whiskers. Be sure to adjust the areas around the erased parts with a pencil.

❻ Squint at the cat and try to detail the whitest part of the chest with a kneaded eraser following the growth direction of the fur. Adjust with a pencil.

❼ Depicting the shadows underfoot will give the cat more presence.

❽ Make certain that the limbs are on the same plane.

❾ Observe and draw the areas on the ground carefully. Look closely at the parts in the foreground and draw them in detail.

There are various types of tails such as ones that are rounded and docked, ones that are long, or ones that are bent in the middle. Express the individuality of each one.

In long-haired breeds, the back side and the stomach side have different types of fur. The stomach side has softer hairs, and some back hairs appear to be clumped in tufts.

Carefully follow the growth of the soft fur to depict it.

Erase the hairs that appear lightly colored as if you were drawing with a kneaded eraser. After erasing, be sure to use a pencil to tidy up the edges.

The hair on the chest is long, and is called the ruff.

(Maine Coon)

Key Point

If you carefully replicate the shapes of the stripes on the curved surface of the body, such as on a brown tabby cat, you will naturally create a three-dimensional form.

The ears of a cat lie back when it is angry, agitated, or alarmed.

Key Point

In profile, the muzzle protrudes just a little and the face is compact. There is some distance between the front and the back of the head. Understanding the shape of the cranium makes it easier to draw cats.

Cats have flexible and complex forms. It is best to actually handle a cat so you can understand the positions and movements of the joints as you draw them.

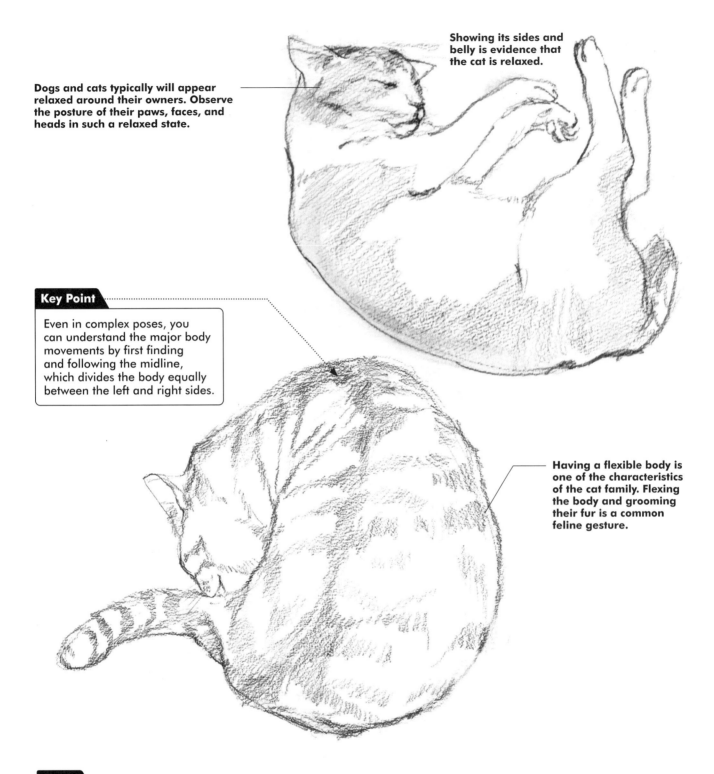

Dogs and cats typically will appear relaxed around their owners. Observe the posture of their paws, faces, and heads in such a relaxed state.

Showing its sides and belly is evidence that the cat is relaxed.

Key Point

Even in complex poses, you can understand the major body movements by first finding and following the midline, which divides the body equally between the left and right sides.

Having a flexible body is one of the characteristics of the cat family. Flexing the body and grooming their fur is a common feline gesture.

Note

The cat's running state and the moment it jumps

When felines run, they flex their spinal columns ventrally and dorsally to move forward. At the moment the trunk is extended, the fore and hind limbs open wide. At the moment the trunk contracts, the spine rounds and the forelimbs and hind limbs cross. In addition to the movement of the limbs, note the shape of the back, which is also the curve of the spinal column.

The trunk contracts, and the forelimbs and hind limbs cross.

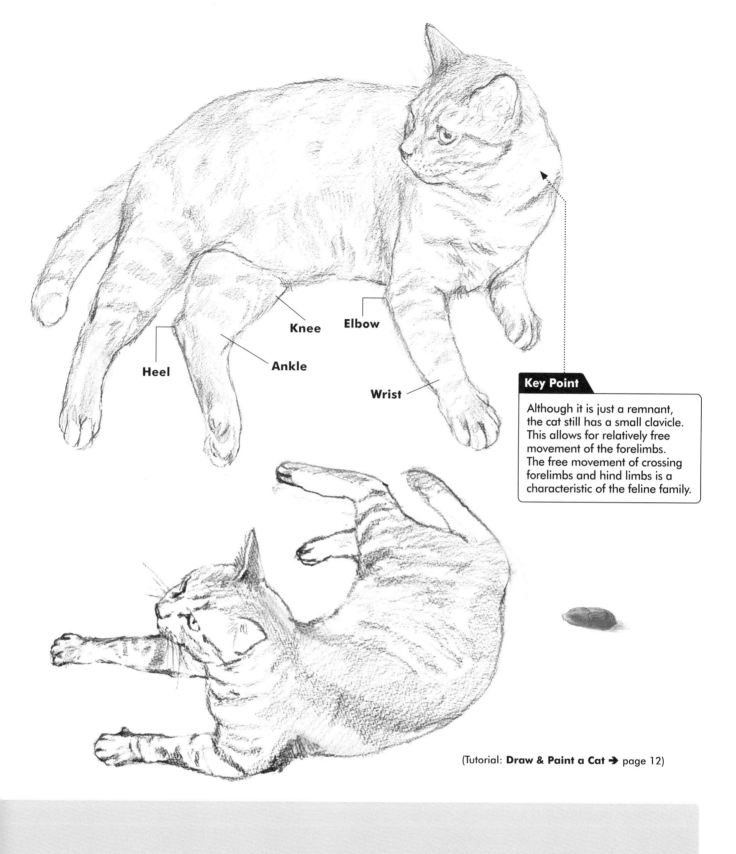

Knee

Elbow

Heel

Ankle

Wrist

Key Point

Although it is just a remnant, the cat still has a small clavicle. This allows for relatively free movement of the forelimbs. The free movement of crossing forelimbs and hind limbs is a characteristic of the feline family.

(Tutorial: **Draw & Paint a Cat** ➜ page 12)

The moment the trunk is extended, the forelimbs and hind limbs open wide.

Drawing Procedure Draw a reclining cat. The key points are to study the whole outline and the shapes of its constituent parts, and observe how the shading is applied.

Draw the Outline

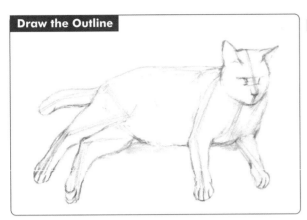

1 Sketch the outline with an eye to the cat's skeletal features and anatomy

Observe carefully, decide on the composition on the paper, and rough it out. Follow the outline of the silhouette and the body as a whole. It is important to be aware of the skeletal prominences (especially the joints) and features seen on the body—not just the external outline. Use the entire paper and compose the drawing so that the entire image fits in well within the frame of the paper. The midline should also be drawn in lightly to provide a hint to the three-dimensionality of the image.

Fill in the Shape

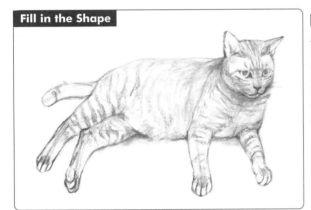

2 Observe the skeleton, muscles and joints closely

Analyze the toned surfaces and shadows on the surface of the body by carefully observing the overall color and play of shadows over the surface. Squinting allows you to get a sense of overall contrast without being distracted by details. Observe the positions and angles of the joints of the forelimbs and hind limbs, handle the subject if possible, and check the relationships between skeleton and musculature. Always draw with sharpened pencils.

Analyze the Shape

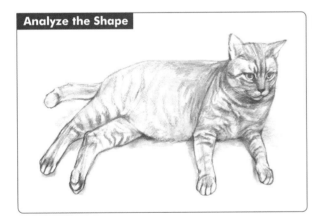

3 If the shape is distorted, correct it immediately

Analyze the shapes in increasing detail, checking the relationship between the whole and its parts, and between adjacent parts. At this time, if you feel that the shape of the cat is off, you can check the lines by looking at the shapes of the negative space surrounding the animal, rather than being overly concerned with the cat itself. If the shape is not correct, adjust it as needed.

Start to Add the Shadows

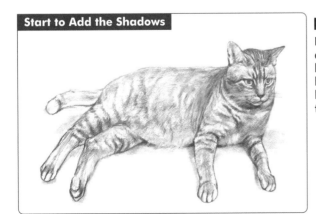

4 Draw in hatching along the lines and surfaces of the form

Begin adding shading according to the lines and surfaces you have analyzed. The lines should not be drawn in dark colors right away, but instead by squinting and starting from the darkest areas, drawing hatching lines of appropriate lengths to express a shaded surface. The hatching lines are layered on the darker areas of the body to depict its three-dimensionality.

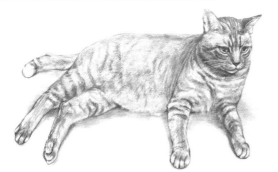

5 Add tones by paying attention to the midrange shades

Study the transition of the midrange tones from one surface to the next, and apply shading. In addition, fill in the stripes with a B or 2B pencil while being sensitive to the growth direction of the fur.

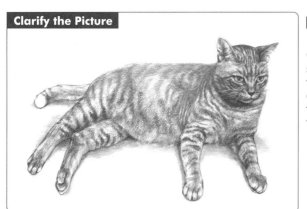

6 Increase the contrast in the foreground to sharpen the image

Occasionally squint at the subject to identify the major areas of shadow and to verify if the shadows in the sketch match up. Apply the darkest tones and then add more shading to increase the three-dimensionality. Add strong contrasts to the fine flow of hair in the foreground to make it sharp. Pay special attention to the head and the forelimbs in the foreground to finish.

Completed Drawing

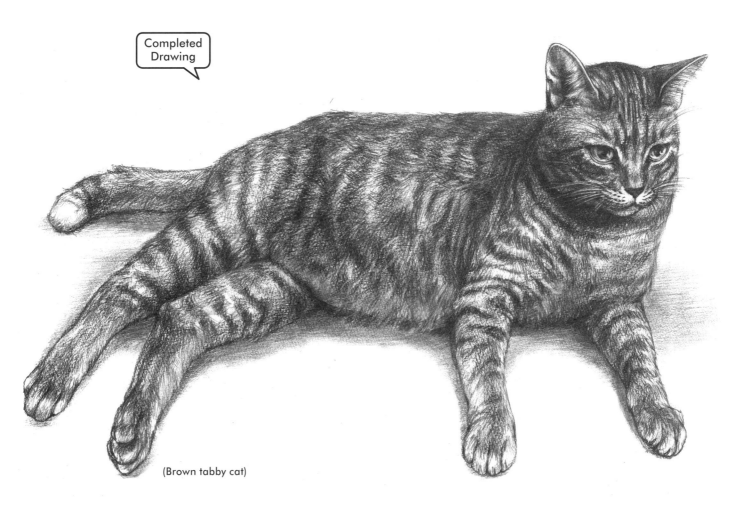

(Brown tabby cat)

Gorilla

(Animalia/Chordata/Vertebrata/Mammalia/Primates/Hominidae)

The gorilla is a large primate that lives on the ground and walks on all fours. Most species of gorillas are threatened with extinction.

Skeletal Diagram

Large primates that are similar to humans are called apes. Gorillas have long forelimbs and walk on all fours with the balled fists of their forelimbs (knuckle walking). The shape of their craniums differ by gender.

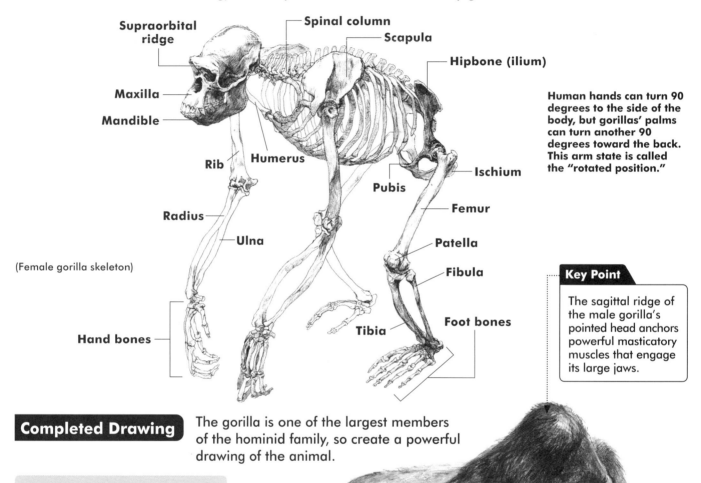

Supraorbital ridge

Spinal column

Scapula

Hipbone (ilium)

Maxilla

Mandible

Rib

Humerus

Ischium

Pubis

Femur

Radius

Ulna

Patella

Fibula

(Female gorilla skeleton)

Hand bones

Tibia

Foot bones

Human hands can turn 90 degrees to the side of the body, but gorillas' palms can turn another 90 degrees toward the back. This arm state is called the "rotated position."

Key Point

The sagittal ridge of the male gorilla's pointed head anchors powerful masticatory muscles that engage its large jaws.

Completed Drawing

The gorilla is one of the largest members of the hominid family, so create a powerful drawing of the animal.

How to Draw

① Start by using an HB pencil to outline the overall form, and then break down all the shapes with wavering lines.

② Apply tones starting with the darkest areas. If your pencil lines carefully follow the surface, the sketchy lines that you drew to break down the shapes and to represent the shaded regions will not disappear.

③ The finishing details in the arm, face and fingers are drawn with 3B and 4B pencils.

④ Lastly, use a kneaded eraser along the back following the growth direction of the fur of the silverback to slightly soften the strokes along the back parts.

The front half of the body is imposing, but the back half is small, especially the buttocks, which are not as full as those of humans.

The gorilla's back foot contacts the ground from heel to toe. Its feet are shaped to suit life on the ground, but it does not have arches like those of humans.

Gorillas are generally mild-mannered and live peacefully in small, relaxed groups. Depict the richness of their expressions.

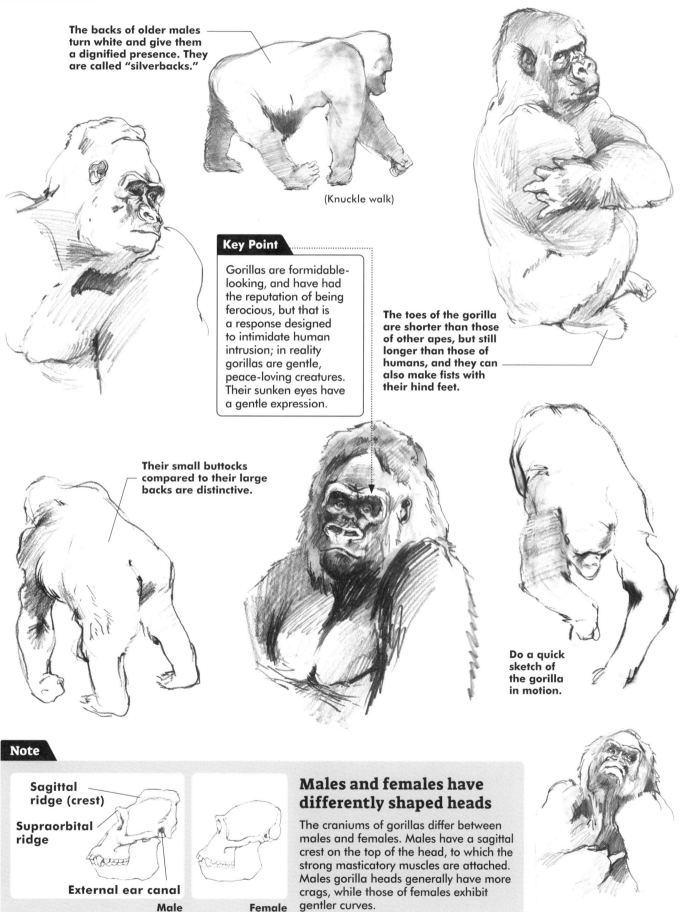

The backs of older males turn white and give them a dignified presence. They are called "silverbacks."

(Knuckle walk)

Key Point

Gorillas are formidable-looking, and have had the reputation of being ferocious, but that is a response designed to intimidate human intrusion; in reality gorillas are gentle, peace-loving creatures. Their sunken eyes have a gentle expression.

The toes of the gorilla are shorter than those of other apes, but still longer than those of humans, and they can also make fists with their hind feet.

Their small buttocks compared to their large backs are distinctive.

Do a quick sketch of the gorilla in motion.

Note

Sagittal ridge (crest)

Supraorbital ridge

External ear canal

Male **Female**

Males and females have differently shaped heads

The craniums of gorillas differ between males and females. Males have a sagittal crest on the top of the head, to which the strong masticatory muscles are attached. Males gorilla heads generally have more crags, while those of females exhibit gentler curves.

Orangutan

(Animalia/Chordata/Vertebrata/Mammalia/Primates/Hominidae/Pongo)

The arms of the orangutan are longer than its legs, and it is covered with long body hair. It lives in the dense jungles of Sumatra and Borneo. "Orangutan" is the Malay word for "forest people," and it has a gentle disposition.

Skeletal Diagram Adapted to arboreal life, the orangutan moves by brachiation (arm-walking). Similar to the gorilla (page 66), the forelimbs of the orangutan are longer than the hind limbs, and its cranium and clavicles are large.

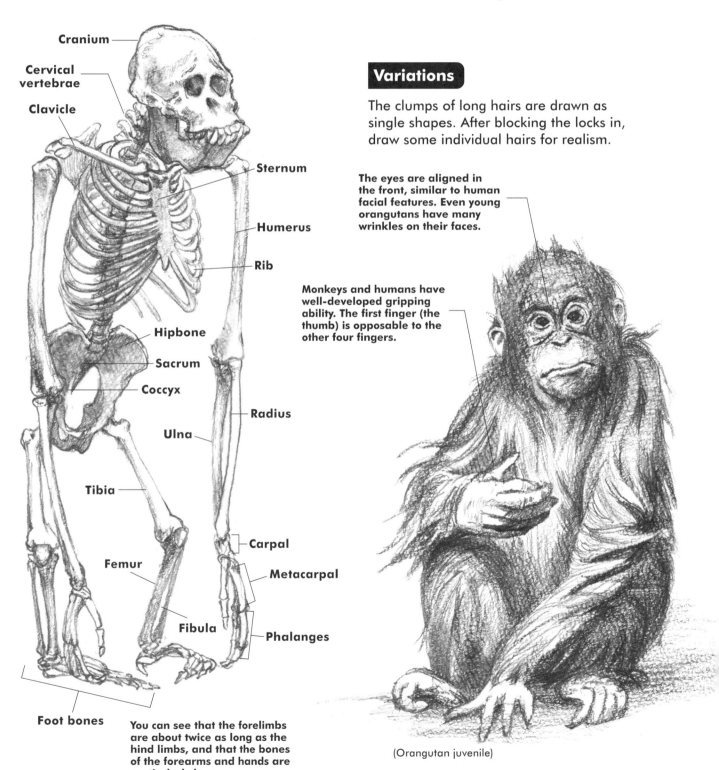

Cranium

Cervical vertebrae

Clavicle

Sternum

Humerus

Rib

Hipbone

Sacrum

Coccyx

Radius

Ulna

Tibia

Carpal

Femur

Metacarpal

Fibula

Phalanges

Foot bones

You can see that the forelimbs are about twice as long as the hind limbs, and that the bones of the forearms and hands are particularly long.

Variations

The clumps of long hairs are drawn as single shapes. After blocking the locks in, draw some individual hairs for realism.

The eyes are aligned in the front, similar to human facial features. Even young orangutans have many wrinkles on their faces.

Monkeys and humans have well-developed gripping ability. The first finger (the thumb) is opposable to the other four fingers.

(Orangutan juvenile)

Orangutan juveniles. The facial expressions are similar to those of humans.

Juvenile orangutans have especially long fore limbs, which are almost as long as the orangutans are tall. Note the proportions of the hands, as they are large as well.

The body hair is reddish brown and long, and the hands and muzzle are hairless. Use different pencils to express these different textures.

Key Point

For the long hairy head, trunk, front and back limbs, and hairless face and palms, change the alignment of the hatching lines a little (page 22) to express the differences in textures.

It has large jaws and a protruding muzzle.

This is drawn with a 3B pencil on rough-textured drawing paper.

As male orangutans age, the skin on their forehead and cheeks becomes long and hangs in droopy folds. As their social status increases, their eyes are covered as if by a hood.

The feet can also hold onto branches—they can grasp like hands.

Chimpanzee

(Animalia/Chordata/Vertebrata/Mammalia/Primates/Homoidea/Homininae/Pan)

The chimpanzee is our closest relation among the living animals of the world. More than 98% of its gene sequence is shared with humans (page 42). They use tools and even make tools.

(page 42)

Skeletal Diagram

Although closely related to humans, chimpanzees are quadrupeds, with long upper limb bones and bent knees. The shape of the pelvis is also widened at the lower opening. Although they may stand on two feet, they typically knuckle-walk with their hands held in fists.

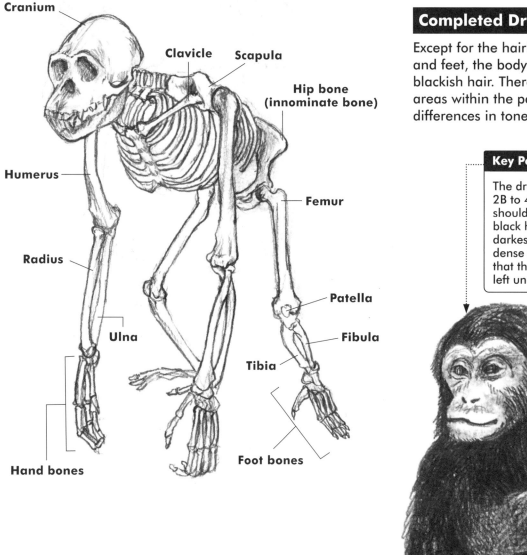

Cranium

Clavicle Scapula

Hip bone
(innominate bone)

Humerus

Femur

Radius

Patella

Ulna

Fibula

Tibia

Foot bones

Hand bones

Completed Drawing

Except for the hairless face, ears, hands and feet, the body is covered with blackish hair. There are lighter and darker areas within the pelt. Be aware of the differences in tones as you draw.

Key Point

The drawing was done with 2B to 4B pencils. Ideally, you should express the tone of the black hairs by filling in the darkest parts of the hairs with a dense collection of strokes, so that there are no areas that are left uncovered.

(Chimpanzee juvenile)

Chimpanzees Are Highly Intelligent and Make Tools

Chimpanzees are intelligent and charming, but they are also aggressive primates. They have rich range of facial expressions and smile by showing their teeth like humans. When there are no suitable twigs to insert into the nests to catch termites—which are their favorite food—they make their own tools by plucking leaves from trees and using the stems to fish out insects. Such skills are passed on generationally within the group.

Chimpanzees split their time between life on the ground and life in the trees. Like gorillas, they use the fists of their forelimbs to move (knuckle walk). Observe their expressions and behaviors carefully and draw scenes that are typical of chimpanzees.

Key Point

There is tonal variation within the generally dark fur color. If you make the darkest parts very saturated, it will lighten the overall tone that previously may have seemed too dark. Lightness is relative. Apply shading with pencil following the growth direction of the fur.

The chimpanzee exhibits a rich range of expressions, including joy, anger, sorrow and pleasure. Capture the facial expressions, but be careful not to make them too human-like.

This chimpanzee is expressed with contour lines only. When the outlines stand out, the image inevitably becomes flat. Make the lines thick or thin, and use heavy and light lines to represent the foreground and the background. Animators primarily use line drawings. It is also important for all artists to draw a large number of line-drawing studies.

Squirrel and Chipmunk

(Animalia/Chordata/Vertebrata/Mammalia/Rodentia)

Because of their adorable appearance while sitting on their haunches to eat food, the squirrel and chipmunk are some of the most anthropomorphized types of animals. Sketch their nimbly moving figures.

Skeletal Diagram The cranium of the squirrel is large compared to its slender limbs and body. The long tail, unlike that of a rat, points upward like a flag.

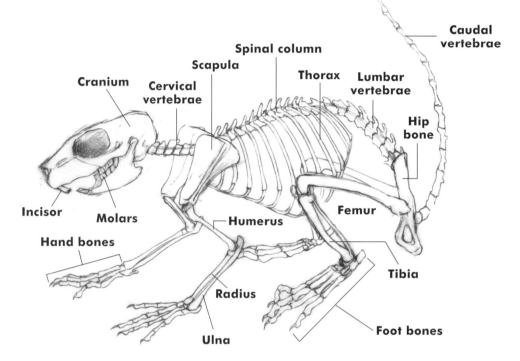

Caudal vertebrae

Spinal column

Scapula

Thorax

Lumbar vertebrae

Cranium

Cervical vertebrae

Hip bone

Incisor

Molars

Femur

Hand bones

Humerus

Radius

Tibia

Ulna

Foot bones

Variations Squirrels can stand up on their hind legs or hunch over—one never gets tired of their diverse gestures. Capture their cute poses. The orientations of the face and tail are important.

Explore their Gestures with Quick Sketches

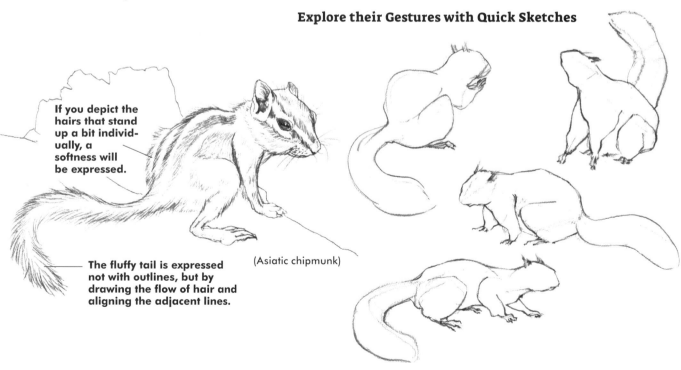

If you depict the hairs that stand up a bit individually, a softness will be expressed.

The fluffy tail is expressed not with outlines, but by drawing the flow of hair and aligning the adjacent lines.

(Asiatic chipmunk)

Completed Drawing Squirrels and chipmunks have relatively more robust forelimbs and longer limbs than rats. Express the irreverent nature of squirrels with their big bushy tails that stand up like a flag.

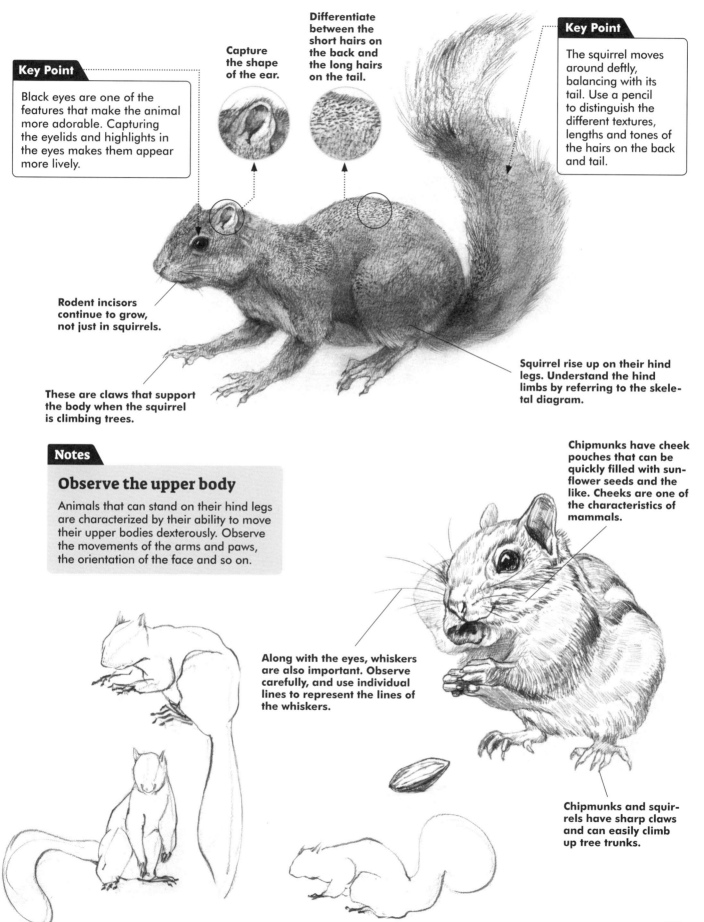

Key Point

Black eyes are one of the features that make the animal more adorable. Capturing the eyelids and highlights in the eyes makes them appear more lively.

Capture the shape of the ear.

Differentiate between the short hairs on the back and the long hairs on the tail.

Key Point

The squirrel moves around deftly, balancing with its tail. Use a pencil to distinguish the different textures, lengths and tones of the hairs on the back and tail.

Rodent incisors continue to grow, not just in squirrels.

These are claws that support the body when the squirrel is climbing trees.

Squirrel rise up on their hind legs. Understand the hind limbs by referring to the skeletal diagram.

Notes

Observe the upper body

Animals that can stand on their hind legs are characterized by their ability to move their upper bodies dexterously. Observe the movements of the arms and paws, the orientation of the face and so on.

Chipmunks have cheek pouches that can be quickly filled with sunflower seeds and the like. Cheeks are one of the characteristics of mammals.

Along with the eyes, whiskers are also important. Observe carefully, and use individual lines to represent the lines of the whiskers.

Chipmunks and squirrels have sharp claws and can easily climb up tree trunks.

Lesson

1-9

Mammals

Giraffe

(Animalia/Chordata/Vertebrata/Mammalia/Giraffidae)

Male giraffes grow to about 15 feet (5 meters) in height. They eat the leaves of trees by plucking them with their long tongues. Those with longer necks have adaptively survived and exist as taller species.

Skeletal Diagram

Giraffes have long necks, but just 7 cervical vertebrae. They have flexible movement. A thick, strong ligament extends behind the cervical spine to support the head and neck.

Muscle Diagram

The giraffe's characteristic neck is full of fine muscles. To understand the way it moves, observe the arrangement of muscles in the chest and legs too.

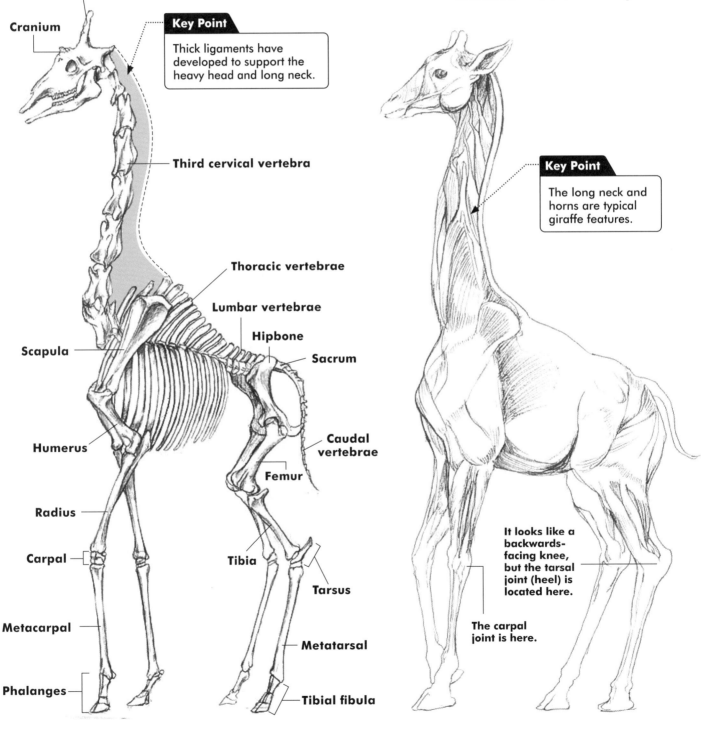

The giraffe's ossicones are composed of bone.

Cranium

Key Point

Thick ligaments have developed to support the heavy head and long neck.

Third cervical vertebra

Thoracic vertebrae

Lumbar vertebrae

Hipbone

Sacrum

Scapula

Caudal vertebrae

Humerus

Femur

Radius

Tibia

Carpal

Tarsus

Metacarpal

Metatarsal

Phalanges

Tibial fibula

Key Point

The long neck and horns are typical giraffe features.

It looks like a backwards-facing knee, but the tarsal joint (heel) is located here.

The carpal joint is here.

Drawing Procedure

Observe the angle of the neck and face carefully, and be aware of the skeletal and muscular features as you draw. The depiction of patterns is also used to express a three-dimensional effect. (Tutorial: **Paint a Giraffe's Head → Page 10**)

Follow the Outlines

1 Observe carefully and follow the outline of the body.

Use faint lines to rough out not only the outer contours, but also the internal shadows. If you squint your eyes and look at the subject, you can grasp the overall three-dimensionality without being distracted by the small details.

Draw in the Shadows

2 Capture the large shadows of the body before you tackle the pattern

Before drawing the pattern, the shading of the body is drawn in. If you squint your eyes and look at the subject, you can capture the large shadows. As you work to depict the overall three-dimensionality of the form, visualize the skeleton inside.

The pattern of the reticulated giraffe (the Somali giraffe) is typical. It looks like irregularly stacked stones in a wall or cracks in dry mud. Because it is not a repeating pattern, observe the shapes carefully before drawing.

Differentiate the pattern in the foreground from the pattern in the background (by using more contrast).

Completed Drawing

Wrist

This is the position of the heel. In other words, everything from this point down is its "foot."

Note

Finger joint

The hoof of the giraffe

This looks like a tarsus, but this is actually the metacarpophalangeal joint (the beginning of the finger). Giraffes, like cattle and deer, have bifurcated hooves, and stand on the tips of their third and fourth toes. A thick hoof surrounds the distal phalanges.

(Reticulated giraffe)

Rhinoceros

(Animalia/Chordata/Vertebrata/Mammalia/Perissodactyla/Rhinocerotidae)

The rhinoceros is a large, nocturnal animal. It has horns at the tip of its nose and a tough hide. They are in danger of extinction due to overhunting by humans.

Skeletal Diagram The rhinoceros has a large dorsal spine with one or two distinctive snout horns.

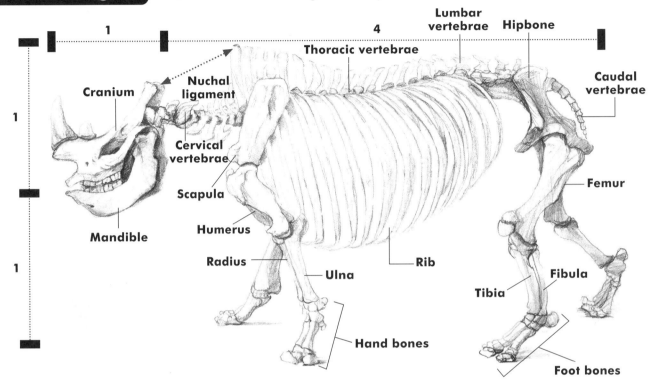

Completed Drawing The rhinoceros is characterized by a large front half of the body compared to its back half. The well-developed nuchal ligament, which supports the heavy head, connects the back of the head to the spinous processes of the cervical spine and the prominent thoracic spine in plate-like fashion. Take note of the raised dorsal surface of the neck and other characteristic points as you capture the shape.

Key Point

If you emphasize the contour lines, the body that should extend to the other side will appear to be cut off there. Draw while visualizing how it is connected to the invisible volume on the other side.

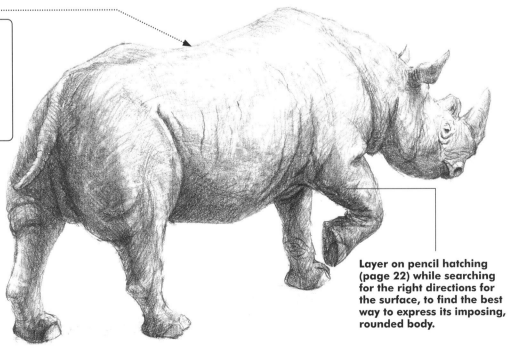

Layer on pencil hatching (page 22) while searching for the right directions for the surface, to find the best way to express its imposing, rounded body.

Some people draw from photographs, but it would be ideal to view live animals at the zoo so that you can do sketches from different angles. You cannot see the other side of an animal from a photograph, but when you are in the presence of the real thing, you can better visualize it in three dimensions.

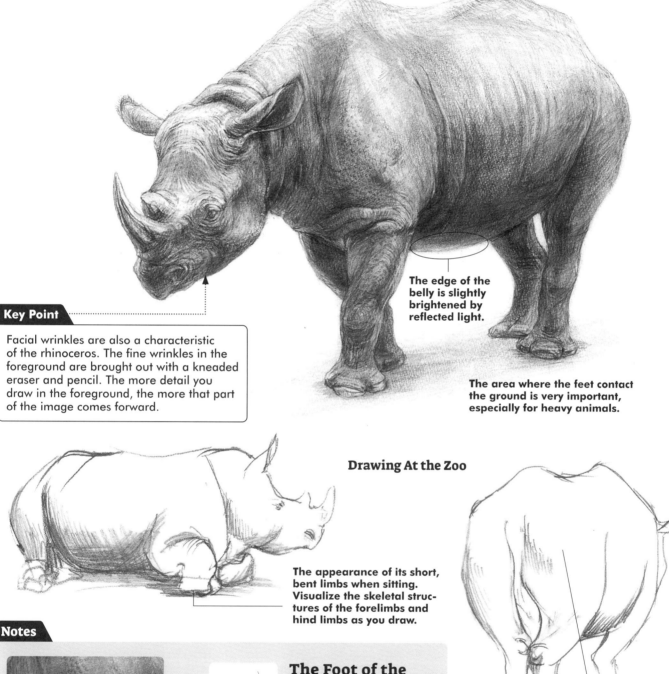

The edge of the belly is slightly brightened by reflected light.

The area where the feet contact the ground is very important, especially for heavy animals.

Key Point

Facial wrinkles are also a characteristic of the rhinoceros. The fine wrinkles in the foreground are brought out with a kneaded eraser and pencil. The more detail you draw in the foreground, the more that part of the image comes forward.

Drawing At the Zoo

The appearance of its short, bent limbs when sitting. Visualize the skeletal structures of the forelimbs and hind limbs as you draw.

Draw the body with the large pelvis and bones of the lower limbs in mind.

Notes

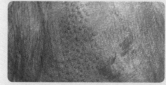

Rough textured skin

The rhino has unique three-dimensional patterns on its thick hide. Instead of depicting all of the texture, suggest it by showing it in the part of the image that is in the foreground.

The Foot of the rhinoceros

The rhinoceros is an odd-toed ungulate with three-toed hooves. The ancestors of the odd-toed ungulates originally had five fingers, but the horse went from three fingers to only one, and the rhinoceros has remained with three fingers to the present day.

Lion and Tiger

(Animalia/Chordata/Vertebrata/Mammalia/Carnivora/Felidae/Panthera)

Lions are found in Africa, but were once found in Eurasia and the Americas. Tigers were once widespread in Asia, but now their range is limited and they are endangered.

Skeletal Diagram

Lions are the second largest member of the cat family after tigers. They are a rare species of cat that live in packs.

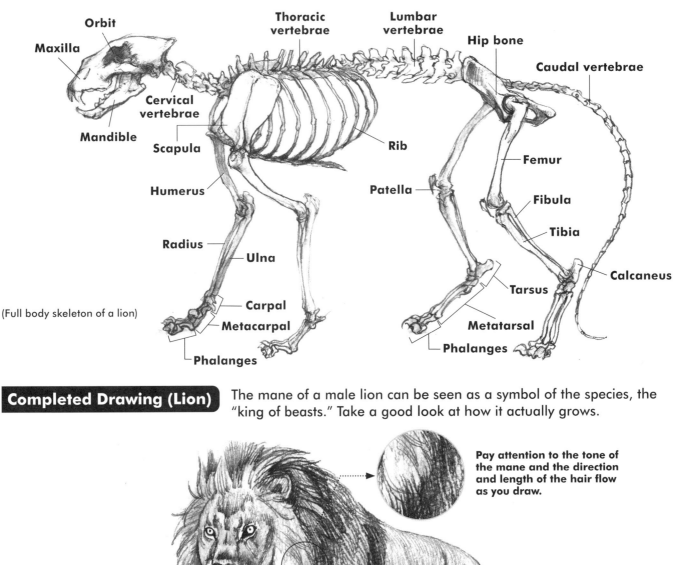

Orbit

Maxilla

Mandible

Cervical vertebrae

Scapula

Humerus

Thoracic vertebrae

Lumbar vertebrae

Hip bone

Caudal vertebrae

Rib

Femur

Patella

Fibula

Tibia

Radius

Ulna

Carpal

Metacarpal

Phalanges

Tarsus

Metatarsal

Phalanges

Calcaneus

(Full body skeleton of a lion)

Completed Drawing (Lion)

The mane of a male lion can be seen as a symbol of the species, the "king of beasts." Take a good look at how it actually grows.

Pay attention to the tone of the mane and the direction and length of the hair flow as you draw.

Digitigrade animals that stand erect on their toes with their heels in the air have high running speeds.

This male lion has a mane that extends from its chest to its belly.

Variations Lions have the reputation of being majestic and resolute, but at the zoo they are often seen sleeping soundly and taking it easy—just like house cats.

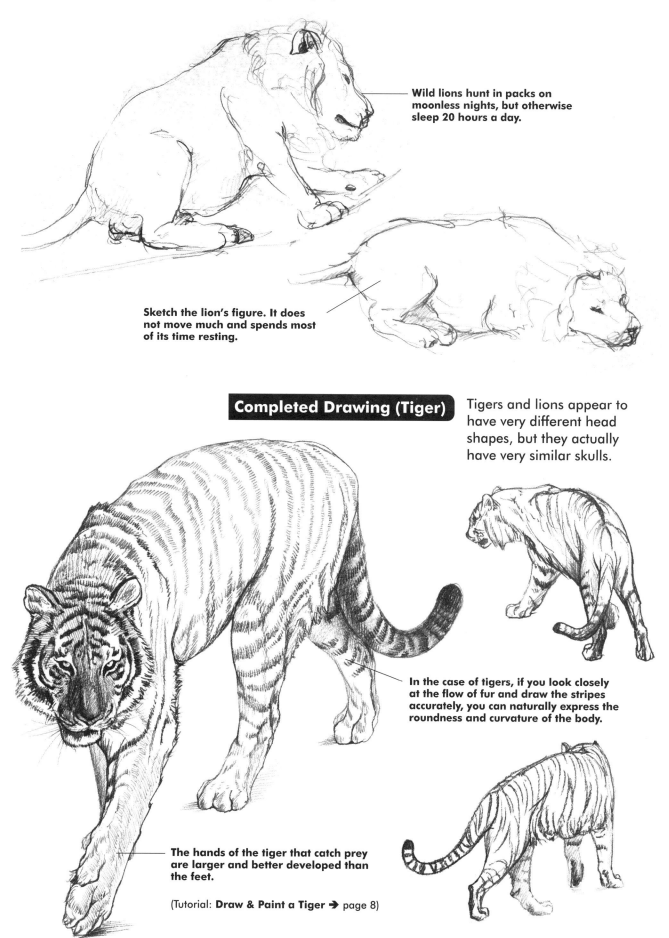

Wild lions hunt in packs on moonless nights, but otherwise sleep 20 hours a day.

Sketch the lion's figure. It does not move much and spends most of its time resting.

Completed Drawing (Tiger)

Tigers and lions appear to have very different head shapes, but they actually have very similar skulls.

In the case of tigers, if you look closely at the flow of fur and draw the stripes accurately, you can naturally express the roundness and curvature of the body.

The hands of the tiger that catch prey are larger and better developed than the feet.

(Tutorial: **Draw & Paint a Tiger** ➜ page 8)

Cow

(Animalia/Chordata/Vertebrata/Mammalia/Bovidae)

The cow is a large animal that is integral to many people's diets. It has bifurcated hooves, and is a ruminant with four stomachs that it uses to digest grass (cellulose). Here, we will look at how to draw domesticated cattle.

Skeletal Diagram

When viewed from the side, the back of the cow, which is entirely square, shows the shape of the spinous processes of the spinal column as they are. If you are aware of the skeleton, it will help you understand the meanings and relationships of the bumps and irregularities on the body and help you draw them.

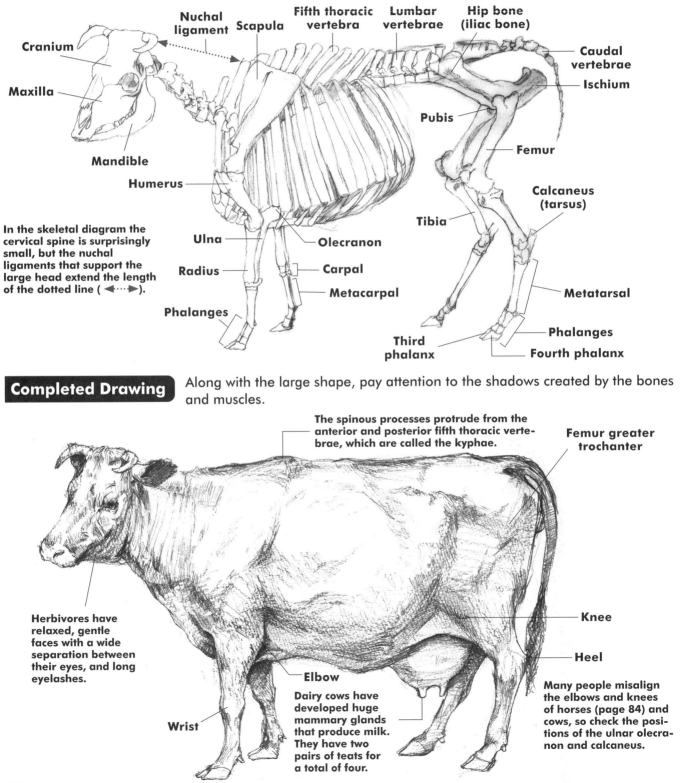

Nuchal ligament

Fifth thoracic vertebra

Scapula

Lumbar vertebrae

Hip bone (iliac bone)

Cranium

Caudal vertebrae

Maxilla

Ischium

Pubis

Mandible

Femur

Humerus

Calcaneus (tarsus)

Tibia

In the skeletal diagram the cervical spine is surprisingly small, but the nuchal ligaments that support the large head extend the length of the dotted line (◄···►).

Ulna

Olecranon

Radius

Carpal

Metacarpal

Metatarsal

Phalanges

Third phalanx

Phalanges

Fourth phalanx

Completed Drawing

Along with the large shape, pay attention to the shadows created by the bones and muscles.

The spinous processes protrude from the anterior and posterior fifth thoracic vertebrae, which are called the kyphae.

Femur greater trochanter

Knee

Heel

Herbivores have relaxed, gentle faces with a wide separation between their eyes, and long eyelashes.

Elbow

Wrist

Dairy cows have developed huge mammary glands that produce milk. They have two pairs of teats for a total of four.

Many people misalign the elbows and knees of horses (page 84) and cows, so check the positions of the ulnar olecranon and calcaneus.

Variations Domestic cattle move slowly and are generally docile. Observe and draw them in various poses.

"Tongue play," in which the cow uses its long tongue to lick its nose, etc., is a common behavior.

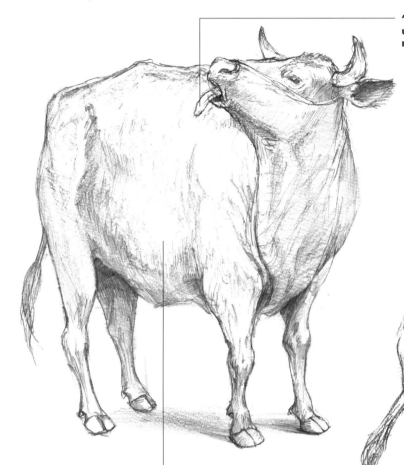

Key Point

One of the reasons for the boxy appearance of the body is the square-shaped, angular rump. This is the outline created by the backward-projecting sciatic bone.

Bovines have four stomachs in sequence, each with its own role in digestion. The first stomach has a capacity of 120-150 liters. The grass is fermented and decomposed with the help of microorganisms, until it passes through the fourth stomach, where it is digested and its nutrients are absorbed.

The four large stomachs, which break down difficult-to-digest grass cellulose into nutrients, occupy most of the belly's volume.

Note

Be aware of the teeth so you can draw realistic facial expressions

Male bovines have six molars in the upper and lower jaws on each side and eight incisors on the front lower jaw. The maxillary incisors are absent, and the area is hardened like a callous. They twirl tufts of grass with their long tongues and bring it to their mouths.

The two hooves are the toenails of the third and fourth finger.

Hippopotamus
(Animalia/Chordata/Vertebrata/Mammalia/Hippopotamidae)
The hippopotamus inhabits the riverside regions of Africa and Eurasia. The body is large, round and fleshy, and the texture of the hide is tight and firm.

Skeletal Diagram The limbs, supporting the large thorax and cranium, are thick—indicating a low center of gravity.

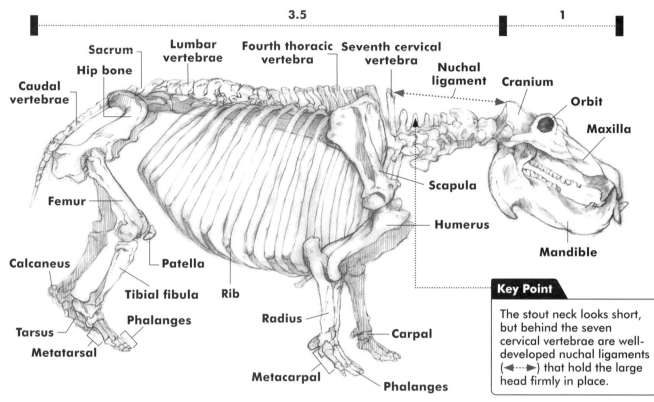

3.5 1

Sacrum
Lumbar vertebrae
Fourth thoracic vertebra
Seventh cervical vertebra
Hip bone
Nuchal ligament
Cranium
Caudal vertebrae
Orbit
Maxilla
Scapula
Femur
Humerus
Mandible
Calcaneus
Patella
Tibial fibula
Rib
Key Point
Tarsus
Phalanges
Radius
The stout neck looks short, but behind the seven cervical vertebrae are well-developed nuchal ligaments (◄···►) that hold the large head firmly in place.
Metatarsal
Carpal
Metacarpal
Phalanges

Completed Drawing It is evident that a sturdy skeleton is supporting the large body. Use the orientation of the pencil lines to express the hippo's three-dimensionality and the tautness of its skin.

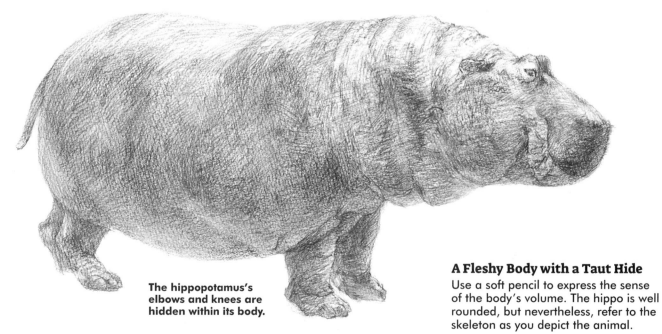

The hippopotamus's elbows and knees are hidden within its body.

A Fleshy Body with a Taut Hide
Use a soft pencil to express the sense of the body's volume. The hippo is well rounded, but nevertheless, refer to the skeleton as you depict the animal.

Variation Pygmy hippopotamuses and hippopotamuses differ in both size and proportions. The pygmy hippopotamus has a large snout, a large abdomen, and a round belly that almost touches the ground.

When expressed with lines, the cartoon-like features come to the fore. By strongly expressing the head and the front-left limb in the foreground, you create a sense of perspective even in a two-dimensional drawing.

The parent-child juxta-position is an image that projects tenderness.

Key Point

The hippopotamus can stay underwater for hours with only its nose and eyes out of the water. Such animals have their ears, eyes and nose aligned horizontally.

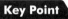

They have small legs in relation to their large bodies and faces. Their large, stubby bodies and faces are adorable, and they are easily turned into cartoon characters.

Hippopotamuses are said to sweat red, but in actuality they do not have sweat glands in their skin. They secrete a red-tinted mucus that protects them from ultraviolet rays.

Skillfully depicting the shading creates a sense of weight.

(Pygmy hippopotamus)

Horse
(Animalia/Chordata/Vertebrata/Mammalia/Perissodactyla/Equidae)
The horse has a long neck and limbs, and its form is adapted for speed. It is an intelligent and beautiful animal with a mane behind the neck and a long-haired tail.

Skeletal Diagram
The skeletal structure of the horse is characterized by a long, strong neck and slender, elongated limbs.

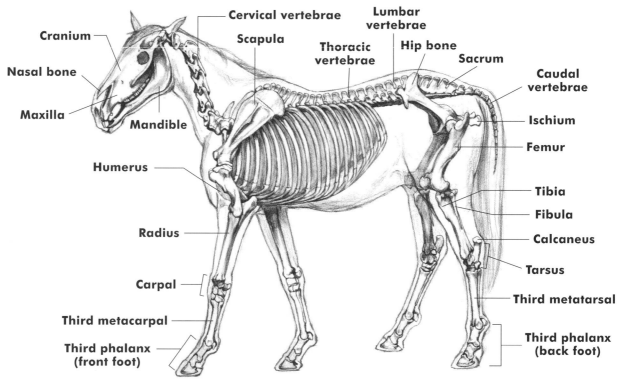

Muscle Diagram
The key to a horse's beauty lies in the rugged definition of its muscles. The short body hairs allow the outlines of the firm musculature of the chest and neck to show on the surface.

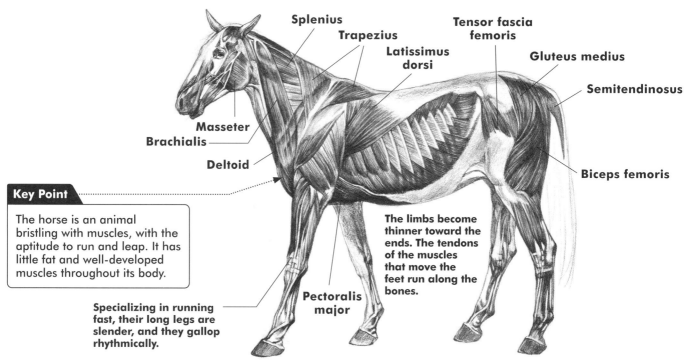

Key Point
The horse is an animal bristling with muscles, with the aptitude to run and leap. It has little fat and well-developed muscles throughout its body.

The limbs become thinner toward the ends. The tendons of the muscles that move the feet run along the bones.

Specializing in running fast, their long legs are slender, and they gallop rhythmically.

Drawing Procedure Understand the skeleton and muscles and follow the dynamic movements of the horse. The slight shading created by the muscles is drawn in little by little.

Trace the Outlines	Draw the Shadows	Define the Darks and Lights
		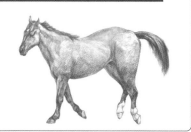

1 Be aware of the rhythm of the movement and of the skeletal structure

Draw a rough sketch with the rhythm of the movement and the skeleton in mind. Look closely at the range of lightness and darkness on the body, and gradually define the inner forms with sketchy lines.

2 Alternatively look at the parts and the whole

Be aware of the range of light and dark areas as ranges as you shade them. If you are preoccupied with a part of the image you will lose sight of the whole, so try to alternate between the parts and the whole by occasionally squinting at the entire image.

3 Express the shade of the coat and the texture of the skin

Depict the tone of the coat and the texture of the skin faithfully, and tidy up the overall image. Express the highlights and shadows created by the short coat, in accordance with the horse's unique coloring.

Note

Express dynamism with the movements of the mane and tail

If you depict the long, flowing hairs of the mane and tail faithfully, you will create a dynamic drawing that captures suggestions of the horse's movements.

① The horse has a long face (nasal bone).
② By adding shadows on the ground, it gives the rear legs the impression of being in mid-jump as they leap up.
③ The horse originally had five fingers, but lost all but the third finger during evolution. It is an adaptation to facilitate running swiftly across the plains.
④ Note the position of the horse's "heel" and the orientation of the hoof.

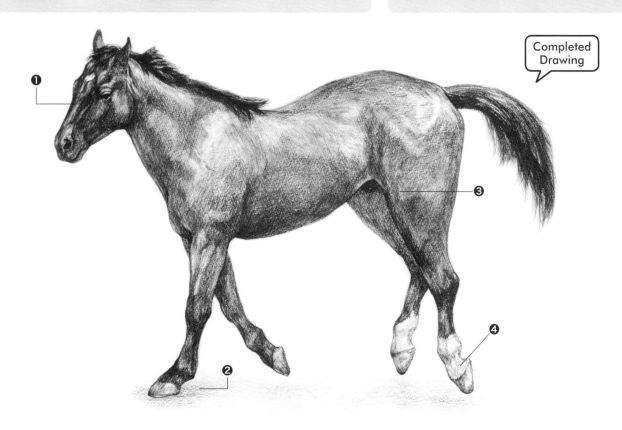

Completed Drawing

Muscular and dignified, horses look good in any pose, whether still or moving. Capture the movement carefully as you draw. The movement of the tail and the outlines of the raised muscles are the key points.

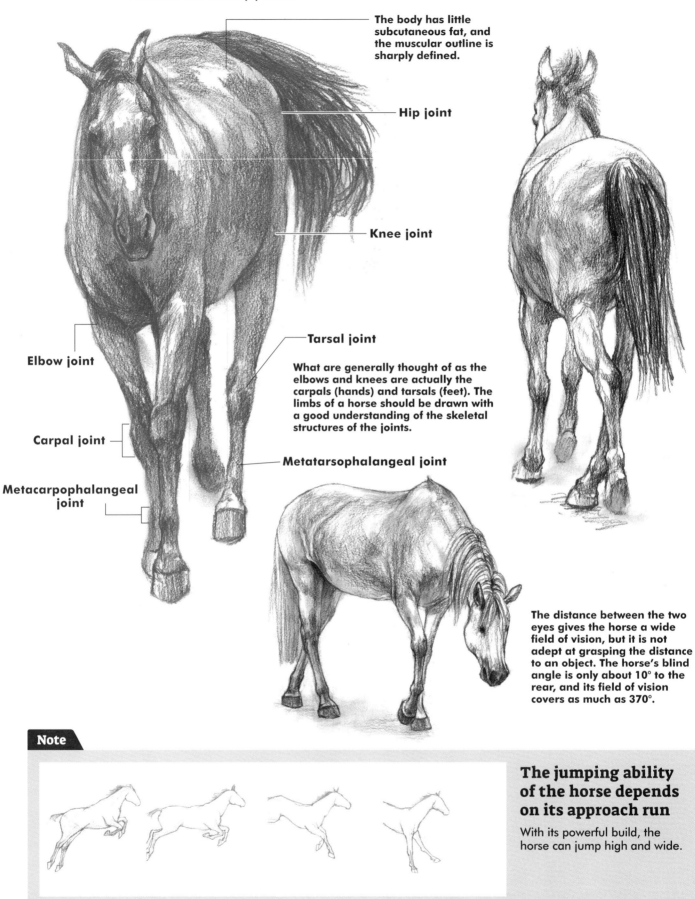

The body has little subcutaneous fat, and the muscular outline is sharply defined.

Hip joint

Knee joint

Elbow joint

Tarsal joint

What are generally thought of as the elbows and knees are actually the carpals (hands) and tarsals (feet). The limbs of a horse should be drawn with a good understanding of the skeletal structures of the joints.

Carpal joint

Metatarsophalangeal joint

Metacarpophalangeal joint

The distance between the two eyes gives the horse a wide field of vision, but it is not adept at grasping the distance to an object. The horse's blind angle is only about 10° to the rear, and its field of vision covers as much as 370°.

Note

The jumping ability of the horse depends on its approach run

With its powerful build, the horse can jump high and wide.

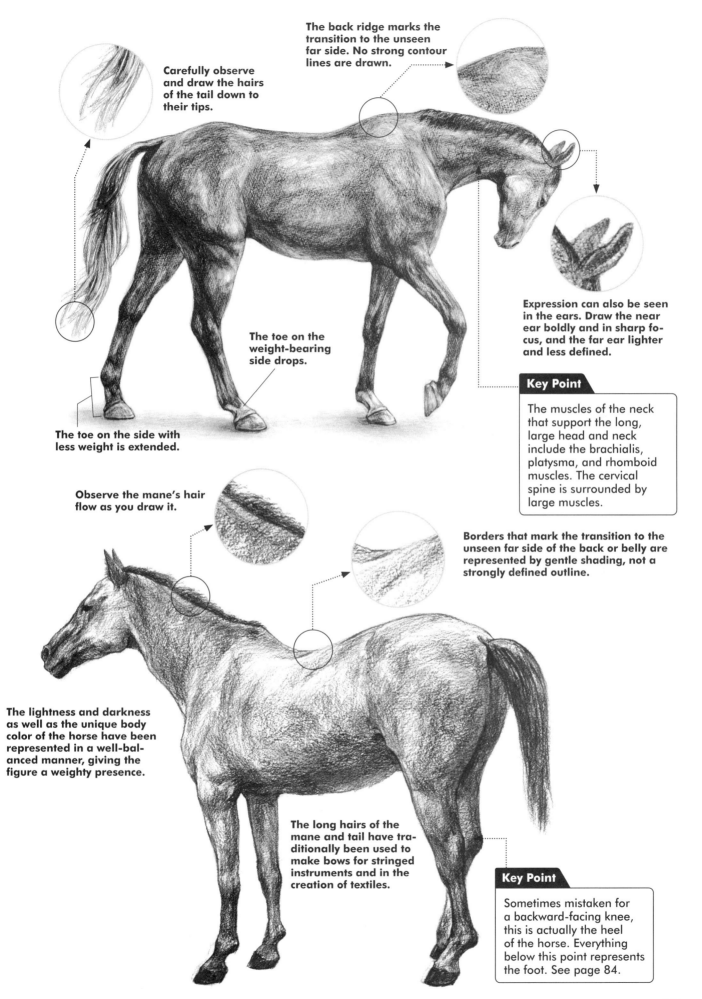

Carefully observe and draw the hairs of the tail down to their tips.

The back ridge marks the transition to the unseen far side. No strong contour lines are drawn.

Expression can also be seen in the ears. Draw the near ear boldly and in sharp focus, and the far ear lighter and less defined.

The toe on the weight-bearing side drops.

The toe on the side with less weight is extended.

Key Point

The muscles of the neck that support the long, large head and neck include the brachialis, platysma, and rhomboid muscles. The cervical spine is surrounded by large muscles.

Observe the mane's hair flow as you draw it.

Borders that mark the transition to the unseen far side of the back or belly are represented by gentle shading, not a strongly defined outline.

The lightness and darkness as well as the unique body color of the horse have been represented in a well-balanced manner, giving the figure a weighty presence.

The long hairs of the mane and tail have traditionally been used to make bows for stringed instruments and in the creation of textiles.

Key Point

Sometimes mistaken for a backward-facing knee, this is actually the heel of the horse. Everything below this point represents the foot. See page 84.

Mammals **87**

Sloth

(Animalia/Chordata/Vertebrata/Mammalia/Pilosa/Bradypodidae)

The name "sloth" was given to the animal because of its characteristically sluggish movements. Sometimes moving only 1 meter in a given day. It inhabits the dense jungles of South and Central America and is threatened with extinction.

Lesson 1-15 / Mammals

Skeletal Diagram

The two-toed sloth has 6 to 7 cervical vertebrae, and the three-toed sloth has 9 cervical vertebrae. Considering that other mammals have seven cervical vertebrae, this is a bit unusual. The three-toed sloth can rotate its neck as much as 270 degrees.

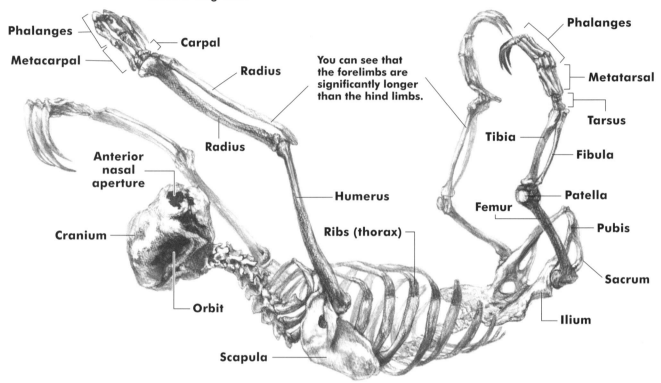

Phalanges
Metacarpal
Carpal
Radius
Radius
Anterior nasal aperture
Cranium
Orbit
Scapula
Humerus
Ribs (thorax)
You can see that the forelimbs are significantly longer than the hind limbs.
Phalanges
Metatarsal
Tarsus
Tibia
Fibula
Femur
Patella
Pubis
Sacrum
Ilium

Completed Drawing

Carefully observe the sloth's grizzled fur and use HB, 2B, 3B and 4B pencils on coarse-grained drawing paper to draw in its expressive face. It is best of think of the sloth as always being paired with a tree or branch.

In most mammals, the hair flow is from dorsal to ventral, but in sloths it flows in the opposite direction, from ventral to dorsal. It is convenient for channeling rainwater to pass from its belly to its back while the sloth hangs suspended from a branch.

Key Point

The hairs around the eyes are dark and radiate outward from the center of the forehead. This creates an "eye shadow" effect, making the eyes look droopy, and giving the sloth a somewhat comical expression.

Make good use of blurring techniques to express perspective and hair texture. Make sure to draw the darker parts of the facial hair to give the face definition.

Define the Shadows

1 Capture the shape and layer on the shadows

Squint at the entire image to see the shading. Squinting will make the small details invisible and allow you to get a sense of the overall three-dimensionality of the shadows. The stiff hair is depicted in large tufts that emphasize the three-dimensionality of the subject.

Observe the Foreground Carefully

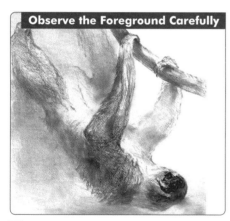

2 Make the foreground sharper and darker

Once the large shadows have been depicted, carefully observe the parts of the subject in the foreground, such as the head, face and left arm, and draw them in. The objects in the foreground are sharper and darker in tone. In this drawing, the artist has used their fingers and a cotton cloth to blur parts of the subject in the background to express a sense of space and softness.

Note

Their claws are key features

The two-toed sloth has two claws, and the three-toed sloth has three claws. Their sharp claws help them defend themselves when attacked by predators. They swim occasionally, and their swimming speed is surprisingly fast.

Completed Drawing

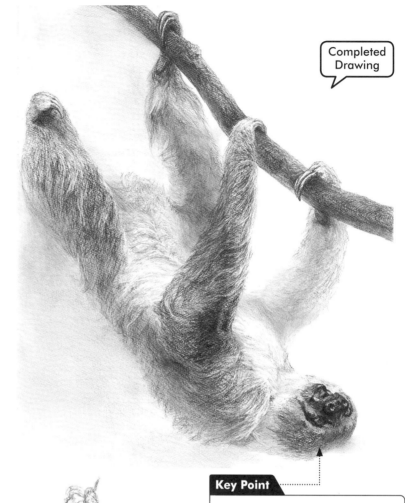

Key Point

The small, round cranium has orbits that house the eyeballs and an anterior nasal aperture that leads to the nasal cavity. Both are roughly horizontally aligned. This facial structure lends a sense of childlike cuteness.

Because they do not move much, moss and algae can actually grow on their body hair. This is why their coats can appear green—a camouflaging asset in tropical rainforests.

The low position of the eyes makes the face look cute.

Goat and Barbary Sheep

(Animalia/Chordata/Vertebrata/Mammalia/Bovidae/Caprinae/Capra)
(Animalia/Chordata/Vertebrata/Mammalia/Bovidae/Caprinae/Ammotragus lervia)

The goat, like the cow (page 80), is a ruminant. It lives on steep slopes such as mountains and cliffs, and has been used as livestock since ancient times because of its high fecundity and ability to survive on a poor diet.

Skeletal Diagram

The goat is in the same genus as the sheep (page 92) and other animals, and although skeletally there is not much difference, the goat does have horns.

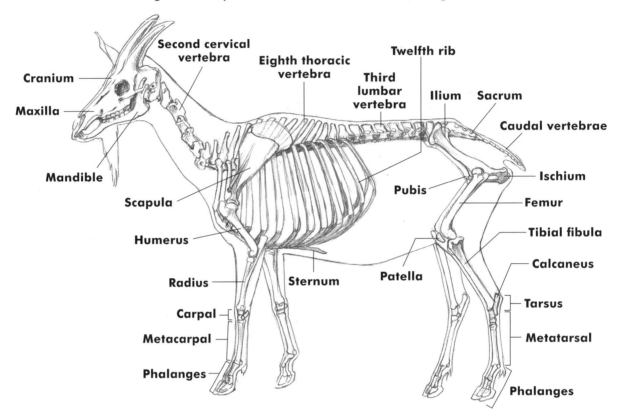

Second cervical vertebra
Eighth thoracic vertebra
Twelfth rib
Cranium
Third lumbar vertebra
Ilium
Sacrum
Maxilla
Caudal vertebrae
Mandible
Ischium
Scapula
Pubis
Femur
Humerus
Tibial fibula
Calcaneus
Radius
Sternum
Patella
Carpal
Tarsus
Metacarpal
Metatarsal
Phalanges
Phalanges

Completed Drawing

These drawings have been expressed with only a little shading on the line drawing. It is difficult to see the skeletal structure of an animal with a shaggy coat, but if you have knowledge of the skeleton, you can capture a realistic appearance as you depict it.

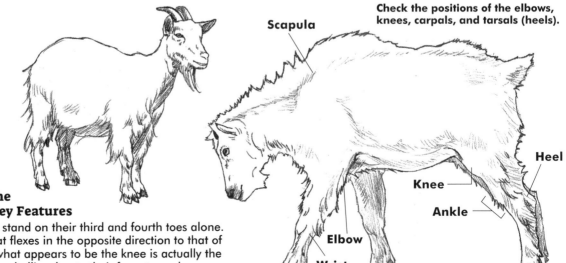

Check the positions of the elbows, knees, carpals, and tarsals (heels).

Scapula

Heel

Knee

Ankle

Elbow

Wrist

The Positions of the Ankles and the Large Belly Are Key Features

Even-toed ungulates stand on their third and fourth toes alone. Instead of a knee that flexes in the opposite direction to that of humans (page 42); what appears to be the knee is actually the ankle. They have large bellies due to their four stomachs.

Variations Carefully observe and draw the texture of the horns with their detailed patterns. Observe the light and shadow and hair flow carefully to draw a goat. There are long-haired breeds in colder regions.

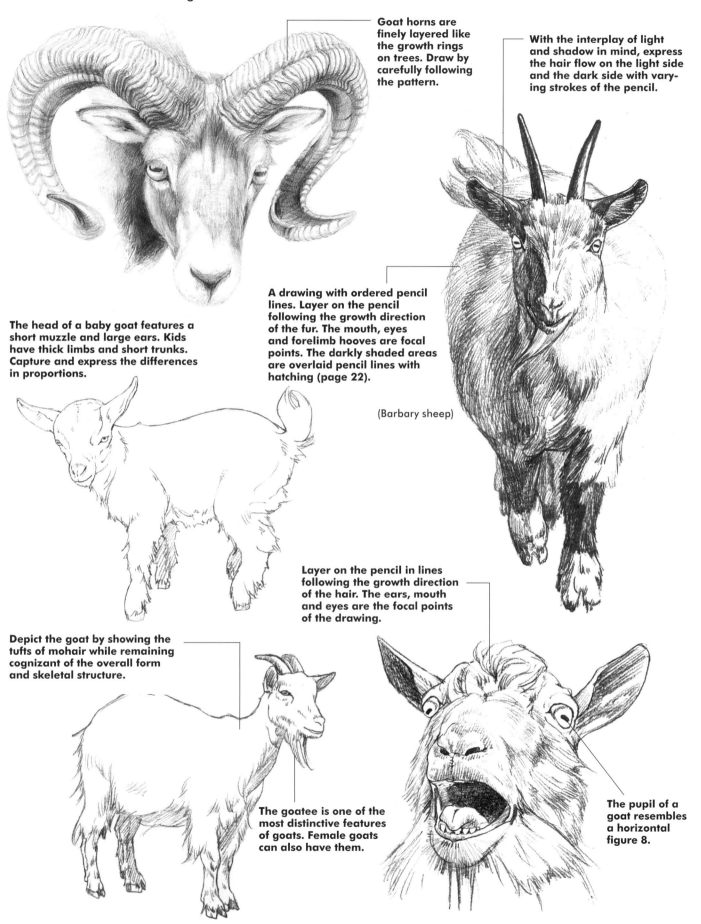

Goat horns are finely layered like the growth rings on trees. Draw by carefully following the pattern.

With the interplay of light and shadow in mind, express the hair flow on the light side and the dark side with varying strokes of the pencil.

The head of a baby goat features a short muzzle and large ears. Kids have thick limbs and short trunks. Capture and express the differences in proportions.

A drawing with ordered pencil lines. Layer on the pencil following the growth direction of the fur. The mouth, eyes and forelimb hooves are focal points. The darkly shaded areas are overlaid pencil lines with hatching (page 22).

(Barbary sheep)

Layer on the pencil in lines following the growth direction of the hair. The ears, mouth and eyes are the focal points of the drawing.

Depict the goat by showing the tufts of mohair while remaining cognizant of the overall form and skeletal structure.

The goatee is one of the most distinctive features of goats. Female goats can also have them.

The pupil of a goat resembles a horizontal figure 8.

Mammals **91**

Sheep

(Animalia/Chordata/Vertebrata/Mammalia/Bovidae/Ovis)

The sheep is a herbivorous ruminant that is covered with hair called wool, which we use for clothing and other purposes. It is also raised for meat.

Skeletal Diagram

You can see that the body of the sheep underneath the fuzzy wool is slender and has thin limbs compared to the cow (page 80).

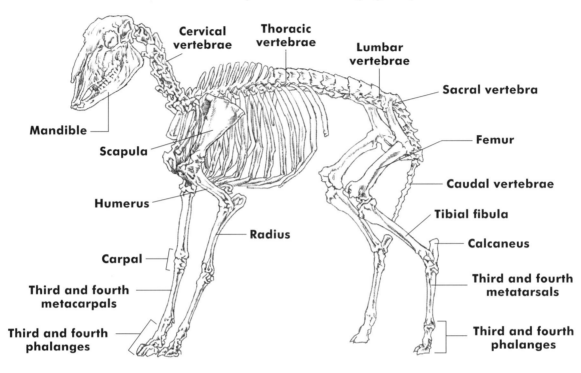

Cervical vertebrae
Thoracic vertebrae
Lumbar vertebrae
Sacral vertebra
Mandible
Scapula
Femur
Humerus
Caudal vertebrae
Radius
Tibial fibula
Calcaneus
Carpal
Third and fourth metacarpals
Third and fourth metatarsals
Third and fourth phalanges
Third and fourth phalanges

Variations

Sheep are animals that can be handled and observed up close at farms and petting zoos. Their movements are gentle and slow, so you can make a lot of sketches of their whole figures and parts.

For sketches, use a soft pencil such as 4B to quickly capture the form.

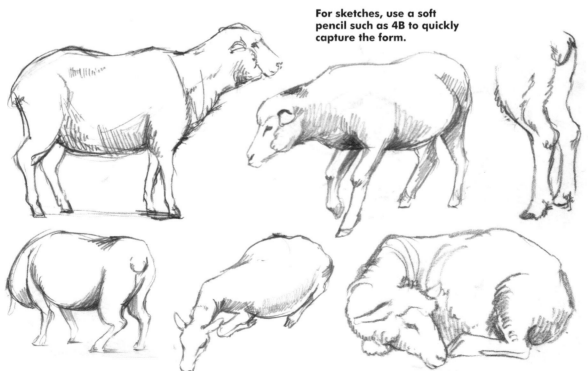

Drawing Procedure

Be aware of shading and pay attention to the three-dimensionality of the shape as well as the texture of the wool. The shapes and orientations of the hooves are also important.

Capture the Shape

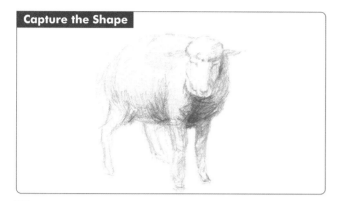

Draw the Small Details

1 Be aware of the whole rounded body

Rough out the shape while taking the three-dimensionality of the entire body into consideration. The wool is thick and it hides the lines of the skin on the surface of the body, but the entire body wrapped in wool is taken as a single form to capture the shadows.

2 See the detail → whole → detail... and repeat again and again

Squint occasionally to check the range of tones, and layer on the pencil in the dark areas. The process of looking at the details and then looking at the whole again repeatedly brings the drawing closer and closer to completion.

Although the body is woolly, follow the connections to the limbs and be aware of the skeleton. If you are able to handle a sheep at a petting zoo, please do so to better understand the distance between the surface of the wool and that of the body.

The shape of the joints and direction of flexion of the limbs are points that should be carefully observed.

Key Point

Don't be too focused on the eyes, nose and mouth. Use a 2B to 4B soft pencil and carefully express them with an eye for capturing a sense of volume.

Completed Drawing

Key Point

Sheep have light, monochromatic wool, but there are various tonal gradations in the shading. Penciling in a solid range of tones will give the drawing a sense of weight.

Draw nearer portions with greater precision. The hair on the right fore-limb is fuzzy, but the hoof at the end of the limb that supports the body is important to create an impression of standing. Draw this part with care.

Camel

(Animalia/Chordata/Vertebrata/Mammalia/Camelidae/Camelus)

In West Asia, the camel is often used as a means of transport and transportation, and it often appears in stories. The single dorsal hump is a distinctive feature of the dromedary camel, which is found in Africa, while the double-humped Bactrian camel is found in both Asia and Africa.

Skeletal Diagram

The camel's hump has no bones. The humerus and femur are extended downward, giving the appearance of long limbs. Also, note the cervical vertebrae in the neck, which move back and forth to maintain balance when the camel sprints.

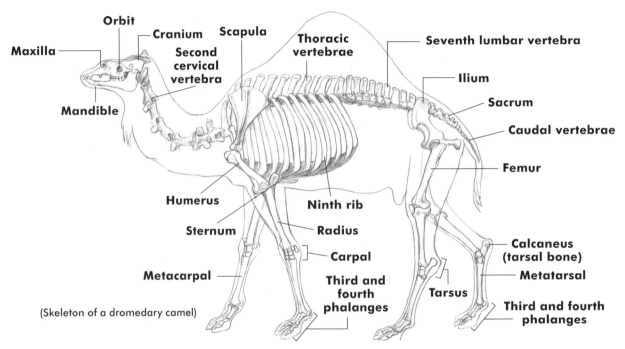

(Skeleton of a dromedary camel)

Muscle Diagram

The upper arms and thighs are heavily muscled, but the spans from elbows to the ends of the front feet and the knees to the ends of the back feet are very thin, with only the tendons of the muscles running through them.

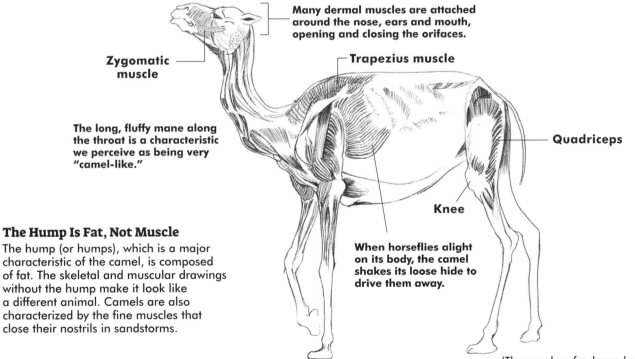

The Hump Is Fat, Not Muscle

The hump (or humps), which is a major characteristic of the camel, is composed of fat. The skeletal and muscular drawings without the hump make it look like a different animal. Camels are also characterized by the fine muscles that close their nostrils in sandstorms.

(The muscles of a dromedary camel)

Drawing Procedure

The volume of the abdomen, which is distended by its three stomachs; the flabby throat mane and hump; and the knobby joints of the limbs, are all common characteristics of the camel's appearance.

Capture the Shape

1 Observe the body and the joint parts closely

Compose the image so that it fills the paper and is well-balanced. Next, determine the overall shape of the animal by measuring the areas that will serve as clues to the shape of the outline. Observe the structures of the joints carefully and analyze them by squinting to identify the large shadows.

Add the Shading

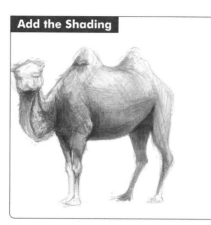

2 Put down shading in the dark areas

Once the shape has been sketched out, start adding hatching (page 22) to create shading, starting from the darker areas. Try to express the tonal range between the dark shadow areas and the light areas as faithfully as possible. If you squint at the object and look for dark areas one after another and layer on the pencil, a three-dimensional effect is naturally created.

Note

The balance of the camel's legs and feet

Note the size of the body, the vertical extension of the legs and hooves, and the fact that the hooves are bifurcated as if to grip the sand.

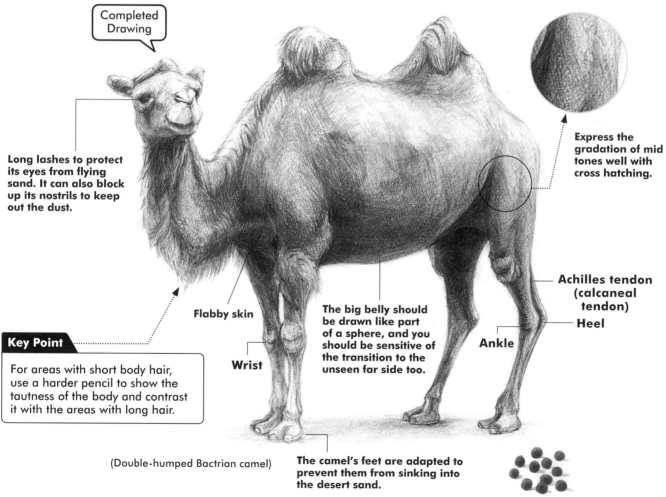

Completed Drawing

Express the gradation of mid tones well with cross hatching.

Long lashes to protect its eyes from flying sand. It can also block up its nostrils to keep out the dust.

Achilles tendon (calcaneal tendon)

Heel

Ankle

Flabby skin

Wrist

The big belly should be drawn like part of a sphere, and you should be sensitive of the transition to the unseen far side too.

Key Point

For areas with short body hair, use a harder pencil to show the tautness of the body and contrast it with the areas with long hair.

(Double-humped Bactrian camel)

The camel's feet are adapted to prevent them from sinking into the desert sand.

Elephant

(Animalia/Chordata/Vertebrata/Mammalia/Elephantoidea/Elephantidae)

The elephant is the largest mammal living on land. With its long nose made of muscle, it can dexterously carry food and water to its mouth. There are African and Asian elephants.

Skeletal Diagram

The skeleton supporting the large body is stout and thick, with a large cranium. The elbow and knee joints are elongated, and the bones of the limbs supporting the huge body are thickened.

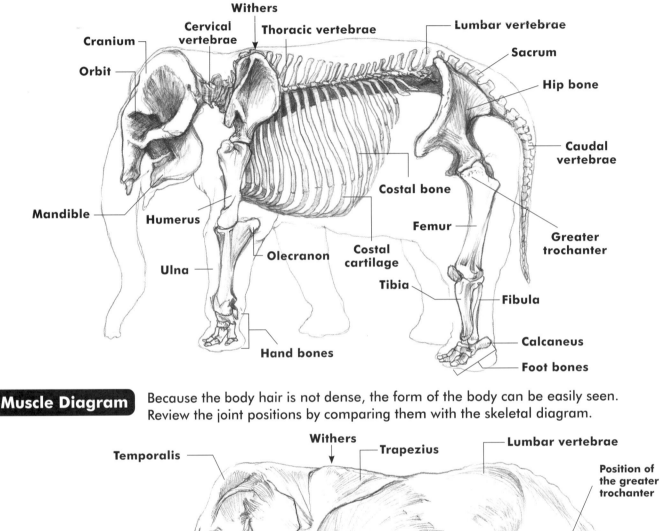

Withers

Cervical vertebrae

Thoracic vertebrae

Lumbar vertebrae

Cranium

Sacrum

Orbit

Hip bone

Caudal vertebrae

Costal bone

Mandible

Femur

Greater trochanter

Humerus

Olecranon

Costal cartilage

Ulna

Tibia

Fibula

Calcaneus

Hand bones

Foot bones

Muscle Diagram

Because the body hair is not dense, the form of the body can be easily seen. Review the joint positions by comparing them with the skeletal diagram.

Withers

Trapezius

Lumbar vertebrae

Temporalis

Position of the greater trochanter

Upper lip nasolabial fold

Buccinator

Triceps brachii

Elbow

Quadriceps

Abdominal obliques

Knee

Gluteus maximus

Biceps femoris

Key Point

The flexible and dexterous trunk has no bones; it moves by means of muscles that run horizontally and vertically. The long trunk corresponds to the nose and upper lip of humans (page 42).

Complete Drawing The weightiness of the elephant is brought out by the shading. Be aware of the shading for both the overall shape and the indications of roundness that gives it a sense of volume. Details such as wrinkles on the body surface can be added at the finishing stage.

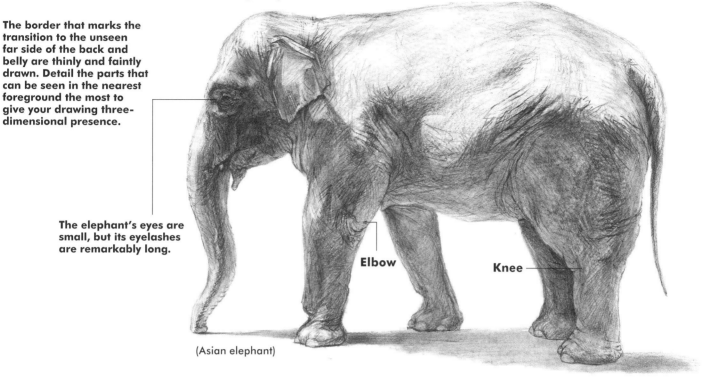

The border that marks the transition to the unseen far side of the back and belly are thinly and faintly drawn. Detail the parts that can be seen in the nearest foreground the most to give your drawing three-dimensional presence.

The elephant's eyes are small, but its eyelashes are remarkably long.

Elbow

Knee

(Asian elephant)

Variations To express the volume of the elephant's body, it is important to grasp the three-dimensionality of the chest. Sketch it from different angles to get a good idea of the large body mass.

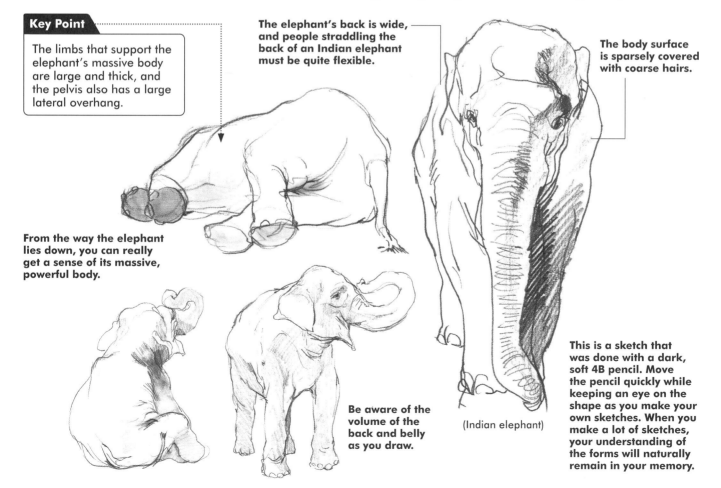

Key Point

The limbs that support the elephant's massive body are large and thick, and the pelvis also has a large lateral overhang.

The elephant's back is wide, and people straddling the back of an Indian elephant must be quite flexible.

The body surface is sparsely covered with coarse hairs.

From the way the elephant lies down, you can really get a sense of its massive, powerful body.

Be aware of the volume of the back and belly as you draw.

(Indian elephant)

This is a sketch that was done with a dark, soft 4B pencil. Move the pencil quickly while keeping an eye on the shape as you make your own sketches. When you make a lot of sketches, your understanding of the forms will naturally remain in your memory.

Mammals **97**

Rabbit

(Animalia/Chordata/Vertebrata/Mammalia/Lagomorpha/Leporidae)

The incisors make the rabbit look like a rodent and it appears to be rodent-like, but two other small incisors are hidden behind the two primary incisors which means it belongs to the Leporidae family. It has large feet with excellent jumping ability.

Skeletal Diagram

The "cottonball" tail of the rabbit makes an impression, but the bones of its tail are actually not insignificant. They are plantigrade, as are humans (page 42); when their feet are stationary, they make contact with the ground from the heel to the toe. When it is the jumping, the heel does not touch the ground, as is the case with digitigrade animals.

▶ In this specimen the right nasal bone is missing, revealing the mandible.

Key Point

Although only two maxillary incisors are visible from the front, two smaller incisors grow behind them.

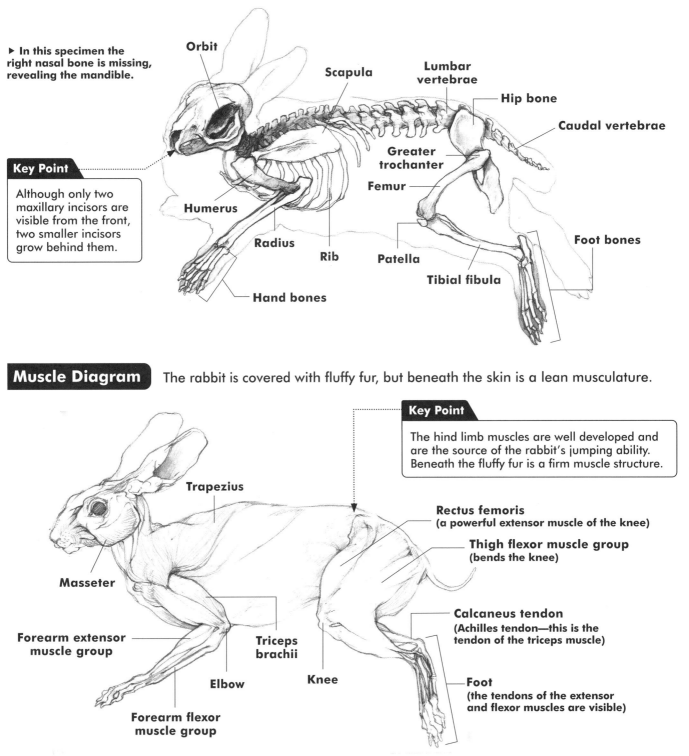

Muscle Diagram

The rabbit is covered with fluffy fur, but beneath the skin is a lean musculature.

Key Point

The hind limb muscles are well developed and are the source of the rabbit's jumping ability. Beneath the fluffy fur is a firm muscle structure.

The texture of the fluffy fur is well represented here. The eyes, muzzle and ears are key points of expression. It helps to establish three-dimensionality if you show finer details on the parts closest to the viewer, and to depict background areas or areas that wrap around to the other side lightly.

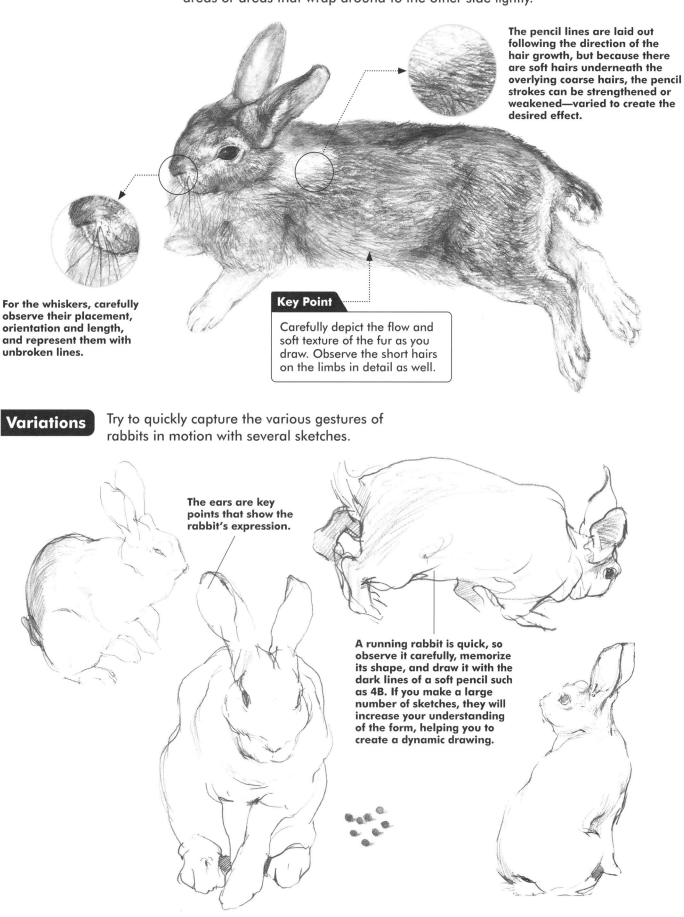

The pencil lines are laid out following the direction of the hair growth, but because there are soft hairs underneath the overlying coarse hairs, the pencil strokes can be strengthened or weakened—varied to create the desired effect.

For the whiskers, carefully observe their placement, orientation and length, and represent them with unbroken lines.

Key Point

Carefully depict the flow and soft texture of the fur as you draw. Observe the short hairs on the limbs in detail as well.

Variations Try to quickly capture the various gestures of rabbits in motion with several sketches.

The ears are key points that show the rabbit's expression.

A running rabbit is quick, so observe it carefully, memorize its shape, and draw it with the dark lines of a soft pencil such as 4B. If you make a large number of sketches, they will increase your understanding of the form, helping you to create a dynamic drawing.

Mammals **99**

Mouse

(Animalia/Chordata/Vertebrata/Mammalia/Rodentia/Muridae)

There are many species of mice, and they are familiar to us in our daily lives. It is an animal that has often been the subject of anthropomorphism because of its ability to stand up on its hind legs and its large black eyes.

Skeletal Diagram

The mouse is characterized by a long, thin tail and a skull that is large relative to its body. Familiarize yourself with how the forelimbs and hind limbs are attached and the proportions of each body part.

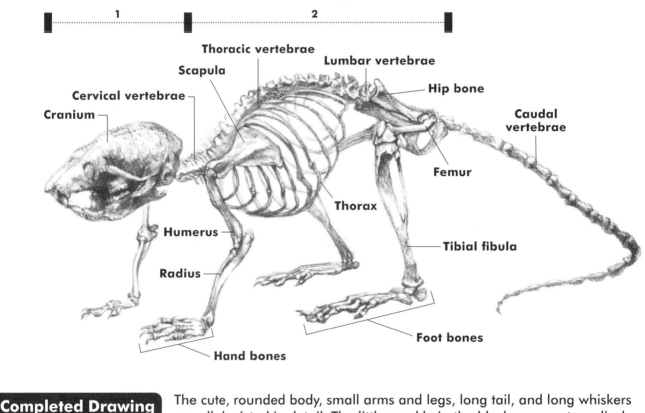

Cranium
Cervical vertebrae
Scapula
Thoracic vertebrae
Lumbar vertebrae
Hip bone
Caudal vertebrae
Femur
Thorax
Humerus
Radius
Tibial fibula
Hand bones
Foot bones

Completed Drawing

The cute, rounded body, small arms and legs, long tail, and long whiskers are all depicted in detail. The little sparkle in the black eye creates a lively expression. The highlight should not be very large.

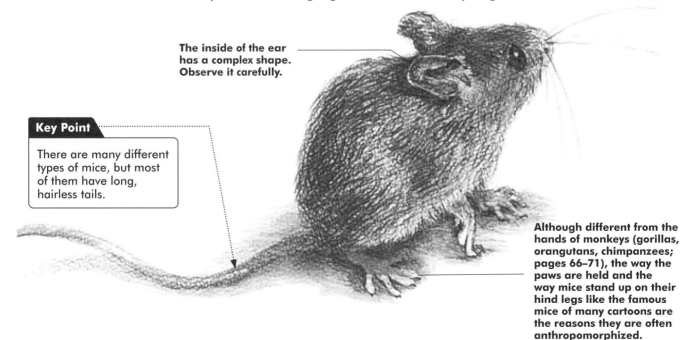

The inside of the ear has a complex shape. Observe it carefully.

Key Point

There are many different types of mice, but most of them have long, hairless tails.

Although different from the hands of monkeys (gorillas, orangutans, chimpanzees; pages 66–71), the way the paws are held and the way mice stand up on their hind legs like the famous mice of many cartoons are the reasons they are often anthropomorphized.

Drawing Procedure Small animals have relatively large heads. The three-dimensional effect is achieved through shading. A sense of volume and presence are expressed.

Capture the Shape

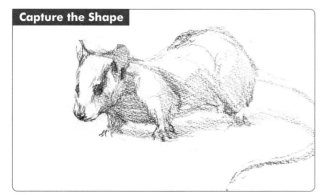

Apply the Shading

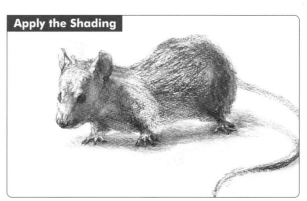

1 After capturing the shape, apply tone in the dark areas

From rough sketches to more precise studies, observe the subject carefully and capture the shape. Then, apply tones to the dark areas with the pencil.

2 Draw the large shadows

Shade the hair while keeping the flow of the fur in mind. Squint your eyes and look at the subject, then apply shading to each dark area. Once the tones have been established, apply a stronger layer of tones to key areas such as the eyes and nose, as well as to the areas of darkest shadow.

Key Point

Indicate a large shadow, and then emphasize the direction of the hair flow. Draw the whiskers and fine hairs last.

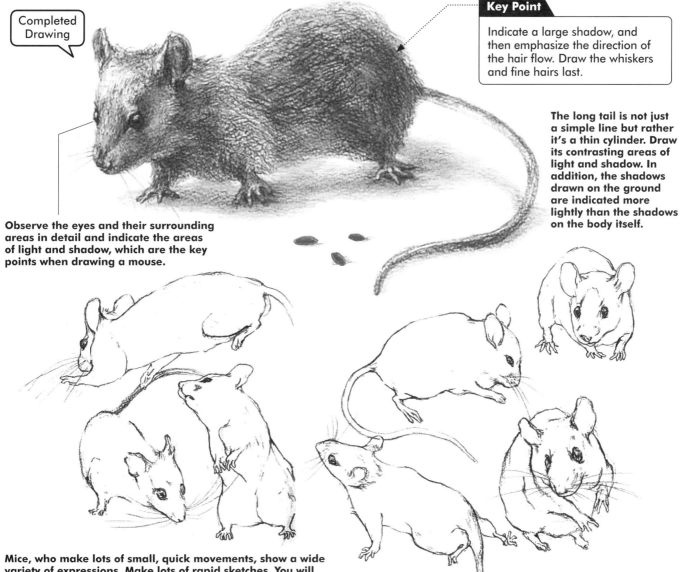

Completed Drawing

The long tail is not just a simple line but rather it's a thin cylinder. Draw its contrasting areas of light and shadow. In addition, the shadows drawn on the ground are indicated more lightly than the shadows on the body itself.

Observe the eyes and their surrounding areas in detail and indicate the areas of light and shadow, which are the key points when drawing a mouse.

Mice, who make lots of small, quick movements, show a wide variety of expressions. Make lots of rapid sketches. You will develop a good understanding of its physical attributes as well as its potential anthropomorphic characteristics.

Capybara
(Animalia/Chordata/Vertebrata/Mammalia/Rodentia/Caviidae/Hydrochoerinae)

The capybara has stiff body hair, is a good swimmer, and lives in groups. With its large head and short forelimbs and hind limbs, it is easy to anthropomorphize this animal.

Skeletal Diagram Capybaras are the largest rodents and are members of the mouse family. They look a little like dogs (page 50), but have large craniums and stocky bodies.

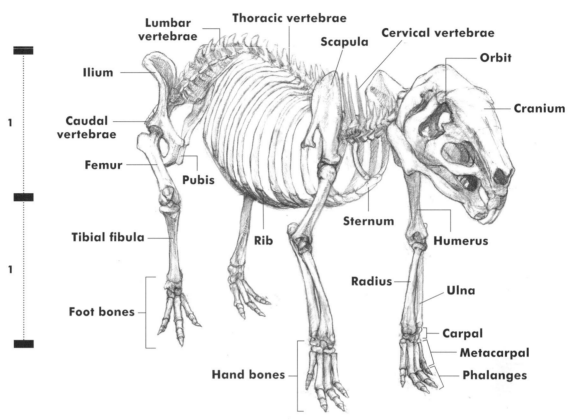

Completed Drawing The capybara has large buttocks and short, thin fore and hind legs. The coarse texture of the hair is drawn roughly to express this essential characteristic.

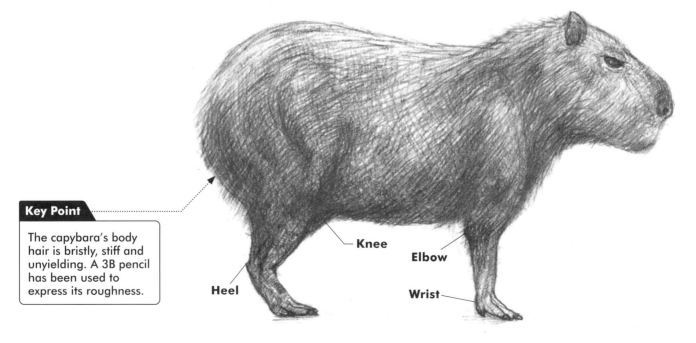

Key Point

The capybara's body hair is bristly, stiff and unyielding. A 3B pencil has been used to express its roughness.

The capybara has a large head and a somewhat comical appearance. It is a good model for relaxed sketching, as it does not move around much.

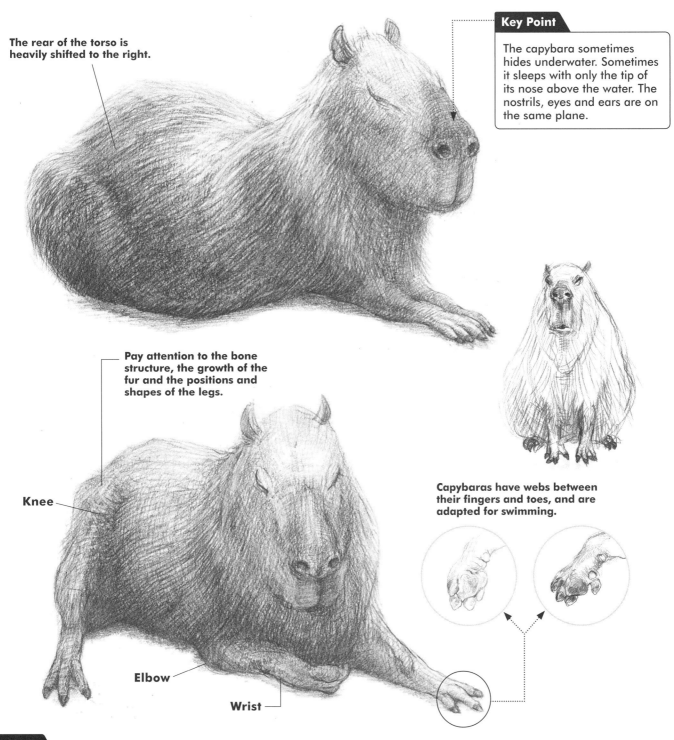

The rear of the torso is heavily shifted to the right.

Key Point

The capybara sometimes hides underwater. Sometimes it sleeps with only the tip of its nose above the water. The nostrils, eyes and ears are on the same plane.

Pay attention to the bone structure, the growth of the fur and the positions and shapes of the legs.

Knee

Elbow

Wrist

Capybaras have webs between their fingers and toes, and are adapted for swimming.

Note

The laid back walk of a capybara

It is a member of the rat family, but because it is large, it walks relatively slowly. Body size and movement speed are related. Focus on capturing the movements of the forelimbs and hind limbs.

Wallaby and Kangaroo

(Animalia/Chordata/Vertebrata/Mammalia/Marsupialia/Diprotodontia/Macropodidae)

The wallaby and kangaroo are excellent jumpers and have a *marsupium*; their newborns mature inside this specialized pouch. They use their thick, large tails for balance when standing up and jumping.

Skeletal Diagram

Both wallabies and kangaroos stand on their hind limbs, but they have large tailbones and tails that serve as a third lower limb. They are also characterized by large feet that are adapted for hopping and moving forward. They are among the few non-primate mammals that have vestigial clavicles, and small forelimbs that move freely.

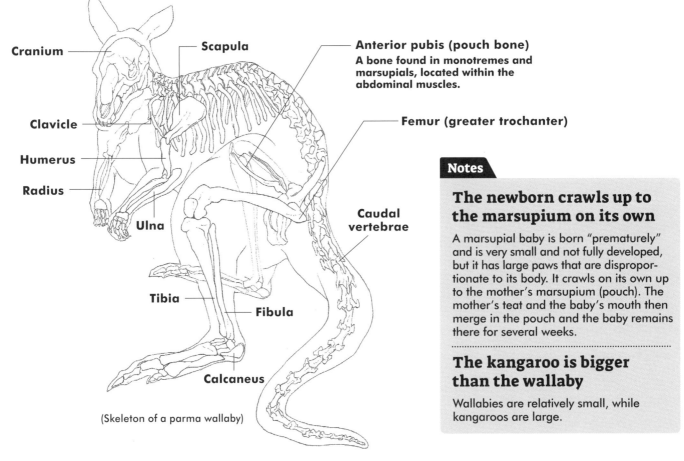

Cranium

Scapula

Anterior pubis (pouch bone)
A bone found in monotremes and marsupials, located within the abdominal muscles.

Clavicle

Femur (greater trochanter)

Humerus

Radius

Ulna

Caudal vertebrae

Tibia

Fibula

Calcaneus

(Skeleton of a parma wallaby)

Notes

The newborn crawls up to the marsupium on its own

A marsupial baby is born "prematurely" and is very small and not fully developed, but it has large paws that are disproportionate to its body. It crawls on its own up to the mother's marsupium (pouch). The mother's teat and the baby's mouth then merge in the pouch and the baby remains there for several weeks.

The kangaroo is bigger than the wallaby

Wallabies are relatively small, while kangaroos are large.

Variations

The tail, with its quantity of muscle, allows for unique jumping locomotion and balance in complex postures. Study the points of movement carefully.

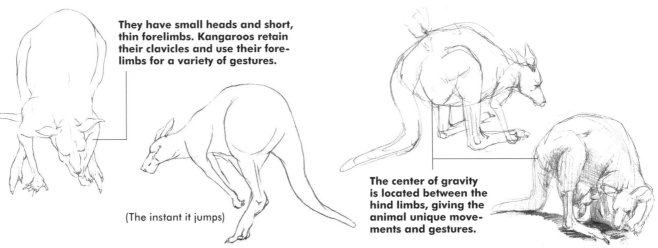

They have small heads and short, thin forelimbs. Kangaroos retain their clavicles and use their fore-limbs for a variety of gestures.

(The instant it jumps)

The center of gravity is located between the hind limbs, giving the animal unique movements and gestures.

Completed Drawing

Be aware of the areas of light and shadow, as well as the shadows created by striations just under the skin, and the texture of fine hairs on the surface.

Key Point

The whole muscular body is covered with short hairs. Start by tracing the large areas of shadow, and then attend to the details.

Wallabies and kangaroos have small heads and relatively large ears.

Depict the softness of the fur. Pay attention to areas of light and shadow as you draw.

The thick tail counterbalances the front half of the body.

(Red kangaroo)

The feet are very large.

The marsupium. Immediately after birth, the newborn climbs into a pouch on the mother's abdomen and remains attached to a teat in the pouch for several weeks while it grows inside. Here, the feet of a juvenile who has already matured somewhat are hanging out.

Note

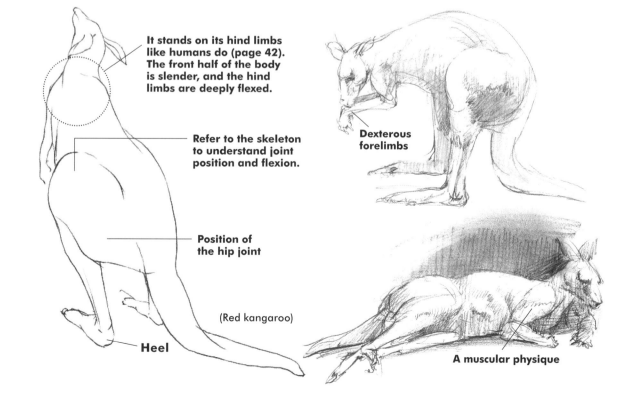

They don't just jump, they also move slowly

Kangaroos also use their fore limbs to balance themselves nicely on all four legs for short strides.

It stands on its hind limbs like humans do (page 42). The front half of the body is slender, and the hind limbs are deeply flexed.

Refer to the skeleton to understand joint position and flexion.

Dexterous forelimbs

Position of the hip joint

(Red kangaroo)

Heel

A muscular physique

Otter

(Animalia/Chordata/Vertebrata/Mammalia/Carnivora/Mustelidae/Otteridae)

The otter is good swimmer and is found near water and in the sea. Sea otters are also Otteridae.

Skeletal Diagram

The spine and tail are long and the trunk is elongated. The humerus and femur face horizontally toward the body, indicating a low center of gravity.

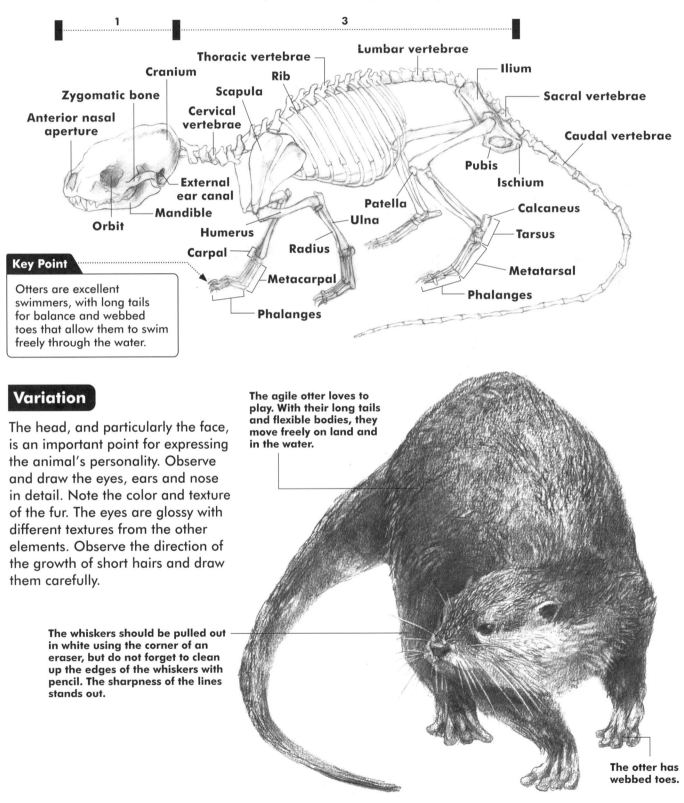

Key Point

Otters are excellent swimmers, with long tails for balance and webbed toes that allow them to swim freely through the water.

Variation

The head, and particularly the face, is an important point for expressing the animal's personality. Observe and draw the eyes, ears and nose in detail. Note the color and texture of the fur. The eyes are glossy with different textures from the other elements. Observe the direction of the growth of short hairs and draw them carefully.

The agile otter loves to play. With their long tails and flexible bodies, they move freely on land and in the water.

The whiskers should be pulled out in white using the corner of an eraser, but do not forget to clean up the edges of the whiskers with pencil. The sharpness of the lines stands out.

The otter has webbed toes.

Completed Drawing The otter has a low center of gravity, with slick, stiff hairs on the outside of the body and a dense undercoat comprised of downy hair. These repel water, which allows it to maintain its body temperature while swimming. Observe the growth direction of the fur and apply strokes that follow that growth direction.

Their noses, eyes, and ears are aligned on one plane, and they pop their heads up to peer out of the water.

The long tail makes the body appear even longer.

Key Point

Sea otters use their front limbs dexterously to break shells with stones, and otters also use their front limbs very skilfully.

Note

Observe the supple body in motion

The otter's body is flexible, moving about easily on both land and in the water. The suppleness of the figure is thanks to the number and flexibility of the individual vertebrae of the spinal column.

Despite their adorable faces, they have a ferocious side, with sharp fangs that can rip apart small mammals and fish.

It has cute round eyes, a full mouth, and small ears relatively close to its eyes. Its nose and ears can be closed underwater.

When your drawing is nearing completion, lightly rub the dark shadows with cotton gauze or similar cloth to partially blur the strokes. This creates a softening effect in the shadows and naturally leads the viewer's gaze to the face in the foreground.

Fox

(Animalia/Chordata/Vertebrata/Mammalia/Carnivora/Canidae/Vulpes)

The fox is a small member of the Canidae family and has a characteristic bushy tail. They live in family units and feed on rodents (mainly mice). It is widely distributed throughout Eurasia.

Skeletal Diagram The skeleton of the fox is similar to that of a dog (page 50). The molars are knife-like lacrimal teeth characteristic of Carnivora. It has seven cervical vertebrae and long neck and limb proportions.

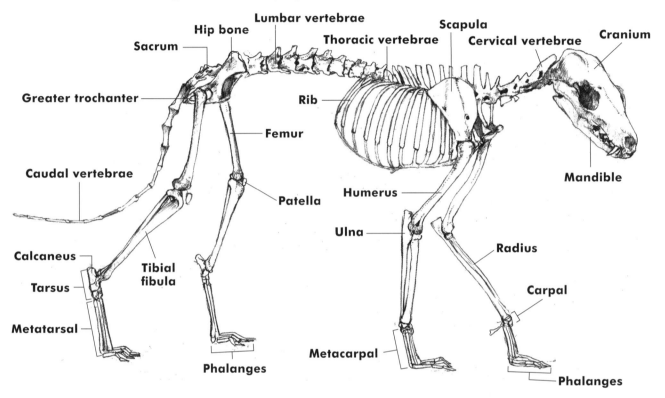

Completed Drawing Understand the differences in surface areas, such as the length of fur on the body and limbs, and differences in texture.

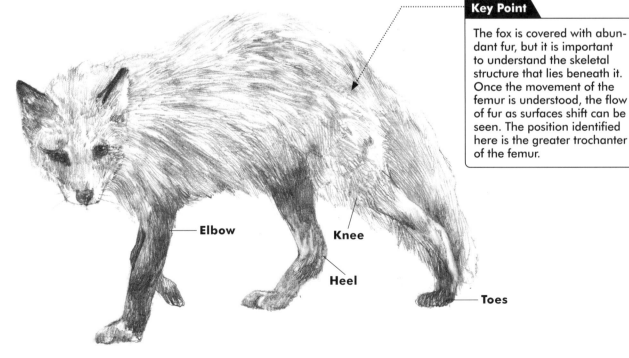

Key Point

The fox is covered with abundant fur, but it is important to understand the skeletal structure that lies beneath it. Once the movement of the femur is understood, the flow of fur as surfaces shift can be seen. The position identified here is the greater trochanter of the femur.

Variations

Observe and draw the expressive movements and gestures of foxes.

The Presence of the Fox

Traditionally, foxes were revered in Japan, where the animal has been a familiar sight since ancient times. The pupil of the fox is vertical like a cat's eye. It lives and raises its young in burrows.

Lines that mark the transition to the unseen far side are expressed faintly.

A pose where the juvenile fox can be seen from the rear.

The fox sits like a human (page 42) with its knees in this position. The feet are in contact with the ground from the heel to the toe. Carefully represent the parts that are in contact with the ground.

The body color of a fox ranges from reddish brown to yellow.

The way they leap and catch their prey makes them look a bit like cats (page 58). Pencil has been used to capture the shapes, and watercolor has been used to indicate the shading.

Bear
(Animalia/Chordata/Vertebrata/Mammalia/Carnivora/Ursidae/Ursus)

The bear is a large animal in the order Carnivora. Even the smallest species can be over 3 feet (1 meter) in length. It can stand up on its hind limbs, and is often made into an anthropomorphized cartoon character.

Skeletal Diagram Bears are plantigrade animals and walk with their entire palms (from carpals to fingertips) and their entire soles (from heels to toes) on the ground. In this aspect, they are the same as us (page 42).

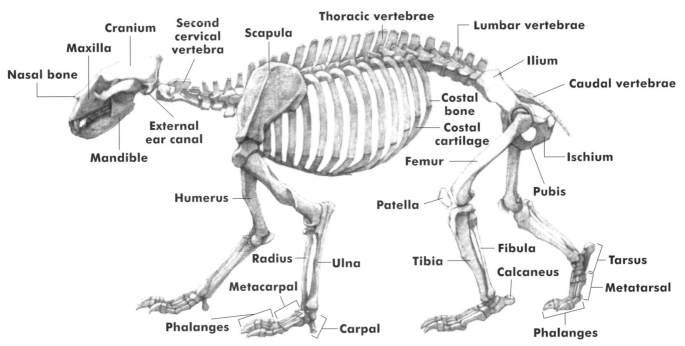

Completed Drawing Although the bear is covered with abundant fur, be aware of the position and orientation of the head, shoulder blades, shoulders, elbows and knees, where the skeletal structure is most evident. The flow of fur is expressed with strokes that capture the character of the tufts.

A Substantial Body

To express a large body and a sense of weight, it is best to layer on the pencil tones for the shading, but here the artist has tried to capture the nuances of the skeleton and fur with minimal shading.

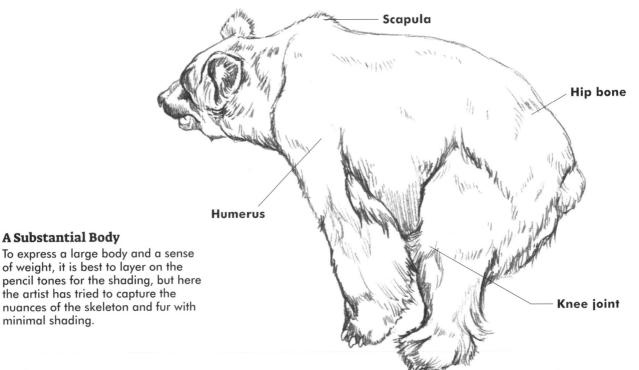

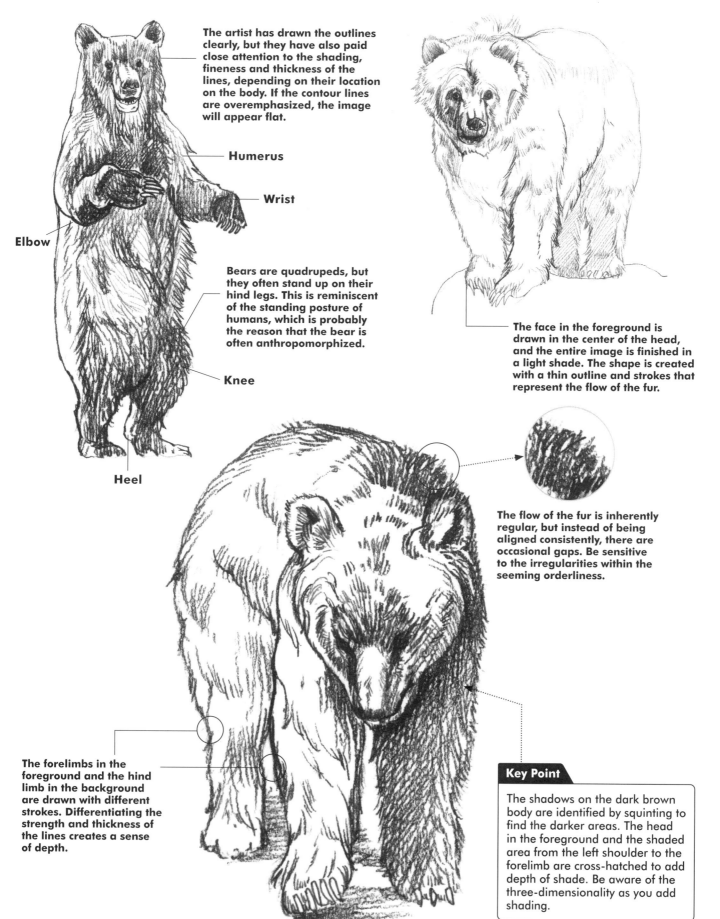

Variations Use pencil to depict the various poses of the bear, its large limbs and body, and the coarseness of its fur.

The artist has drawn the outlines clearly, but they have also paid close attention to the shading, fineness and thickness of the lines, depending on their location on the body. If the contour lines are overemphasized, the image will appear flat.

Humerus

Wrist

Elbow

Bears are quadrupeds, but they often stand up on their hind legs. This is reminiscent of the standing posture of humans, which is probably the reason that the bear is often anthropomorphized.

Knee

Heel

The face in the foreground is drawn in the center of the head, and the entire image is finished in a light shade. The shape is created with a thin outline and strokes that represent the flow of the fur.

The flow of the fur is inherently regular, but instead of being aligned consistently, there are occasional gaps. Be sensitive to the irregularities within the seeming orderliness.

The forelimbs in the foreground and the hind limb in the background are drawn with different strokes. Differentiating the strength and thickness of the lines creates a sense of depth.

Key Point

The shadows on the dark brown body are identified by squinting to find the darker areas. The head in the foreground and the shaded area from the left shoulder to the forelimb are cross-hatched to add depth of shade. Be aware of the three-dimensionality as you add shading.

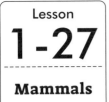

Lesson 1-27
Mammals

Panda
(Animalia/Chordata/Vertebrata/Mammalia/Carnivora/Ursidae/Ailuropoda)
The main characteristic of the giant panda is the distinct black coloring of its ears, eyes and part of its body, and the white appearance of the rest of its fur. It lives in bamboo forests in Sichuan Province, China, and prefers to eat bamboo grass.

Skeletal Diagram The hind limbs appear shorter than the forelimbs, but this is an illusion caused by the black and white fur, and both the forelimbs and hind limbs have strong bones of approximately equal length. The palm and the entire sole of the foot touch the ground, which is a characteristic of the bear family.

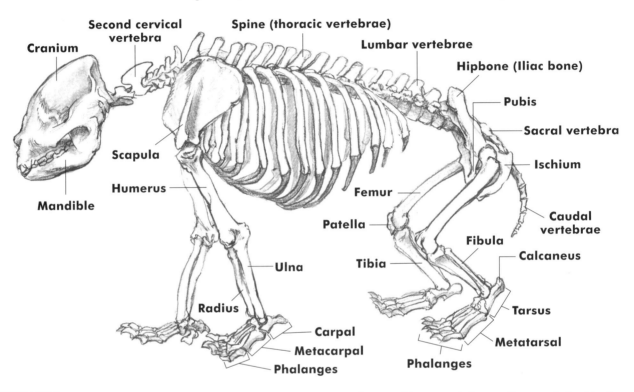

Variation Pandas often sit and make gestures similar to those of human infants. Be careful with the shading of the black fur on the body, and try to draw the animal's endearing poses.

The contrast between black and white is clear, but carefully observe the various tones within the black as you draw. This is a large 4.7×7.8-inch (119×197-mm) drawing.

The panda's forelimb was believed to have six fingers, but recently the presence of a seventh finger—the carpal bone—has been revealed. Bear paws were not originally suited for grasping things; the thumb and pinky subcarpals of the panda became enlarged through adaptation to support and hold bamboo.

(Giant panda)

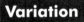

Completed Drawing

The black patches around the eyes give them an adorable appearance, but closer inspection reveals that the eyes are surprisingly small and expressive. They can actually reveal the demeanor of a bear (page 110).

(page 110)

Key Point

Pay attention to the shading of the white body fur. If the fur looks dirty because of too much shading, it is because the black fur has not been sufficiently darkened. If you use a 4B pencil to darken the black areas even further, the white areas will appear whiter. Tonal perception is relative, so be sure to analyze white areas as you apply shading.

The left scapula is sticking up.

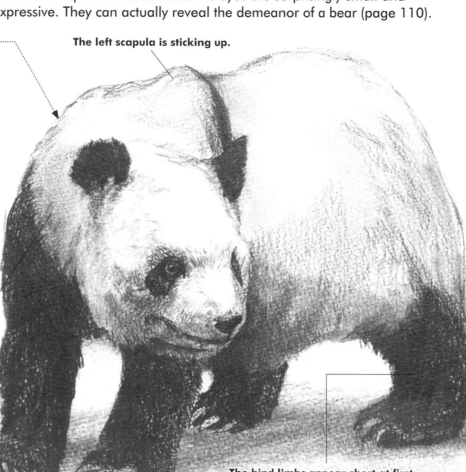

Note that even white hairs are dark in the shaded areas.

The hind limbs appear short at first glance, but they have solid, long bones. However, as far as the outward appearance is concerned, only the knee on down can be seen.

Like humans, they have plantigrade feet.

The panda's tail is white or cream-colored, not black.

With its rounded body, sitting with its hind legs outstretched, holding a bamboo stick in its hand and chewing it, the panda looks sweet, like a human toddler. Its calm and comical gestures are endearing to those who see it.

Panda feces. Undigested bamboo fibers as well as groomed hairs can be seen within it.

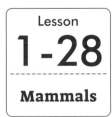

Armadillo

(Animalia/Chordata/Vertebrata/Mammalia/Xenarthra/Cingulata/Dasypodidae)
(Animalia/Chordata/Vertebrata/Mammalia/Xenarthra/Cingulata/
Chlamyphoridae)

The body of the armadillo is covered with a scaly carapace that is hair that has been transformed into scales. It is a South American animal that is sometimes used for food and can also be kept as a pet. It is characterized by a tough shell that protects its body.

Skeletal Diagram

The armadillo's skeleton consists of a cranium with a distinctive pointed proboscis and a large pelvis that supports the carapace. Its sharp claws are an important component for digging underground burrows.

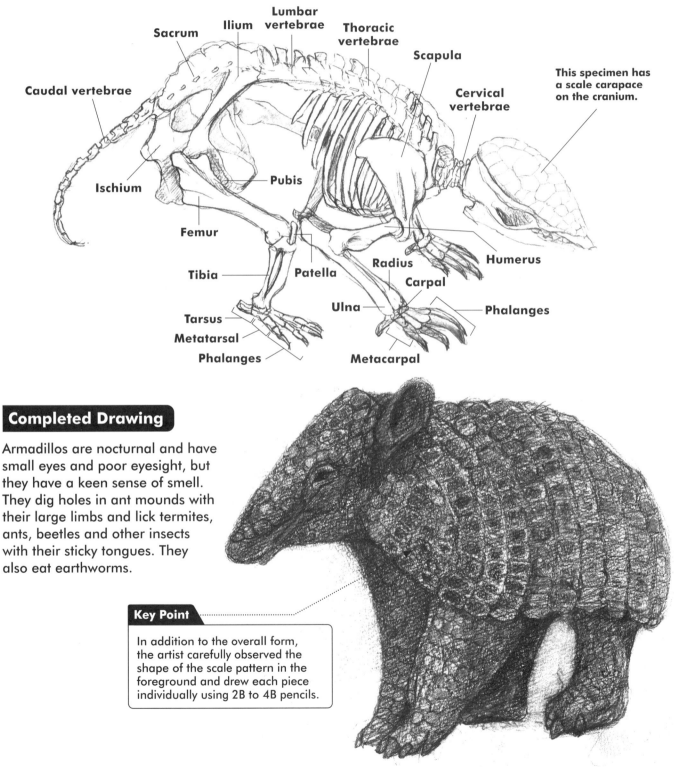

Completed Drawing

Armadillos are nocturnal and have small eyes and poor eyesight, but they have a keen sense of smell. They dig holes in ant mounds with their large limbs and lick termites, ants, beetles and other insects with their sticky tongues. They also eat earthworms.

Key Point

In addition to the overall form, the artist carefully observed the shape of the scale pattern in the foreground and drew each piece individually using 2B to 4B pencils.

Variations The most distinctive feature of the Brazilian three-banded armadillo is its defensive pose, in which it curls up like a ball when it senses danger.

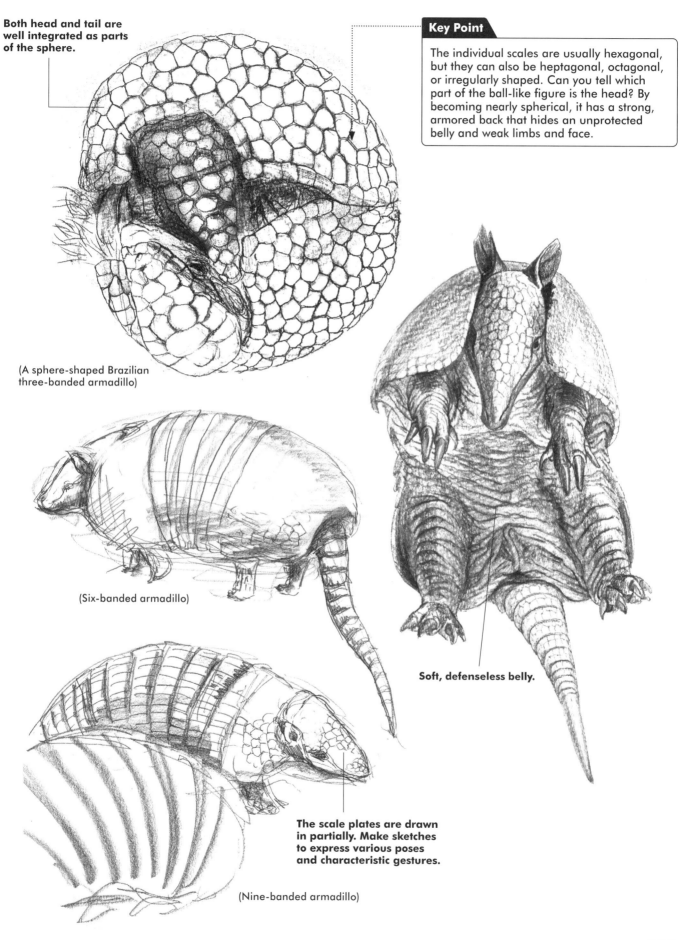

Both head and tail are well integrated as parts of the sphere.

The individual scales are usually hexagonal, but they can also be heptagonal, octagonal, or irregularly shaped. Can you tell which part of the ball-like figure is the head? By becoming nearly spherical, it has a strong, armored back that hides an unprotected belly and weak limbs and face.

(A sphere-shaped Brazilian three-banded armadillo)

(Six-banded armadillo)

Soft, defenseless belly.

The scale plates are drawn in partially. Make sketches to express various poses and characteristic gestures.

(Nine-banded armadillo)

Pangolin

(Animalia/Chordata/Vertebrata/Mammalia/Pholidota/Eupholidota/Manidae)

The body is covered with scales that have blade-like keratin edges. In China and India, the pangolin is prized for its medicinal and culinary qualities, and it is in danger of extinction.

Skeletal Diagram

Although the shape and ecology of the pangolin is similar to that of the armadillo (page 114), they live in completely different habitats and are classified in different taxonomic groups. The similarity of traits may be due to convergent evolution (i.e., animals of completely different lineages develop similar forms as a result of similar adaptations to their environments).

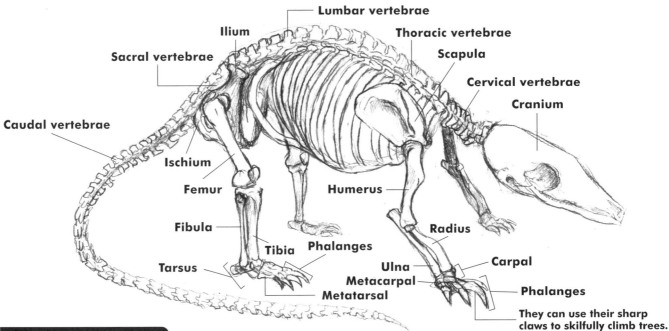

Lumbar vertebrae
Ilium
Sacral vertebrae
Thoracic vertebrae
Scapula
Cervical vertebrae
Cranium
Caudal vertebrae
Ischium
Femur
Humerus
Fibula
Radius
Tibia Phalanges
Tarsus
Ulna Carpal
Metacarpal
Metatarsal
Phalanges

They can use their sharp claws to skilfully climb trees.

Completed Drawing

Because of their long tongues and other characteristics, such as feeding on ants and termites, they were once classified as anteaters and other endentata (animals with weak teeth), but are now considered to be a group close to the Carnivora and odd-toed ungulates.

It forms a protective ball differently than an armadillo.

Key Point

The scales, which are a characteristic of the pangolin, resemble those of the artichoke plant, and each one has a three-dimensional appearance. A kneaded eraser is used to depict the areas where the highlights appear.

White areas appear to be larger than they actually are. With this illusion in mind, we will define the white area as smaller than what is seen, and the borders will be adjusted with a pencil.

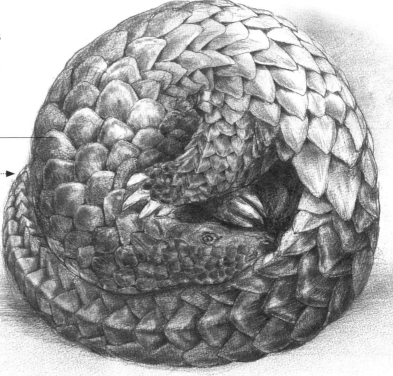

This is a pangolin curled up into a ball. Draw each scale carefully. At the same time, be aware of light and shadow so as not to lose sight of the three-dimensionality of the form.

Draw the Entire Animal

1 Draw as if depicting a sphere

Capture the overall shape and determine how it will be placed on the paper. Because it is rounded like a large ball, sketch it as if you were drawing a sphere.

Draw the Scales

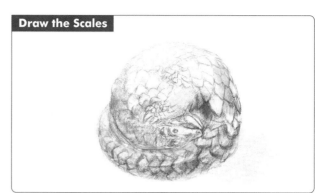

2 Trace the detailed shapes, as well as the shadows

The head, limbs and scales are drawn one by one, following their shapes and connections. With even deeper shadows in mind, shading is added with pencil on top of the image.

Draw the Details

3 Draw with the finished texture in mind

Keep moving forward by drawing in the details. Check that the head, limbs and their connections to the trunk and the whole body are working well together. In addition, draw in with an eye toward achieving the desired texture of the finished product. At the same time, make sure that you capture the spherical appearance as well.

Completed Drawing

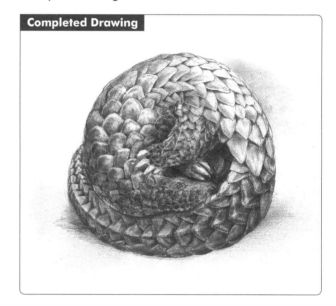

Variations

Like armadillos, pangolins adopt a defensive posture against predators by curling up into a ball. Because it has a smaller head and longer tail than the armadillo, it can hang from branches by its tail.

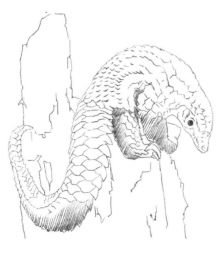

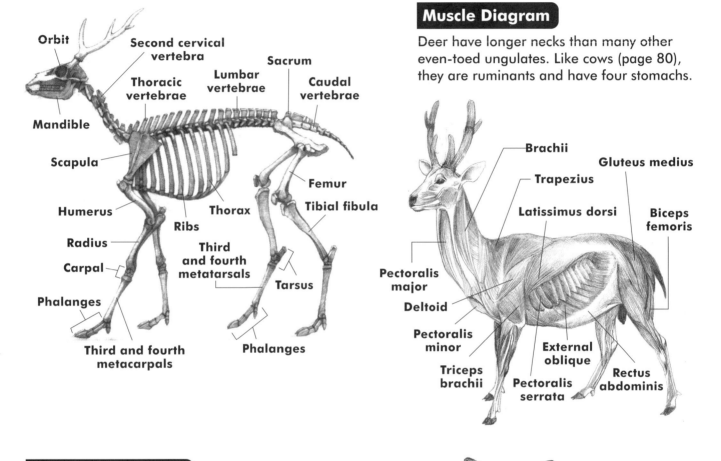

Deer

(Animalia/Chordata/Vertebrata/Mammalia/Artiodactyl/Cervidae)

In Japanese *waka* poetry, the deer is the seasonal word indicating the fall. There are many species and they are found in mountainous areas and fields all over the world. With its slender limbs and adorable face, the deer often appears in the visual arts.

Lesson 1-30 Mammals

Skeletal Diagram

The male's horns are shed in the spring, and new horns grow in their place.

Orbit
Second cervical vertebra
Thoracic vertebrae
Lumbar vertebrae
Sacrum
Caudal vertebrae
Mandible
Scapula
Femur
Tibial fibula
Humerus
Thorax
Ribs
Radius
Third and fourth metatarsals
Carpal
Tarsus
Phalanges
Phalanges
Third and fourth metacarpals

Muscle Diagram

Deer have longer necks than many other even-toed ungulates. Like cows (page 80), they are ruminants and have four stomachs.

Brachii
Gluteus medius
Trapezius
Latissimus dorsi
Biceps femoris
Pectoralis major
Deltoid
Pectoralis minor
External oblique
Rectus abdominis
Triceps brachii
Pectoralis serrata

Completed Drawing

A fawn with white spots is also called a *kanoko* in Japanese. The white spots are generally considered to be a characteristic of fawns, but these spots are often seen on adult deer as well.

Even-toed means cloven hooves. The deer stands on the tips of the third and fourth fingers.

(Japanese sika deer) (Reeves's muntjac)

PART 2

Amphibians & Reptiles

Snake

(Animalia/Chordata/Vertebrata/Reptilia/Squamata/Ophidia)

The snake has a flexible body and has lost its limbs through degeneration. They are rope-like and vary in size, with the largest being the reticulated python and anaconda, which can reach about 30-feet (10-meters) long.

Skeletal Diagram Snakes have many vertebrae and ribs, which they move in order to ambulate. The lack of a sternum also allows them to swallow prey larger than themselves.

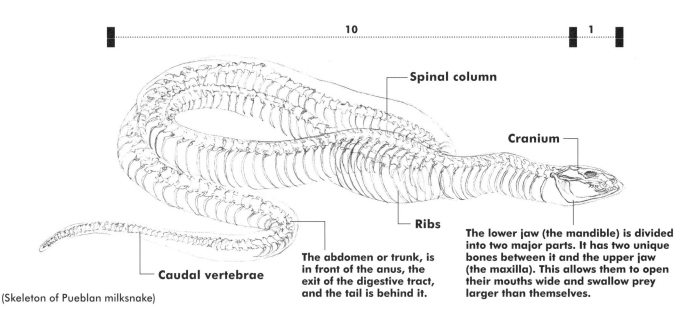

10 1

Spinal column

Cranium

Ribs

Caudal vertebrae

The abdomen or trunk, is in front of the anus, the exit of the digestive tract, and the tail is behind it.

The lower jaw (the mandible) is divided into two major parts. It has two unique bones between it and the upper jaw (the maxilla). This allows them to open their mouths wide and swallow prey larger than themselves.

(Skeleton of Pueblan milksnake)

Completed Drawing The texture of the fine scales is carefully captured while the three-dimensionality of the cylindrical body is expressed through patterns and shading. Draw the overlapping coils in a way that is not confusing.

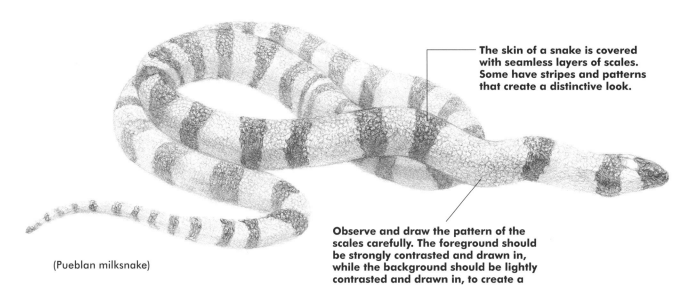

The skin of a snake is covered with seamless layers of scales. Some have stripes and patterns that create a distinctive look.

Observe and draw the pattern of the scales carefully. The foreground should be strongly contrasted and drawn in, while the background should be lightly contrasted and drawn in, to create a sense of perspective and force.

(Pueblan milksnake)

Characteristics

Draw the snake's beautiful patterns and supple body. Reptiles lack facial expressions, but the head is an important feature to observe and draw in carefully.

The feces of the snake.

Carefully portray the mesh pattern.

The head is also coated with scales. The eyes are relatively small and the pupils are long and narrow.

(Reticulated python)

Characteristic 1: Pit Organ

The pit is an indentation between the eyes and the nose that looks like a scale that is peeling off. This is an infrared-sensing organ that allows the snake to target prey even in the dark.

(Reticulated python)

Characteristic 3: The Jaw of the Snake

The two bones connecting the upper and lower jaw allow the mouth to open wide. The python is a nonvenomous snake that tightens its body in coils around its prey, asphyxiating it.

Characteristic 2: A Supple Spine

Snakes have a neck that can pivot sharply to enable them to catch their prey quickly.

Key Point

The scales of the snakes are finely and evenly arranged, resembling a geometric pattern, but the spacing and size of the scales vary slightly from small to large and back to small, exhibiting an organic characteristic. If you can capture the subtle irregularities within the regularity, it will look more natural.

(Pueblan milksnake)

Lizard

(Animalia/Chordata/Vertebrata/Reptilia/Squamata/Lacertoidea)
Lizards are widely distributed on the continents of the world, and some of them, such as the Komodo dragon, can grow up to 10 feet (3 meters) in length. In some parts of the world, lizards and geckos live in close proximity to the human population.

Skeletal Diagram The lizard has a large cranium, with the humerus and femur overhanging laterally like the legs of a table, providing stable support for the trunk.

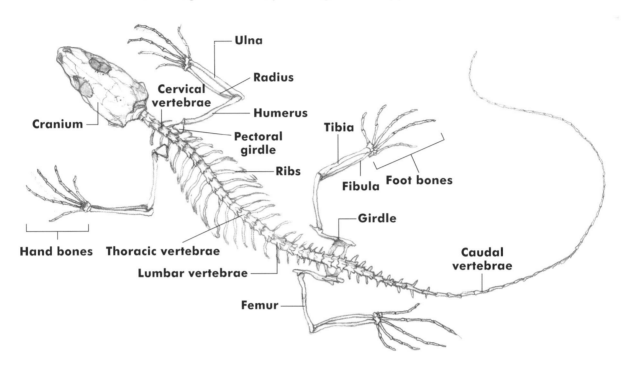

Ulna

Radius

Cervical vertebrae

Humerus

Cranium

Pectoral girdle

Tibia

Ribs

Fibula Foot bones

Girdle

Hand bones Thoracic vertebrae

Caudal vertebrae

Lumbar vertebrae

Femur

Completed Drawing The glossy texture of the scales was drawn with HB to 2B pencils. Aim to emulate a surface that gives a sense of the lizard's weight and cool body temperature. The position of the forelimbs and hind limbs is indicative of the lizard-like nature of the animal.

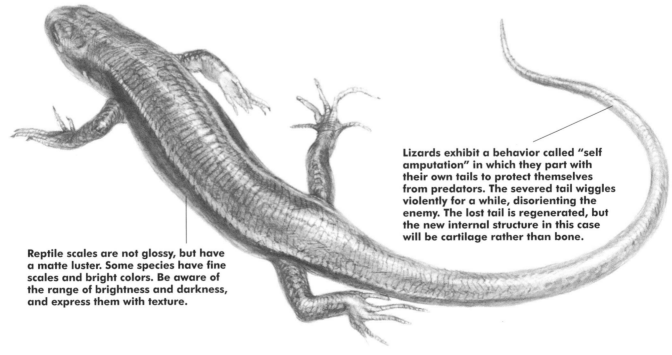

Lizards exhibit a behavior called "self amputation" in which they part with their own tails to protect themselves from predators. The severed tail wiggles violently for a while, disorienting the enemy. The lost tail is regenerated, but the new internal structure in this case will be cartilage rather than bone.

Reptile scales are not glossy, but have a matte luster. Some species have fine scales and bright colors. Be aware of the range of brightness and darkness, and express them with texture.

This lizard is characterized by its small limbs that protrude to the sides and the shape of its spinal column, which curves from side to side. Carefully observe and draw all the way to the tip of the tail.

Capture the Shape

Lay Down the Shading

Completed Drawing

1 Observe the overall shape carefully

Draw the entire shape by looking at it carefully. The thickness and density of the lines also give the lizard a sense of three-dimensionality.

2 Once the shape is established, add shading

Once you have a good grasp of the shape, start adding tone to the darker areas.

Variations

Bearded lizards are often kept as pets. Observe and draw the detailed scales as well as the expressions of the eyes and mouth.

Even if you don't draw the entire image in detail, you can express the lizard's character by drawing the key points and nuanced details.

The rounded area behind the cheek is the ear drum. The eyes are characterized by the presence of lower eyelids.

The forelimbs have five fingers and a fine skeleton, like human fingers. Pay attention to the spread of the fingers and the orientation of the claws.

The abdomen of the Australian spiny-tailed lizard is protected by ribs and is taut. The outline and slight shading are all that are required to depict it.

(Bearded lizard)

Turtle

(Animalia/Chordata/Vertebrata/Reptilia/Testudinata)

A turtle can retract its head and limbs into its shell. There are many species in Japan, where they are a symbol of longevity. They are also kept as pets and inhabit a wide variety of environments.

Skeletal Diagram

The spine is formed in accordance with the carapace (the shell), particularly the thoracic spine, which is arched along the carapace.

The Shell is a Rib

It is now known that the turtle's carapace (shell) is an adapted rib.

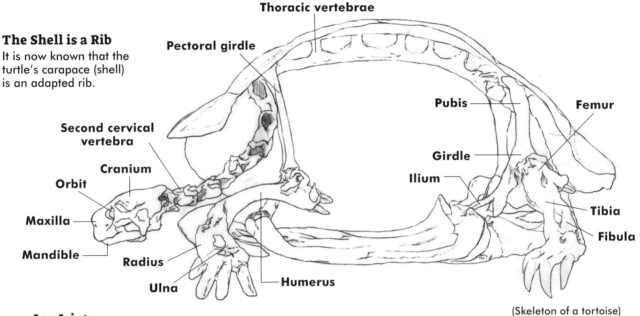

(Skeleton of a tortoise)

Leg Joints

The tail and limbs can be retracted into the shell. As for the head, there are two types: one that is pulled into the shell and one that is tucked into the side of the shell.

Completed Drawing

The carapace rises like a mountain, the head and neck are key points, and the fore and hind limbs support the considerable body weight. This image is drawn from a turtle's vantage point. Be aware of the texture of the leathery skin, its thickness, and how it drapes in heavy folds.

(Tortoise)

Drawing Procedure

Draw the shell, head and neck, and forelimbs with increased density and detail. Be aware of the midline* of the shell. It has a symmetrical pattern.

*Midline: A line running vertically down the center of the front and back of a symmetrical creature.

Draw the Shape

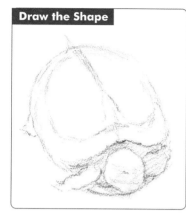

1 Observe the overall balance and sketch out the shapes

Determine how the image will be placed on the paper, the orientation in which you want to pose the subject, and the overall balance of the image and create an outline. Capture the overall shape and be aware of the midline.

Key Point

The shell pattern is literally the origin of the term "tortoiseshell." The shape of the pattern is different between the center and the edges, so observe carefully. Be aware of the expression of fine patterns and textures, and the sense of three-dimensionality.

Completed Drawing

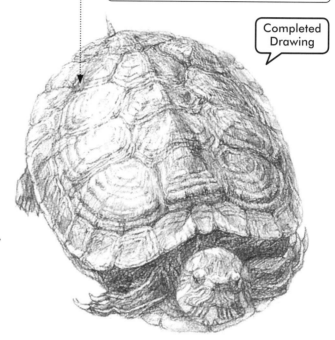

Add the Shading

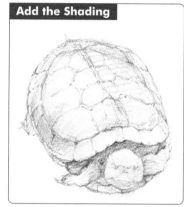

2 Apply tones with shading in mind

Draw the pattern on the shell. Squint your eyes and gradually apply more and more shading, starting from the darkest areas. The detail in the foreground is important, so observe and draw carefully.

Variations

Turtles move slowly, so observe them carefully and draw them in various poses.

Stretching the neck—a movement that turtles often do.

Large turtles walking leisurely with their heavy shells on their backs is a sight to behold.

(Tortoise)

The front flippers of sea turtles contain hand bones, and their back flippers have proper foot bones. Although we need to refer to photographs of sea turtles swimming, we can still depict their lively movements.

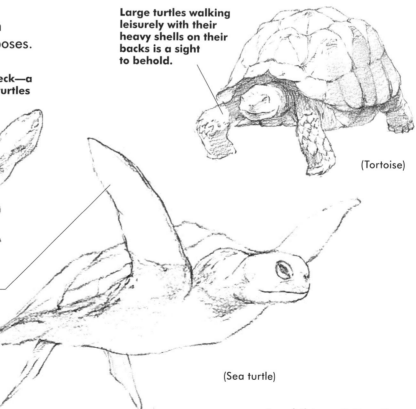

(Sea turtle)

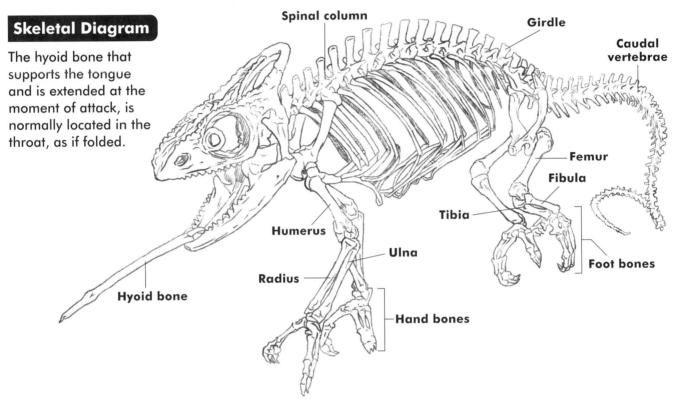

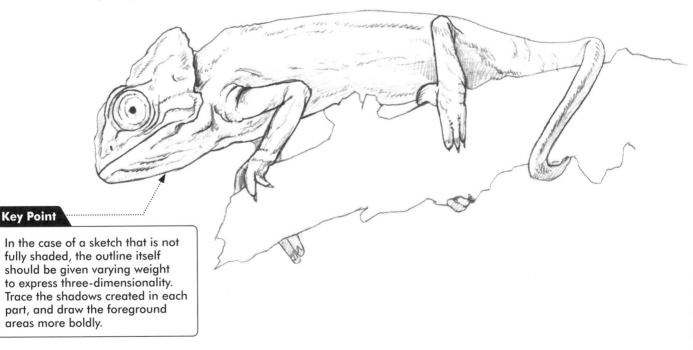

Chameleon

(Animalia/Chordata/Vertebrata/Reptilia/Squamata/Iguania/Chamaeleonidae)

Chameleons are mainly found in African and Eurasian forests, and the most famous species are those that change their green body colors to mimic their surroundings. They move their eyes separately to the left and right, and their long tongues protrude to snare their prey.

Skeletal Diagram

The hyoid bone that supports the tongue and is extended at the moment of attack, is normally located in the throat, as if folded.

Spinal column

Girdle

Caudal vertebrae

Femur

Fibula

Tibia

Foot bones

Hyoid bone

Humerus

Ulna

Radius

Hand bones

Variation

The chameleon is unique in that it has left and right eyes that can move 360° separately, and limbs that terminate with two and three fingers like mittens (two-fingered gloves) to grasp branches. In addition, the tongue is covered with a sticky substance and can be quickly extended to seize prey.

Key Point

In the case of a sketch that is not fully shaded, the outline itself should be given varying weight to express three-dimensionality. Trace the shadows created in each part, and draw the foreground areas more boldly.

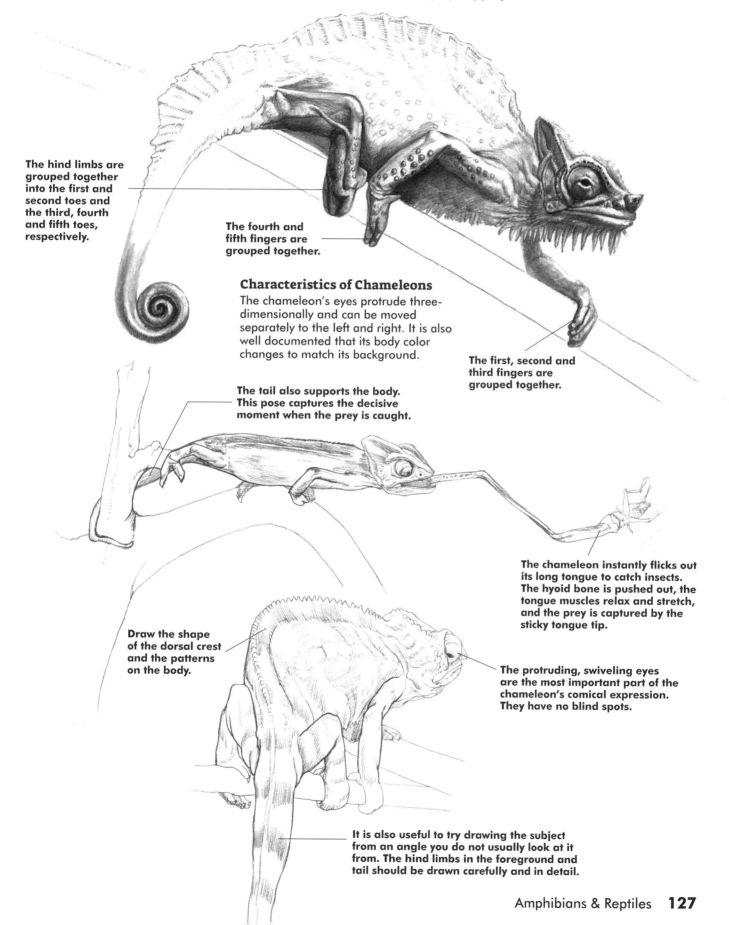

Completed Drawing Chameleons have five fingers or five toes at the end of each limb, with two and three fingers grouped together, but the fingers that are grouped together differ between the forelimbs and hind limbs. They firmly grasp branches with widely separated fingers and toes. The hooked ends of the toes have claws that can be used to support the body by digging into the branch.

The hind limbs are grouped together into the first and second toes and the third, fourth and fifth toes, respectively.

The fourth and fifth fingers are grouped together.

Characteristics of Chameleons
The chameleon's eyes protrude three-dimensionally and can be moved separately to the left and right. It is also well documented that its body color changes to match its background.

The first, second and third fingers are grouped together.

The tail also supports the body. This pose captures the decisive moment when the prey is caught.

The chameleon instantly flicks out its long tongue to catch insects. The hyoid bone is pushed out, the tongue muscles relax and stretch, and the prey is captured by the sticky tongue tip.

Draw the shape of the dorsal crest and the patterns on the body.

The protruding, swiveling eyes are the most important part of the chameleon's comical expression. They have no blind spots.

It is also useful to try drawing the subject from an angle you do not usually look at it from. The hind limbs in the foreground and tail should be drawn carefully and in detail.

Frog
(Animalia/Chordata/Vertebrata/Amphibia/Anura)

Although they are terrestrial creatures, they are called amphibians because they require a body of water to live in while in the juvenile stage, and later they spawn in water as well. They are excellent jumpers, have webs between their fingers and toes, and are good swimmers.

Skeletal Diagram

Frogs have long hind limbs with excellent jumping ability. This can be ascertained from the skeletal diagram.

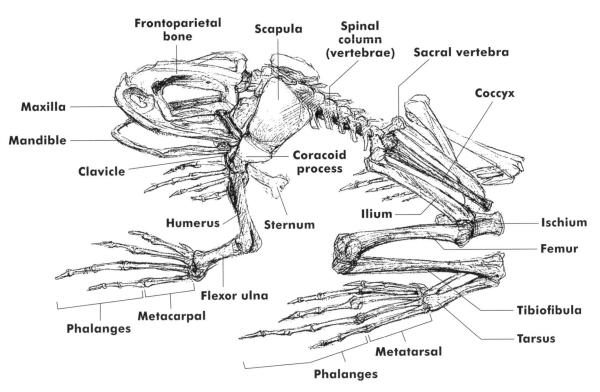

Frontoparietal bone — Scapula — Spinal column (vertebrae) — Sacral vertebra — Coccyx — Maxilla — Mandible — Clavicle — Coracoid process — Ilium — Ischium — Femur — Humerus — Sternum — Flexor ulna — Phalanges — Metacarpal — Tibiofibula — Tarsus — Metatarsal — Phalanges

Completed Drawing

When viewed from the front, the frog has a comical expression. The distance between the eyes and the large, long cleft mouth* creates the defining frog-like appearance.

* Cleft mouth: cleft consisting of the upper and lower lips

A Charming Expression

Here, the frog is puffing up its vocal sac* in its oral cavity. When drawn from the front, the impression of human facial expressions is projected on the frog and forms an amusing image.

* Vocal sac: soft skin pouch on either side of the throat of male frogs that swells when they croak.

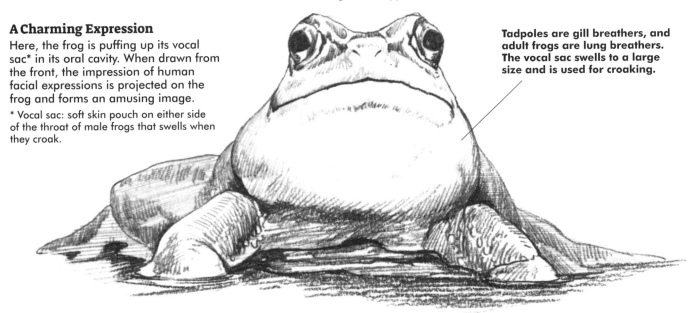

Tadpoles are gill breathers, and adult frogs are lung breathers. The vocal sac swells to a large size and is used for croaking.

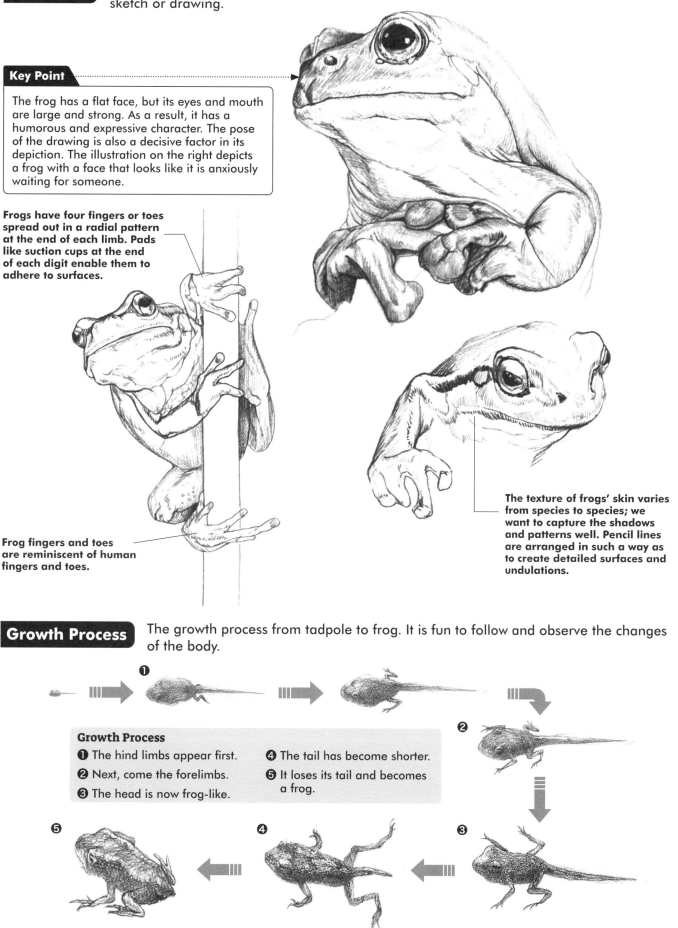

Variations The gestures of the limbs and the orientation of the face can be used to create a compelling sketch or drawing.

Key Point

The frog has a flat face, but its eyes and mouth are large and strong. As a result, it has a humorous and expressive character. The pose of the drawing is also a decisive factor in its depiction. The illustration on the right depicts a frog with a face that looks like it is anxiously waiting for someone.

Frogs have four fingers or toes spread out in a radial pattern at the end of each limb. Pads like suction cups at the end of each digit enable them to adhere to surfaces.

Frog fingers and toes are reminiscent of human fingers and toes.

The texture of frogs' skin varies from species to species; we want to capture the shadows and patterns well. Pencil lines are arranged in such a way as to create detailed surfaces and undulations.

Growth Process The growth process from tadpole to frog. It is fun to follow and observe the changes of the body.

Growth Process
❶ The hind limbs appear first.
❷ Next, come the forelimbs.
❸ The head is now frog-like.
❹ The tail has become shorter.
❺ It loses its tail and becomes a frog.

Giant Salamander

(Animalia/Chordata/Vertebrata/Amphibia/Cryptobranchidae)

The giant salamander is the world's largest amphibian, only inhabiting the streams and shallows of rivers in Japan. They can live for 40 to 50 years. Some grow to be over 3 feet (1 meter) long.

Skeletal Diagram

The giant salamander is characterized by ribs that line the back of the body, and a large cranium. There are bones all the way to the end of its flat tail.

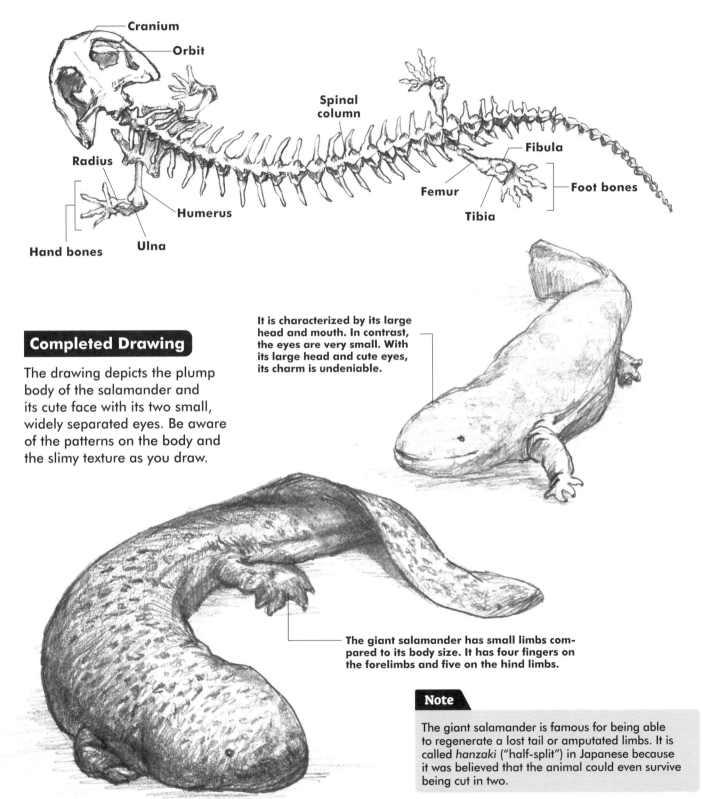

Cranium

Orbit

Spinal column

Fibula

Radius

Femur

Foot bones

Humerus

Tibia

Hand bones

Ulna

Completed Drawing

The drawing depicts the plump body of the salamander and its cute face with its two small, widely separated eyes. Be aware of the patterns on the body and the slimy texture as you draw.

It is characterized by its large head and mouth. In contrast, the eyes are very small. With its large head and cute eyes, its charm is undeniable.

The giant salamander has small limbs compared to its body size. It has four fingers on the forelimbs and five on the hind limbs.

Note

The giant salamander is famous for being able to regenerate a lost tail or amputated limbs. It is called *hanzaki* ("half-split") in Japanese because it was believed that the animal could even survive being cut in two.

Aquatic & Waterside Animals

Crocodile and Alligator

(Animalia/Chordata/Vertebrata/Reptilia/Crocodilia)

The alligator and crocodile prefer tropical and subtropical waters. Crocodilians are divided into three families—Crocodylidae, Alligatoridae and Gavialidae—and possess prehistoric characteristics.

Skeletal Diagram The large cranium facilitates a very strong bite, while on the other hand, the muscles for opening the jaw up are relatively weak. Another characteristic feature is the humerus and femur, which extend horizontally to the sides. In the water, the paddle-like tail churns from side to side to provide propulsion.

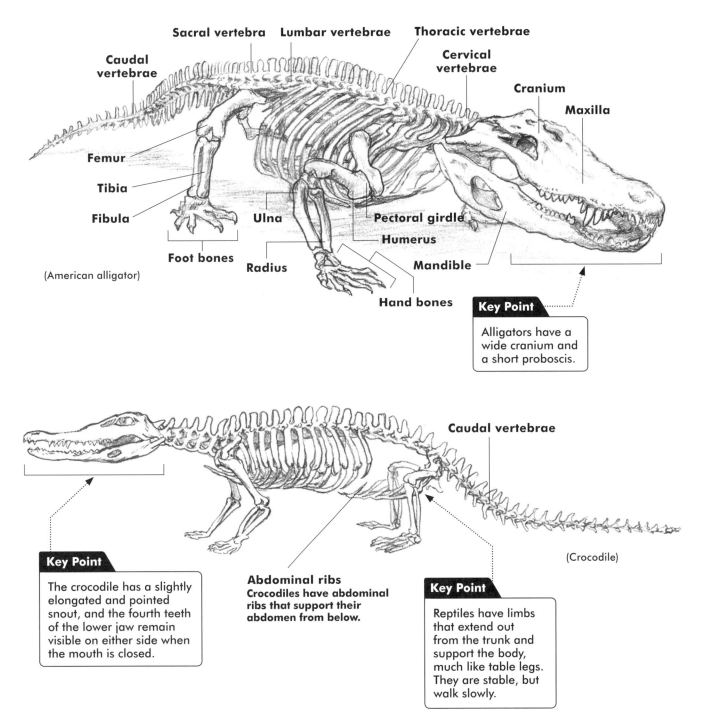

Sacral vertebra Lumbar vertebrae Thoracic vertebrae

Caudal vertebrae

Cervical vertebrae

Cranium

Maxilla

Femur

Tibia

Fibula

Ulna

Pectoral girdle

Humerus

Foot bones

Radius

Mandible

Hand bones

(American alligator)

Key Point

Alligators have a wide cranium and a short proboscis.

Caudal vertebrae

(Crocodile)

Key Point

The crocodile has a slightly elongated and pointed snout, and the fourth teeth of the lower jaw remain visible on either side when the mouth is closed.

Abdominal ribs
Crocodiles have abdominal ribs that support their abdomen from below.

Key Point

Reptiles have limbs that extend out from the trunk and support the body, much like table legs. They are stable, but walk slowly.

Completed Drawing Crocodiles and alligators often stay on their bellies. The patterns and the lumpy, characteristic texture of the hide are expressed by making good use of the bumpy texture of the drawing paper.

Living Mainly By Water

Crocodiles and alligators live in groups, mostly near water. They may move onto land, but they never stray far from the water's edge. Although they appear clumsy and sluggish on land, they are agile swimmers in the water and are the apex freshwater predator.

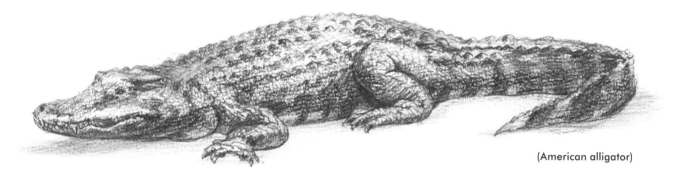

(American alligator)

Variations Sketch the crocodile or alligator from different angles. If you understand the structure of the body, you can grasp a sense of three-dimensionality.

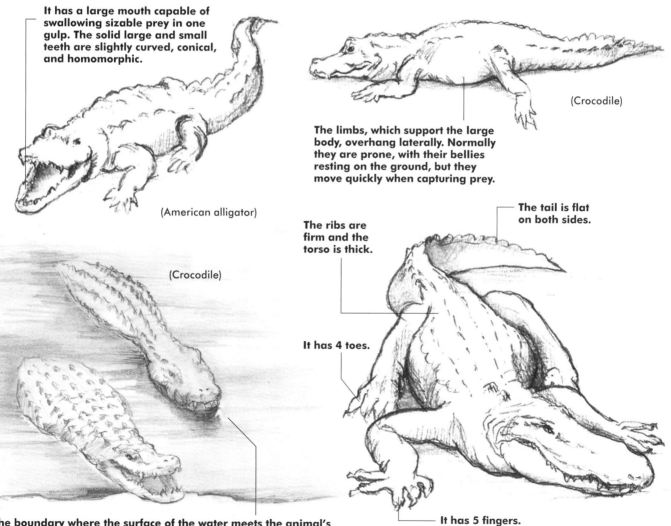

It has a large mouth capable of swallowing sizable prey in one gulp. The solid large and small teeth are slightly curved, conical, and homomorphic.

(American alligator)

(Crocodile)

The limbs, which support the large body, overhang laterally. Normally they are prone, with their bellies resting on the ground, but they move quickly when capturing prey.

The ribs are firm and the torso is thick.

It has 4 toes.

The tail is flat on both sides.

It has 5 fingers.

(Crocodile)

The boundary where the surface of the water meets the animal's body alternates between being defined and invisible. It is important to carefully observe how water interacts with the body. Also note that the weight and width of the lines vary depending upon whether the foreground or background is being depicted.

(American alligator)

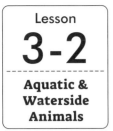

Lesson

3-2

Aquatic &
Waterside
Animals

Koi

(Animalia/Chordata/Vertebrata/Cypriniformes/Cyprinidae)

Since ancient times, this freshwater carp bred naturally in Japanese rivers. Ornamental carp, also known as "swimming jewels," have beautiful colors.

Skeletal Diagram

Fish have fine ribs and move their spinal column from side to side, allowing them to swim freely through the water. The head has a large cranium. Why not take a closer look when you encounter a whole cooked fish?

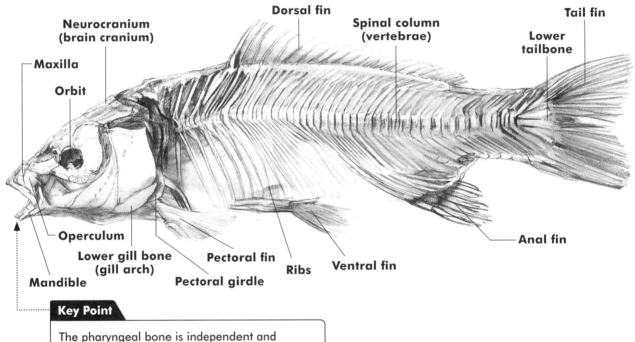

Neurocranium (brain cranium)

Maxilla

Orbit

Dorsal fin

Spinal column (vertebrae)

Tail fin

Lower tailbone

Operculum

Mandible

Lower gill bone (gill arch)

Pectoral girdle

Pectoral fin

Ribs

Ventral fin

Anal fin

Key Point

The pharyngeal bone is independent and supported by the surrounding muscles. Although koi have few teeth, they have a strong bite.

Completed Drawing

The body surface is covered with scales, and the dorsal and caudal fins are soft and delicately textured. The head has no scales and has a hard texture.

Koi Carp

Since ancient times, Japan has had a tradition of raising carp for ornamental purposes. Nishikigoi is one of the types that will tempt you to add color with watercolor paints.

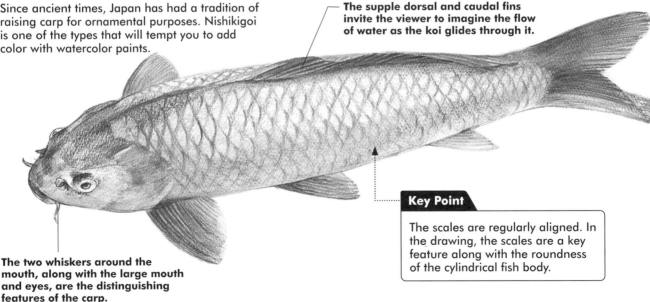

The supple dorsal and caudal fins invite the viewer to imagine the flow of water as the koi glides through it.

Key Point

The scales are regularly aligned. In the drawing, the scales are a key feature along with the roundness of the cylindrical fish body.

The two whiskers around the mouth, along with the large mouth and eyes, are the distinguishing features of the carp.

Variations The details around the face, such as the eyes, mouth and whiskers, as well as the dorsal fins and scales visible in the foreground, can be depicted to tighten up the drawing.

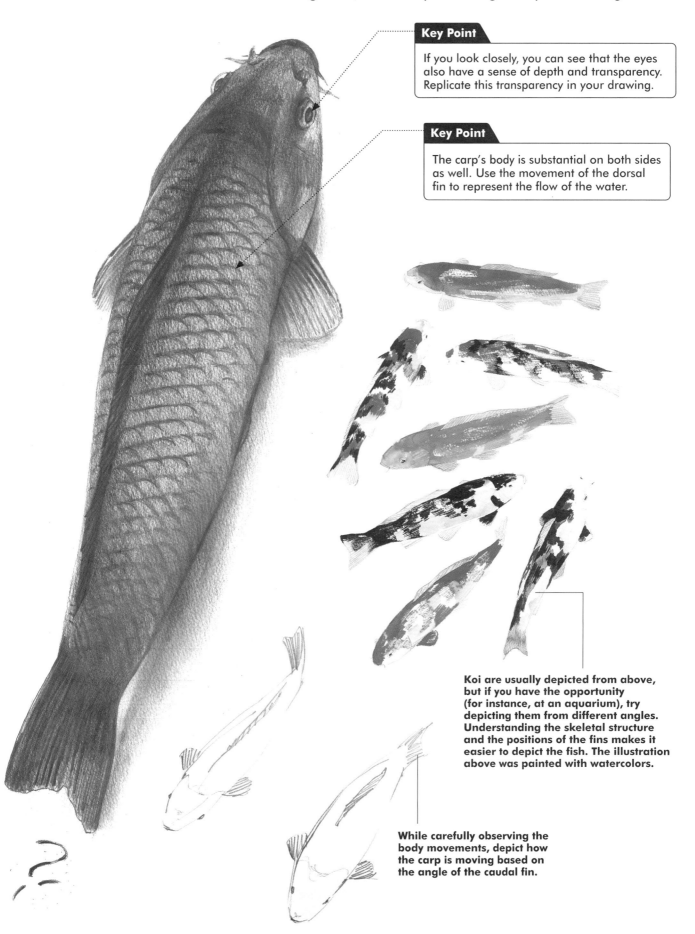

Key Point

If you look closely, you can see that the eyes also have a sense of depth and transparency. Replicate this transparency in your drawing.

Key Point

The carp's body is substantial on both sides as well. Use the movement of the dorsal fin to represent the flow of the water.

Koi are usually depicted from above, but if you have the opportunity (for instance, at an aquarium), try depicting them from different angles. Understanding the skeletal structure and the positions of the fins makes it easier to depict the fish. The illustration above was painted with watercolors.

While carefully observing the body movements, depict how the carp is moving based on the angle of the caudal fin.

Octopus and Squid

(Animalia/Mollusca/Cephalopoda/Octopoda)
(Animalia/Mollusca/Cephalopoda/Decapodiformes)

The octopus and squid are mollusks that live in the sea. They have no bones. The octopus has eight arms, while the squid has ten. Both animals have suckers on their arms.

Completed Drawing (Squid)

Use pencils to express the unique texture of the slight transparency of a live squid with its taut flesh. Try to create a sense of transparency with the expression of the subtle patterns.

Expressing a Sense of Dynamism
Even if it is not a giant squid, the squid projects a sense of cohesive mass as it swims with its legs together. Make the baluster-shaped body semi-transparent to express its lively appearance underwater.

The swimming arms are opaque and are shaded.

This illustration is depicted with the light coming from above. Express the transparency of the fins.

(A swimming squid)

Variation (Squid)

Cuttlefish swim in a lively way, undulating their fins dynamically. The eyeballs are also clear and shining. These are the parts you'll want to pay special attention to.

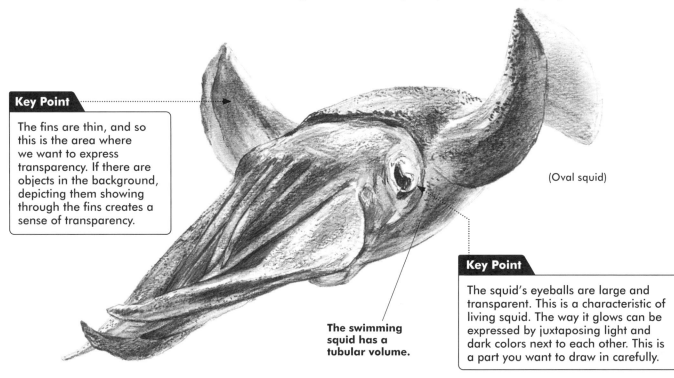

Key Point

The fins are thin, and so this is the area where we want to express transparency. If there are objects in the background, depicting them showing through the fins creates a sense of transparency.

(Oval squid)

The swimming squid has a tubular volume.

Key Point

The squid's eyeballs are large and transparent. This is a characteristic of living squid. The way it glows can be expressed by juxtaposing light and dark colors next to each other. This is a part you want to draw in carefully.

Completed Drawing (Octopus)

An important point to consider when drawing is the texture of the body surface. Be aware of the flow of the pencil line.

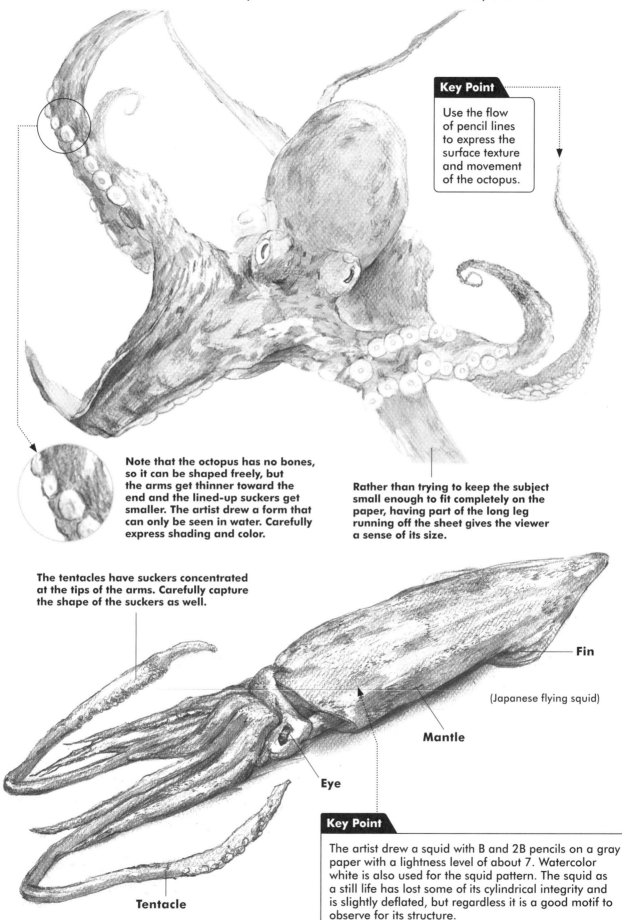

Key Point

Use the flow of pencil lines to express the surface texture and movement of the octopus.

Note that the octopus has no bones, so it can be shaped freely, but the arms get thinner toward the end and the lined-up suckers get smaller. The artist drew a form that can only be seen in water. Carefully express shading and color.

Rather than trying to keep the subject small enough to fit completely on the paper, having part of the long leg running off the sheet gives the viewer a sense of its size.

The tentacles have suckers concentrated at the tips of the arms. Carefully capture the shape of the suckers as well.

Fin

(Japanese flying squid)

Mantle

Eye

Tentacle

Key Point

The artist drew a squid with B and 2B pencils on a gray paper with a lightness level of about 7. Watercolor white is also used for the squid pattern. The squid as a still life has lost some of its cylindrical integrity and is slightly deflated, but regardless it is a good motif to observe for its structure.

Aquatic & Waterside Animals **137**

Dolphin
(Animalia/Chordata/Vertebrata/Mammalia/Cetacea/Odontoceti)

Dolphins, beloved by aquarium visitors, are intelligent and friendly. Biologically, they are considered small cetaceans.

Skeletal Diagram

The dolphin is characterized by a large cranium and a spine that run the length of the body. Their ribs are also large, and the forelimbs of dolphins have evolved into forms that serve as fins to equip them for life in the sea.

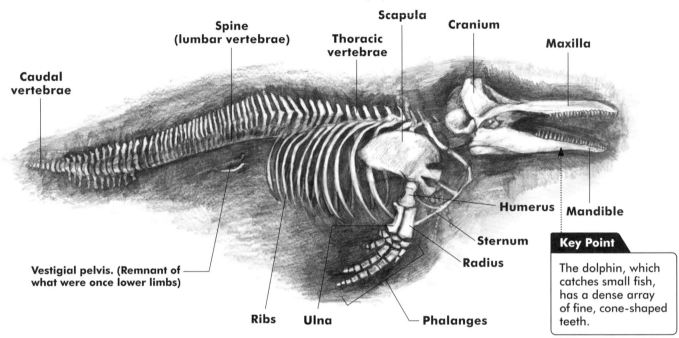

Spine (lumbar vertebrae)

Scapula

Cranium

Thoracic vertebrae

Maxilla

Caudal vertebrae

Humerus

Mandible

Sternum

Radius

Vestigial pelvis. (Remnant of what were once lower limbs)

Ribs

Ulna

Phalanges

Key Point

The dolphin, which catches small fish, has a dense array of fine, cone-shaped teeth.

Variation

Draw the dolphin's expressive face with its eyes, mouth, and various curving surfaces.

Dolphins are friendly and show a range of expressions.

A Ready-made Cartoon Character

Dolphins are easy to turn into whimsical characters. The cleft mouth (page 128) is raised at the left and right corners, giving the impression of a smile. The movements of the fins, along with the head, are also an expressive part of depicting this animal.

Completed Drawing The glossy, dark skin is delicately shaded with pencil. Draw it so that is appears supple but still allows the viewer to imagine the movement of the skeleton.

Echolocation

The dolphin's round head is not formed from bone, but rather from an organ called a "melon" that emits ultrasonic waves that provide sonar feedback enabling the dolphin to avoid obstacles and find schools of fish. Compare the dolphin's head against the cranium in the skeletal diagram.

The nostrils (*fumaroles*) are located at the top of the head and are used for breathing.

Key Point

A jumping dolphin is one of the most popular ways to depict dolphins. Note that, unlike fish, the body curves ventrally and dorsally. This curving is characteristic of mammals.

The head and the fins in the foreground are drawn with heavier lines, creating a sense of perspective.

Key Point

The body surfaces of mammals that live in the water, including dolphins, are shiny and taut, with no body hair. This illustration is drawn with HB and B pencils.

Key Point

When dolphins swim, their streamlined form reduces water resistance. Be sure to depict the beautiful rounded shape faithfully.

Harbor Seal and Fur Seal

(Animalia/Chordata/Vertebrata/Mammalia/Carnivora/Pinnipedia/Phocidae)
(Animalia/Chordata/Vertebrata/Mammalia/Carnivora/Pinnipedia/Otariidae)

These seals are marine mammals, widely distributed throughout the world. In German, the word for seal means "dog of the sea," and the word for fur seal means "bear of the sea." They eat fish and squid.

Skeletal Diagram

From the cervical spine to the lumbar spine, the seal's spinal column has a great deal of curvature, giving it a baluster-shaped body suitable for swimming in the sea.

They have bones to the tips of the fingers and toes

In fur seals, the forelimbs are shaped like fins and the front half of the body can be raised. The limbs are finned along the caudal vertebrae, but the limb bones are all well-developed, even down to the fingertip bones.

The skeleton shows strong forelimbs that are capable of raising the body, while the hind limbs are used like fins.

The bones of the toes of the foot are long and thin.

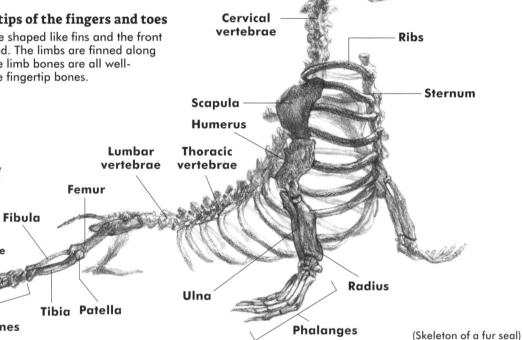

Labels: Orbit · Cranium · Cervical vertebrae · Ribs · Sternum · Scapula · Humerus · Lumbar vertebrae · Thoracic vertebrae · Femur · Fibula · Ulna · Radius · Tibia · Patella · Foot bones · Phalanges

(Skeleton of a fur seal)

Drawing Procedure

Here, various forms of seals have been drawn on a single sheet. The number and poses of the animals are determined from the sketches that have been prepared. Get a grasp on the overall silhouette, add shading, and draw in a little at a time. Reflections of light from the ground can create a sense of volume and texture.

Grasp the Overall Shapes

1 Decide on the composition and trace the shapes

Observe carefully and trace the outlines of the bodies. If the shapes are not correct, correct them and add three-dimensionality.

Layer on the Shading

2 After drawing the details of the forms, fill in the tones

The head and fins, as well as the leopard-like spots on the body, are key points. The shapes are carefully followed, and once formed, the shading is layered on with pencil.

Completed Drawing Seals are carnivores like dogs and cats. Their streamlined bodies, along with their finned limbs, show a convergence* toward marine animals with low water resistance. The hind limbs extend backward and are fin-like.

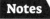

Notes

Characteristics of seals and how to draw them

❶ Sea lions and fur seals can raise the front half of their bodies using their forelimbs for support, but seals cannot.

❷ The spine is flexible vertically and horizontally.

❸ The ears form small indentations behind the eyes.

❹ The hooked claws on the forelimbs are characteristic of seals. The tones were painted on the drawing with watercolor. They were superimposed on the shading and the leopard-spot pattern.

❺ Seals swim quickly, like torpedoes in the water, making full use of the horizontally and vertically curving movements of the spinal column.

❻ Look carefully at the relationship between the baluster-shaped forms and the surface that they are in contact with as you depict the animals.

❼ All the individual animals should be drawn boldly, with the sharpest details in the foreground.

* Convergence: a phenomenon in which organisms from different lineages evolve toward having very similar traits.

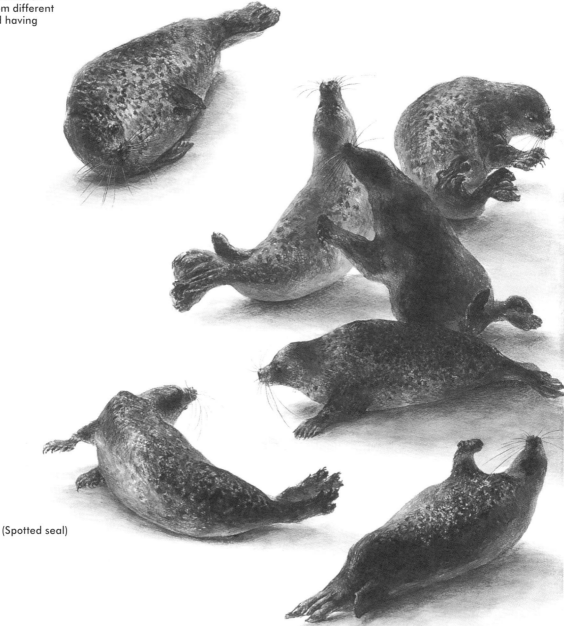

(Spotted seal)

Penguin
(Animalia/Chordata/Vertebrata/Aves/Sphenisciformes/Spheniscidae)

Outside of zoos, penguins are found in the colder climes of the Southern Hemisphere, and because of their waddling gait they are often inspiration for cartoon characters. In Antarctica, there are the emperor penguin and the Adelie penguin.

Skeletal Diagram

The portions of the hind limbs that are outwardly visible are short because the long femur and tibiotarsal bones are hidden.

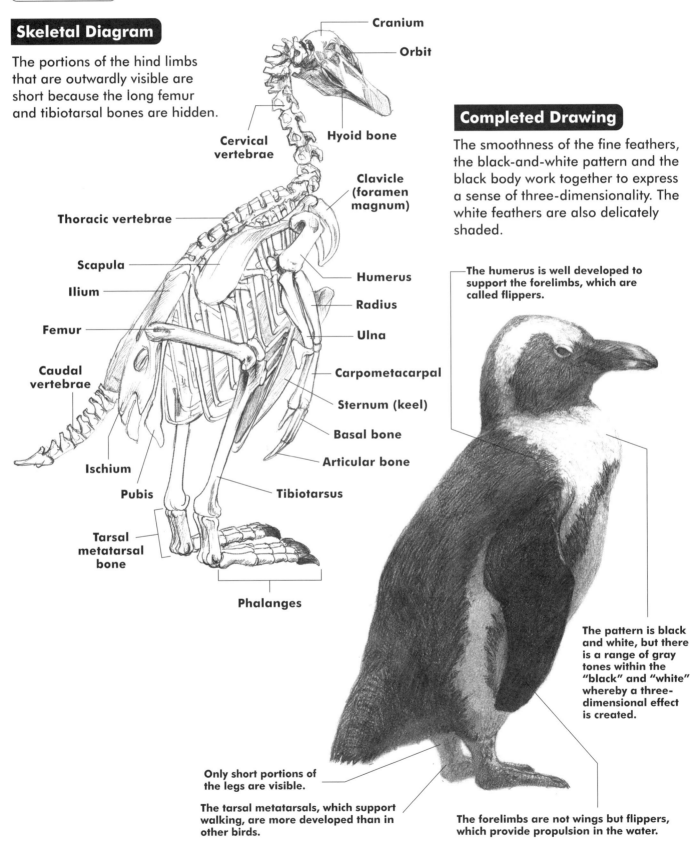

Cranium

Orbit

Hyoid bone

Cervical vertebrae

Thoracic vertebrae

Scapula

Ilium

Femur

Caudal vertebrae

Ischium

Pubis

Tarsal metatarsal bone

Phalanges

Clavicle (foramen magnum)

Humerus

Radius

Ulna

Carpometacarpal

Sternum (keel)

Basal bone

Articular bone

Tibiotarsus

Completed Drawing

The smoothness of the fine feathers, the black-and-white pattern and the black body work together to express a sense of three-dimensionality. The white feathers are also delicately shaded.

The humerus is well developed to support the forelimbs, which are called flippers.

The pattern is black and white, but there is a range of gray tones within the "black" and "white" whereby a three-dimensional effect is created.

Only short portions of the legs are visible.

The tarsal metatarsals, which support walking, are more developed than in other birds.

The forelimbs are not wings but flippers, which provide propulsion in the water.

Variations Sketch penguins in their various adorable poses, such as when they crawl on their stomachs instead of walking and when they are sliding on the snow.

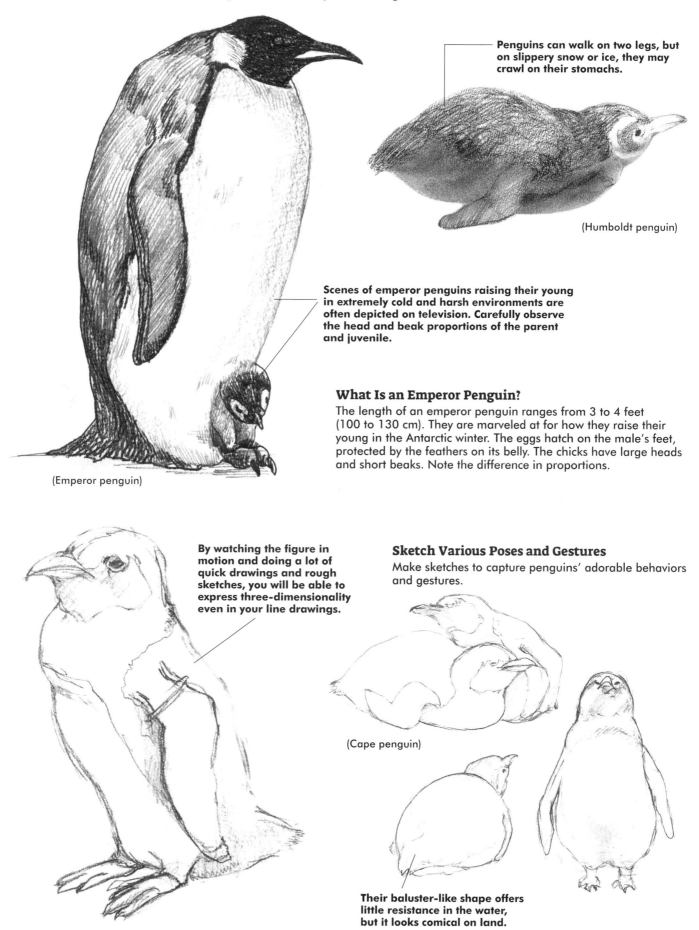

Penguins can walk on two legs, but on slippery snow or ice, they may crawl on their stomachs.

(Humboldt penguin)

Scenes of emperor penguins raising their young in extremely cold and harsh environments are often depicted on television. Carefully observe the head and beak proportions of the parent and juvenile.

What Is an Emperor Penguin?

The length of an emperor penguin ranges from 3 to 4 feet (100 to 130 cm). They are marveled at for how they raise their young in the Antarctic winter. The eggs hatch on the male's feet, protected by the feathers on its belly. The chicks have large heads and short beaks. Note the difference in proportions.

(Emperor penguin)

By watching the figure in motion and doing a lot of quick drawings and rough sketches, you will be able to express three-dimensionality even in your line drawings.

Sketch Various Poses and Gestures

Make sketches to capture penguins' adorable behaviors and gestures.

(Cape penguin)

Their baluster-like shape offers little resistance in the water, but it looks comical on land.

Whale

(Animalia/Chordata/Vertebrata/Mammalia/Cetacea)

Whales, who with their large bodies are at home in the oceans, are the largest mammals. There are two types of whales: beaked whales and baleen whales. The distinctions between beaked whales and dolphins are blurred.

Skeletal Diagram

The sperm whale has a head that occupies one third of their body. The large head has a "melon" mass that is composed of fat and connective tissue. The mandible follows the shape of the skeleton as it is, but the large, fleshy head extends well beyond the cranial bone structure.

The melon is situated here.

(Sperm whale)

A small amount of pelvic bone remains. In the distant past, it must have also had lower limbs.

Completed Drawings

For large, powerful whales, try to create a composition that makes them appear elongated and large.

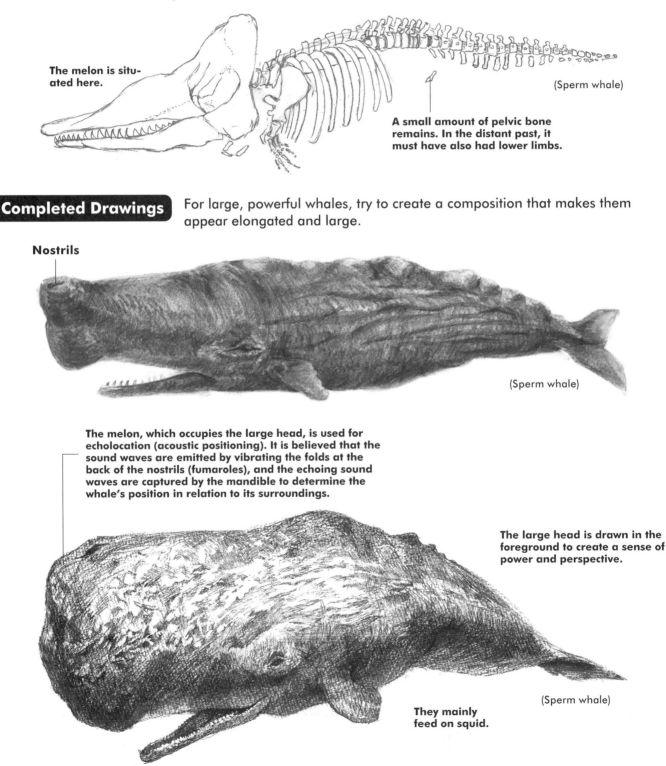

Nostrils

(Sperm whale)

The melon, which occupies the large head, is used for echolocation (acoustic positioning). It is believed that the sound waves are emitted by vibrating the folds at the back of the nostrils (fumaroles), and the echoing sound waves are captured by the mandible to determine the whale's position in relation to its surroundings.

The large head is drawn in the foreground to create a sense of power and perspective.

(Sperm whale)

They mainly feed on squid.

Variations

When whales dive, they raise their tails high. It's fun to try to imagine the size of the whale from just its tail. Pay attention to splashes and the surface of the water as you draw.

Try to express the light from the surface of the water reflected on the whale's huge body.

What Is a Blue Whale?

Blue whales are baleen whales that feed on plankton and small fish. This is the largest whale, ranging from 65 to 110 feet (20 to 34 meters) in length. The artist for the illustration below depicted the moment when the whale breaches the surface of the water. Pay attention to the shape of the fins and the surfaces of the whale where they come into contact with the water.

(Blue whale)

Environment

Animals seen in zoos and aquariums are separated from their original habitats. Understanding the actual habitats in which these animals live will make their depictions more profound.

In the coral reef sea
Corals inhabit warm waters, where the three-dimensional movements of animals can be observed.

Corals in shallow water in the tropics differ from those in the deep sea in terms of shape and other characteristics.

Looking up from the Seabed to the Surface of the Sea

Use contrast to show how light reaches the coral from underwater. It is an interesting perspective to look up from the bottom of the sea and to paint the white bellies of the fish, an angle that is not usually seen. The painting was done with watercolors.

There are various types and shapes of corals.

Coral and Starfish

Corals are not plants. They are made of a calcareous skeleton created by cnidarian coralline worms.

Starfish are echinoderms with five arms radiating out from the center of their bodies, giving them a star-like appearance. Shellfish and corals are their staple food.

Highlands Scenery

The plants that thrive here are adapted to withstand the large temperature fluctuations that occur within just a few days.

Trees of the Savannah

The nature and flora of Africa, where many wild animals live, is an important background for drawing animals.

The appearance is quite different from what we are usually accustomed to seeing. Acacia leaves are a favorite of elephants and giraffes.

Sidebar 2

Animal Droppings

Animals eat, digest, and absorb nutrients and water, and the residuals become fecal matter. Here, we have collected feces from a variety of animals with different dietary habits.

Feces is the Product of the Intestinal Tract

Stool is called *daiben* in Japanese, which means "big news," so bowel movements are the "big news" from the body! (In turn, urine is called *shoben* in Japanese, which means "small news.") In other words, waste tells us about the state of an organism's digestive organs.

Horse dung contains undigested straw and panda dung contains bamboo grass fibers. Similarly, the feces of the reticulated python contain animal bones and hair. Rabbit droppings are small and round, and camel and goat droppings are similarly rounded pellets.

Don't always keep feces out of sight; consider them to be an important source of information about a given animal's condition.

Horse feces
Undigested straw can be seen.

Reticulated python feces
Small pieces of undigested animal bones that have been swallowed whole can be seen.

Panda feces
In addition to undigested bamboo shafts, groomed hair can also be seen.

Rabbit droppings

Dromedary camel droppings

Goat droppings

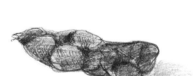

Cat feces

Dog feces

Hyena feces

Mouse droppings

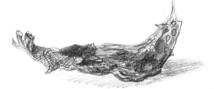

Weasel feces
It contains a lot of hair from prey animals.

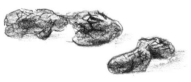

Koi carp feces

Parrot droppings

Flying Animals

Dove and Pigeon
(Animalia/Chordata/Vertebrata/Aves/Columbiformes/Columbidae)

Pigeons are found throughout Japan and are very prolific. They have well-developed pectoral muscles and have a "pivoting gait," in which their heads bob when they walk. The tradition of the dove as a symbol of peace comes from Europe.

Skeletal Diagram

The upper limbs of the bird are the wings. The basic structure of the skeleton is the same as that for many other vertebrates in that it has a humerus, radius, ulna and "hand," but the hand bones are particularly long.

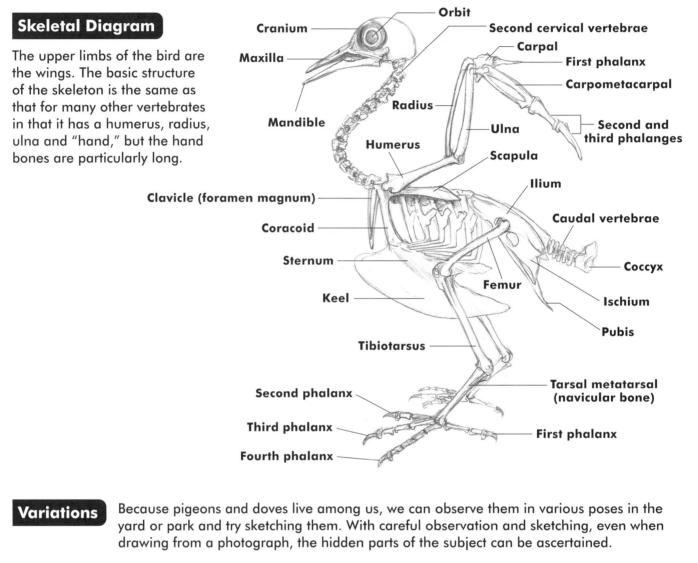

Orbit
Cranium
Second cervical vertebrae
Maxilla
Carpal
First phalanx
Carpometacarpal
Radius
Second and third phalanges
Mandible
Ulna
Humerus
Scapula
Ilium
Clavicle (foramen magnum)
Caudal vertebrae
Coracoid
Coccyx
Sternum
Femur
Keel
Ischium
Pubis
Tibiotarsus
Tarsal metatarsal (navicular bone)
Second phalanx
Third phalanx
First phalanx
Fourth phalanx

Variations

Because pigeons and doves live among us, we can observe them in various poses in the yard or park and try sketching them. With careful observation and sketching, even when drawing from a photograph, the hidden parts of the subject can be ascertained.

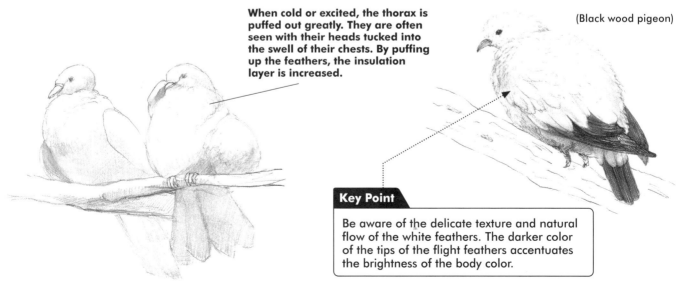

When cold or excited, the thorax is puffed out greatly. They are often seen with their heads tucked into the swell of their chests. By puffing up the feathers, the insulation layer is increased.

(Black wood pigeon)

Key Point

Be aware of the delicate texture and natural flow of the white feathers. The darker color of the tips of the flight feathers accentuates the brightness of the body color.

The fine feathering details are expressed with an HB pencil. The key point is to draw in the overall shading, moving from section to section without dwelling on any one area for too long.

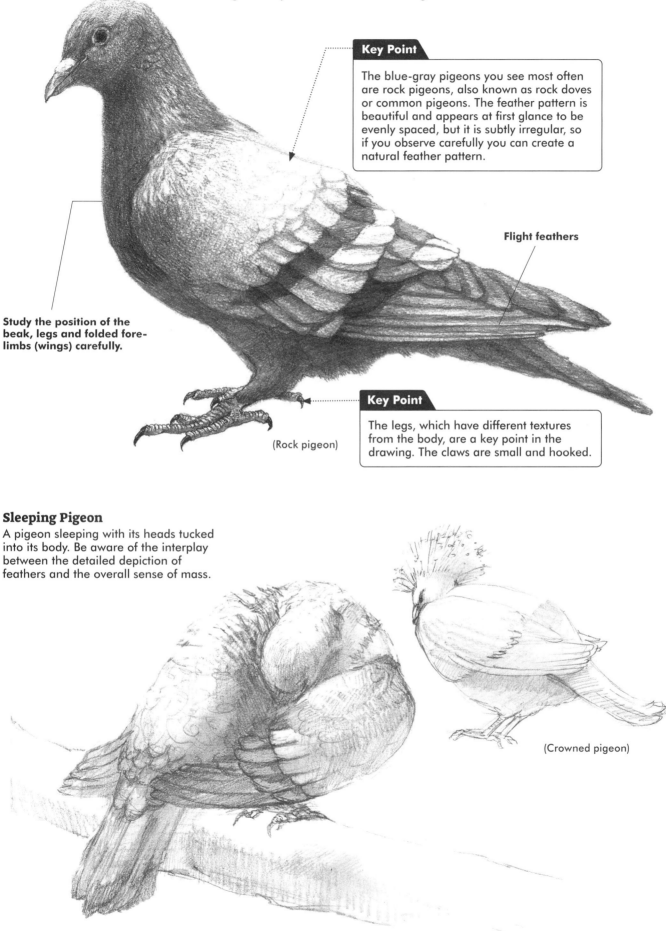

Key Point

The blue-gray pigeons you see most often are rock pigeons, also known as rock doves or common pigeons. The feather pattern is beautiful and appears at first glance to be evenly spaced, but it is subtly irregular, so if you observe carefully you can create a natural feather pattern.

Flight feathers

Study the position of the beak, legs and folded forelimbs (wings) carefully.

(Rock pigeon)

Key Point

The legs, which have different textures from the body, are a key point in the drawing. The claws are small and hooked.

Sleeping Pigeon

A pigeon sleeping with its heads tucked into its body. Be aware of the interplay between the detailed depiction of feathers and the overall sense of mass.

(Crowned pigeon)

Flying Animals **151**

Crow

(Animalia/Chordata/Vertebrata/Aves/Passeriformes/Corvoidea/Corvidae/Corvus)

The crow is a relatively large bird species that is familiar to us. It is intelligent, social and enjoys playing. It is also very expressive. It is an omnivore, eating a variety of foods.

Skeletal Diagram

The crow is characterized by a large bill and long hind limbs. Familiarize yourself with the position and structure of the forelimbs (wings) when folded.

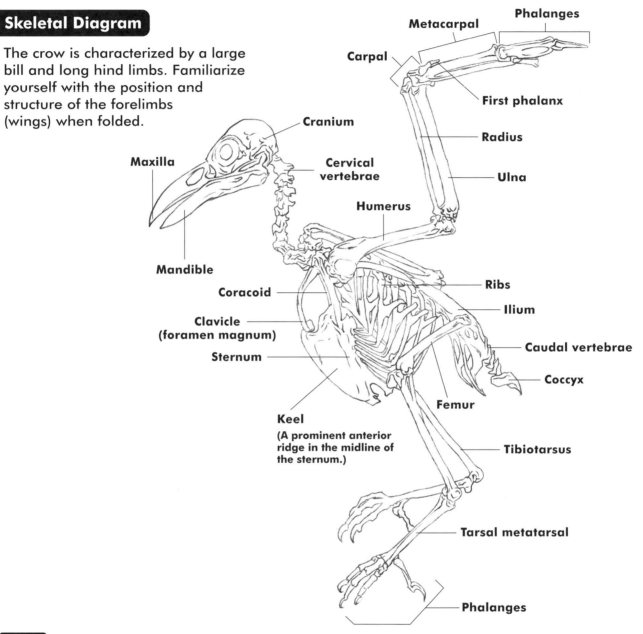

Phalanges

Metacarpal

Carpal

First phalanx

Radius

Cranium

Maxilla

Cervical vertebrae

Ulna

Humerus

Mandible

Coracoid

Ribs

Clavicle (foramen magnum)

Ilium

Sternum

Caudal vertebrae

Coccyx

Keel
(A prominent anterior ridge in the midline of the sternum.)

Femur

Tibiotarsus

Tarsal metatarsal

Phalanges

Note

Distinguish between species by their beaks

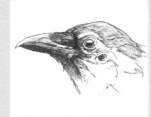

Carrion crow
The crows with a slender beak are called "carrion crows," and their faces do not protrude as much as that of jungle crows. They feed mainly on fruits and seeds.

▶ The "hashi" of *hashibosokarasu*, the Japanese name, means "beak."

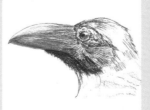

Jungle crow
The beak is thick and the face protrudes slightly. They are omnivorous, but also eat small animals and carrion. The shape of the beak is thought to be an adaptation to new feeding behaviors.

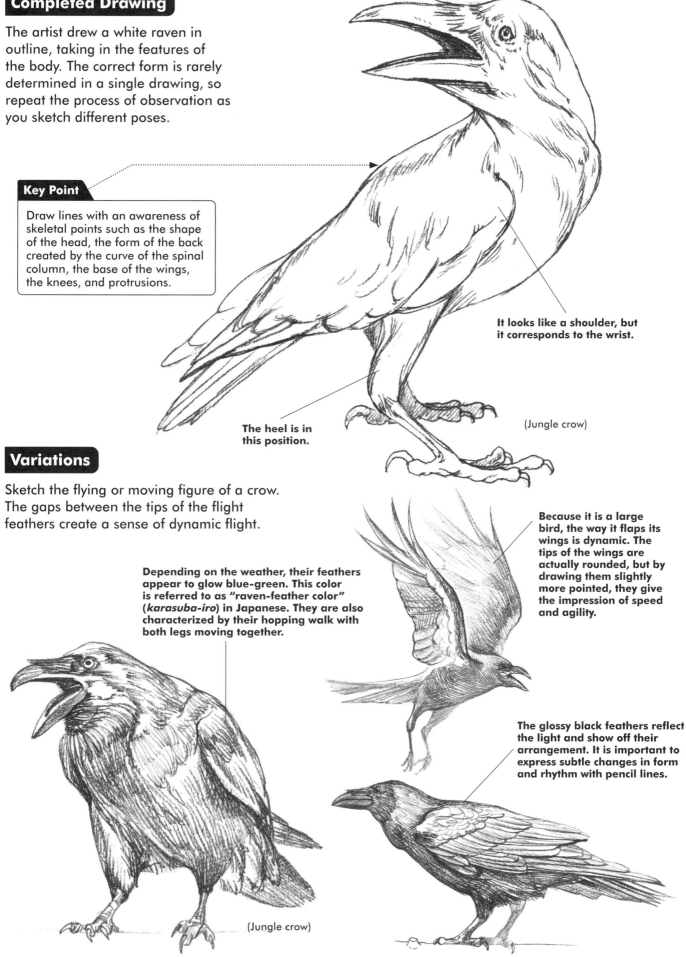

Completed Drawing

The artist drew a white raven in outline, taking in the features of the body. The correct form is rarely determined in a single drawing, so repeat the process of observation as you sketch different poses.

Key Point

Draw lines with an awareness of skeletal points such as the shape of the head, the form of the back created by the curve of the spinal column, the base of the wings, the knees, and protrusions.

It looks like a shoulder, but it corresponds to the wrist.

The heel is in this position.

(Jungle crow)

Variations

Sketch the flying or moving figure of a crow. The gaps between the tips of the flight feathers create a sense of dynamic flight.

Depending on the weather, their feathers appear to glow blue-green. This color is referred to as "raven-feather color" (*karasuba-iro*) in Japanese. They are also characterized by their hopping walk with both legs moving together.

Because it is a large bird, the way it flaps its wings is dynamic. The tips of the wings are actually rounded, but by drawing them slightly more pointed, they give the impression of speed and agility.

The glossy black feathers reflect the light and show off their arrangement. It is important to express subtle changes in form and rhythm with pencil lines.

(Jungle crow)

Flying Animals **153**

Sparrow
(Animalia/Chordata/Vertebrata/Aves/Passeriformes/Passeridae)
The sparrow is one of the species of birds that live among humans.

Skeletal Diagram

The sparrow has a large cranium compared to its body. The skeleton of the long hind limb is almost completely buried within the body, with only the tarsal metatarsals and below visible to the observer.

▶ In this skeletal drawing, a black ballpoint pen was also used to emphasize the darker lines.

Note

Superior vision

Birds in general have excellent vision. The orbits of the eyes are large and occupy a large portion of the cranial area.

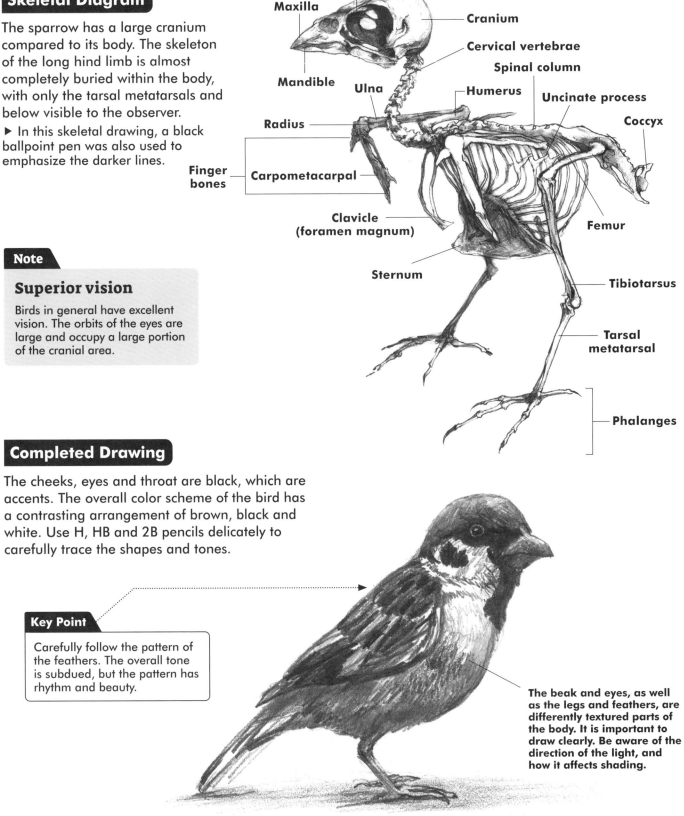

Orbit
Maxilla
Mandible
Ulna
Radius
Finger bones
Carpometacarpal
Cranium
Cervical vertebrae
Spinal column
Humerus
Uncinate process
Coccyx
Femur
Clavicle (foramen magnum)
Sternum
Tibiotarsus
Tarsal metatarsal
Phalanges

Completed Drawing

The cheeks, eyes and throat are black, which are accents. The overall color scheme of the bird has a contrasting arrangement of brown, black and white. Use H, HB and 2B pencils delicately to carefully trace the shapes and tones.

Key Point

Carefully follow the pattern of the feathers. The overall tone is subdued, but the pattern has rhythm and beauty.

The beak and eyes, as well as the legs and feathers, are differently textured parts of the body. It is important to draw clearly. Be aware of the direction of the light, and how it affects shading.

The silhouette of the sparrow changes with the summer and winter seasons. Winter sparrows fluff and puff up, creating an insulating layer of feathers.

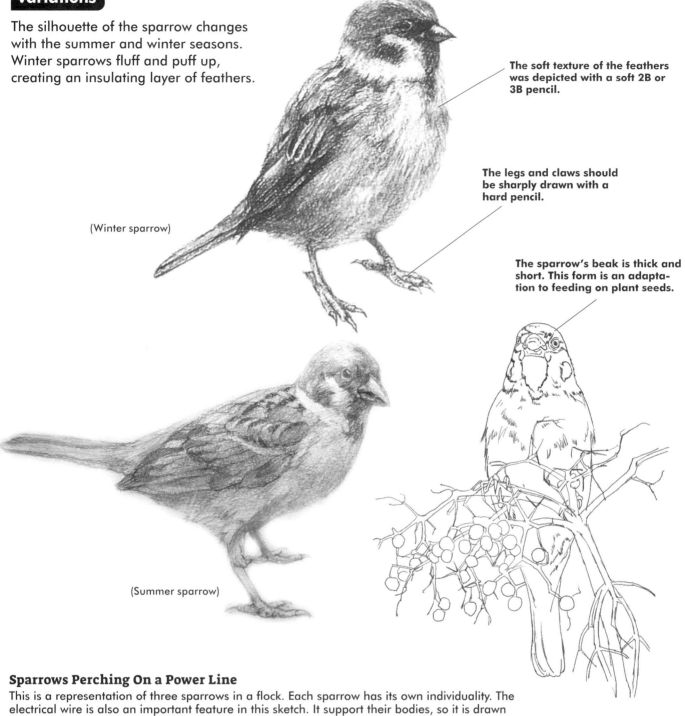

The soft texture of the feathers was depicted with a soft 2B or 3B pencil.

The legs and claws should be sharply drawn with a hard pencil.

The sparrow's beak is thick and short. This form is an adaptation to feeding on plant seeds.

(Winter sparrow)

(Summer sparrow)

Sparrows Perching On a Power Line

This is a representation of three sparrows in a flock. Each sparrow has its own individuality. The electrical wire is also an important feature in this sketch. It support their bodies, so it is drawn with the same quality of line as the sparrows. The birds in a line are expressed by rhythms of strength, lightness, and slow and fast strokes. Also note the orientation of the tail feathers.

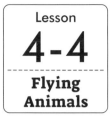

Lesson
4-4
**Flying
Animals**

Owl

(Animalia/Chordata/Vertebrata/Aves/Strigiformes/Strigidae)

Many owls are nocturnal, preying on small mammals, birds and insects. Horned owls are in the same group.

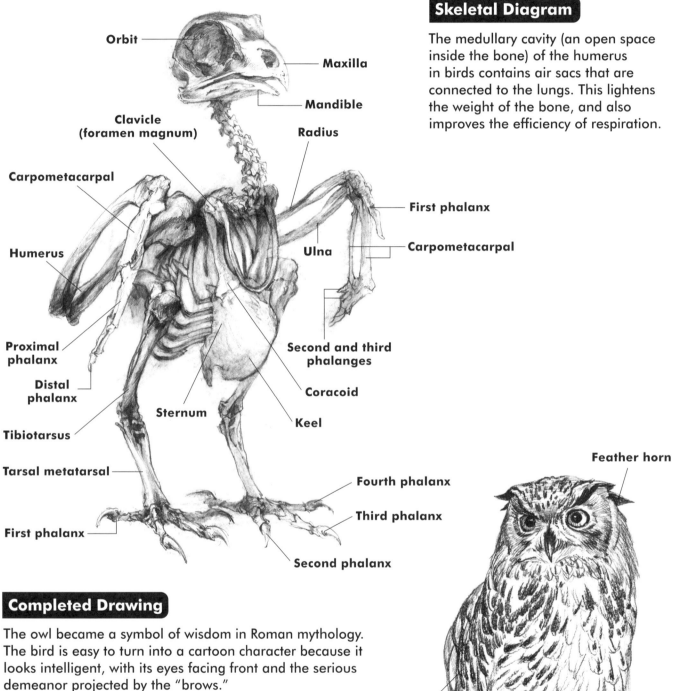

- Orbit
- Maxilla
- Mandible
- Clavicle (foramen magnum)
- Radius
- Carpometacarpal
- First phalanx
- Humerus
- Ulna
- Carpometacarpal
- Proximal phalanx
- Second and third phalanges
- Distal phalanx
- Coracoid
- Sternum
- Keel
- Tibiotarsus
- Tarsal metatarsal
- Fourth phalanx
- Third phalanx
- First phalanx
- Second phalanx

Skeletal Diagram

The medullary cavity (an open space inside the bone) of the humerus in birds contains air sacs that are connected to the lungs. This lightens the weight of the bone, and also improves the efficiency of respiration.

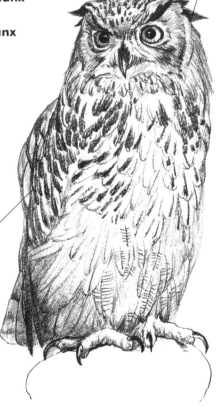

- Feather horn

The arrangement of the feathers has a regularity and at the same time a natural and subtle irregularity. Observe this rhythm carefully.

Completed Drawing

The owl became a symbol of wisdom in Roman mythology. The bird is easy to turn into a cartoon character because it looks intelligent, with its eyes facing front and the serious demeanor projected by the "brows."

Characteristics of the Horned Owl

The horned owl is a member of the owl family with feathers that resemble ears. Although horned owls are not called owls in Japanese, there is no taxonomic difference between them and other owls.

Variations Beautiful patterns and a dignified appearance. We want to draw these lines boldly.

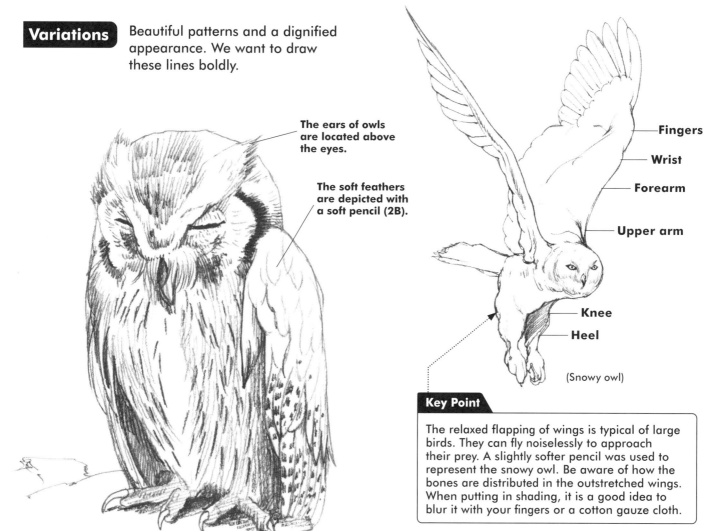

The ears of owls are located above the eyes.

The soft feathers are depicted with a soft pencil (2B).

Fingers

Wrist

Forearm

Upper arm

Knee

Heel

(Snowy owl)

Key Point

The relaxed flapping of wings is typical of large birds. They can fly noiselessly to approach their prey. A slightly softer pencil was used to represent the snowy owl. Be aware of how the bones are distributed in the outstretched wings. When putting in shading, it is a good idea to blur it with your fingers or a cotton gauze cloth.

Owls Sleep During the Day

Owls are nocturnal and sleep during the day. The round eyes are less pronounced when closed, but the long, bold eye slits (where the upper and lower eyelids meet) should be depicted to add expression. The beak and talons are also key points, as they have different textures than the feathers.

The feathers surrounding the eyes are expressed with the soft touch of a pencil. The tail feather pattern, talons and claws are also clearly drawn.

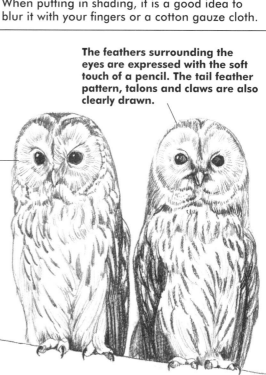

The owl's eyes line up in front of its face, giving it a wide stereoscopic field of vision and allowing it to accurately measure the distance to its prey. The same is true of other carnivorous birds such as hawks and eagles. Compare the position of the eyes with the pigeon (page 150) or the sparrow (page 154). Owls' binocular field of vision is narrower than their stereoscopic field of vision, but their necks can rotate to an amazing 270°.

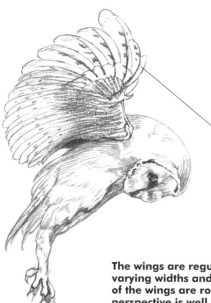

The wings are regularly aligned, but have varying widths and lengths, and the tips of the wings are rounded and curved. The perspective is well expressed here.

Chicken

(Animalia/Chordata/Vertebrata/Aves/Galliformes/Phasianidae)

Humans selectively bred and domesticated a type of pheasant to make the animal easier to farm, leading to the modern-day chicken. They are deeply connected to human life: their feathers are used for bedding, and their meat and eggs are used for food. They are also raised to be ornamental birds.

Skeletal Diagram Chickens, like humans, are bipedal, but you can see that they do not stand upright, but rather bend sharply at the knees and other parts of the body.

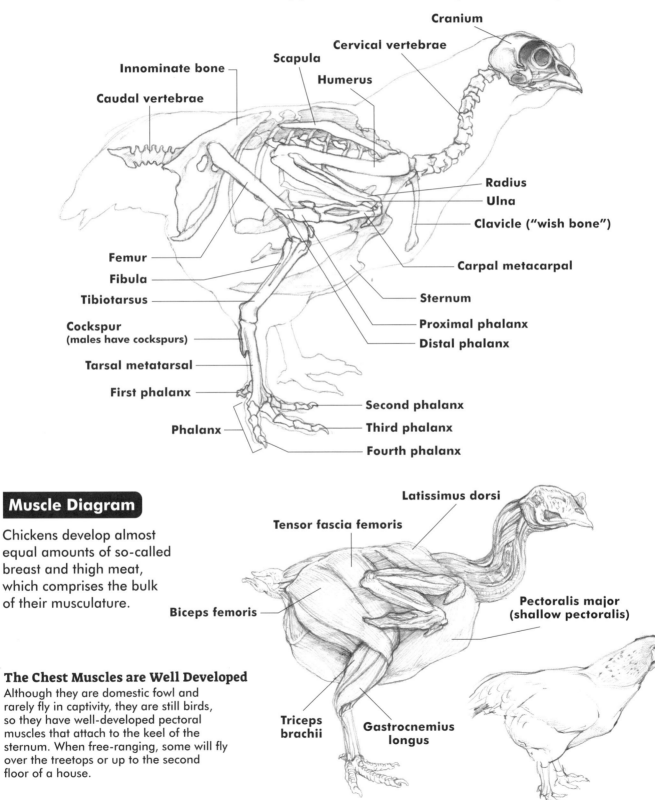

Cranium

Cervical vertebrae

Scapula

Humerus

Innominate bone

Caudal vertebrae

Radius

Ulna

Clavicle ("wish bone")

Femur

Fibula

Tibiotarsus

Carpal metacarpal

Sternum

Proximal phalanx

Cockspur
(males have cockspurs)

Distal phalanx

Tarsal metatarsal

First phalanx

Second phalanx

Phalanx

Third phalanx

Fourth phalanx

Muscle Diagram

Chickens develop almost equal amounts of so-called breast and thigh meat, which comprises the bulk of their musculature.

Latissimus dorsi

Tensor fascia femoris

Biceps femoris

Pectoralis major
(shallow pectoralis)

The Chest Muscles are Well Developed

Although they are domestic fowl and rarely fly in captivity, they are still birds, so they have well-developed pectoral muscles that attach to the keel of the sternum. When free-ranging, some will fly over the treetops or up to the second floor of a house.

Triceps
brachii

Gastrocnemius
longus

Drawing Procedure ❶ Depict the shading of the white feathers and the texture of the crest and feet.

Draw the Outlines

Add Three-dimensionality

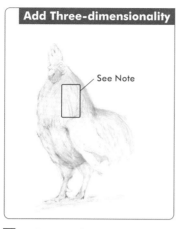

See Note

See Note

❶ Capture the whole form

Determine how the image will be placed on the paper, and then capture the overall shape of the image. Look closely at the shape and details, analyze the form, and correct inaccuracies.

❷ Add shading to create a three-dimensional effect

Use a 3B pencil to create fine shading. The overlapping lines are used to create the flow of the feathers and the three-dimensional effect.

Note

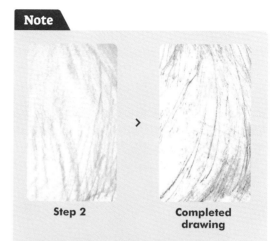

Step 2 Completed drawing

Use contrast to boost areas of white

In step 2 the chicken may appear to be gray all over, but in the completed image the chicken appears to be white. This is because, in the finished drawing, black pencil tone was added boldly in the shaded areas; the eraser has not been used much at all. Even when working on a white bird, don't be afraid and draw in the details well!

Completed Drawing

Key Point

Even within the white feathers, variations of gray are visible. If you squint or otherwise observe the scene overall, you should be able to notice a broad tonal spectrum.

See Note

See Note

Note

Deepen your observation skills

Make lots of sketches of live birds. It is difficult to capture the shape of the animal because it moves so much, but any part of the animal, such as the head, back or chest, can be observed, even if not the whole. Through repeated sketches, your ability to observe will deepen.

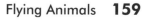

Drawing Procedure ❷ Here, a black chicken has been depicted. Even within the dark tones, there are variations in saturation. Draw the image so that there is a range of light and dark tones.

Draw the Outlines

Add Shading

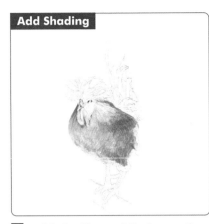

Add Tone

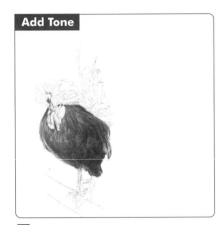

1 **Trace the outline of the body**

Observe the chicken's movements carefully beforehand and trace its body outlines. This time, the drawing was drawn from a photograph.

2 **Add shading with the surface in mind**

Squint your eyes and keep adding the pencil to the darker areas of the subject. Use hatching (page 22) to align pencil strokes in the direction of the contour and darken the shading.

3 **Be aware of the texture of the feathers**

Apply tones while being aware of the color and texture of each feather. Squint occasionally to see the large tonal changes throughout the image, and be sure to express the roundness and depth of the body.

Completed Drawing

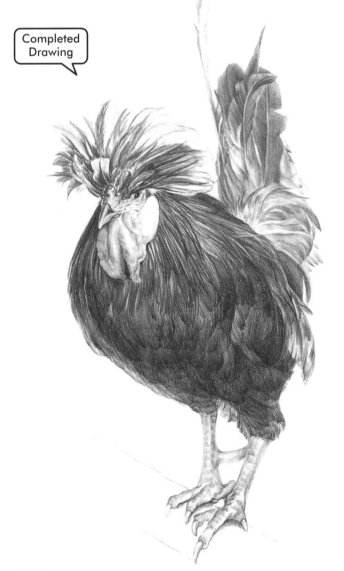

Notes

Take care with how you apply lights and darks

❶ The crown feathers, beak and eyes are key areas. The beak is sharply drawn so that it is clearly distinguished from the dark feather tones of the background.

❷ The position of the carpus (the wrist) is also an important place to show where the flow of feathers diverts.

❸ The legs with their contrasting texture are another key point to draw in.

❹ Draw in the details of parts in the foreground, such as the chicken's crown, feathers, beak and legs. By slightly reducing the saturation of distant objects such as tail feathers and being conscious of contrast with the foreground, a sense of depth and power can be created.

The head has a comb and the jaw has a red skin flap called a wattle, both of which are larger in the male than in the female. In the case of chicks, differences between the sexes are not immediately obvious.

Chicks are not simply cute; they have oversized, sharp bills that are out of proportion to their small bodies. This is a chick that is on the cusp of becoming an adolescent chicken.

This is a white leghorn that is lengthening its body and taking on a combative posture. This is the usual posture of the gamecock.

Leghorn females lay more than 200 eggs per year.

(White leghorn)

Key Point

By drawing just the frontmost few feathers in detail, an overall impression of roundness and softness is achieved.

Gaudy colors are favored for ornamental purposes, and some chickens have pheasant-like plumage. Chickens with long tail feathers are called long-tailed chickens and are highly prized in Japan.

The movement is captured with lines. Once the shape has been captured, the darker areas are colored using hatching (page 22).

(Long-tailed chicken)

Cockatiel

(Animalia/Chordata/Vertebrata/Aves/Psittaciformes/Psittacidae)

The circular orange spot on the cheeks is the origin of the "okame" part of its name in Japanese, *okame inko*. They are one of the most beloved pet birds because they can be taught to repeat words and phrases.

Skeletal Diagram

The cockatiel has a distinctive rounded beak and a large skull. The basic structure of the skeleton is similar to that of other birds.

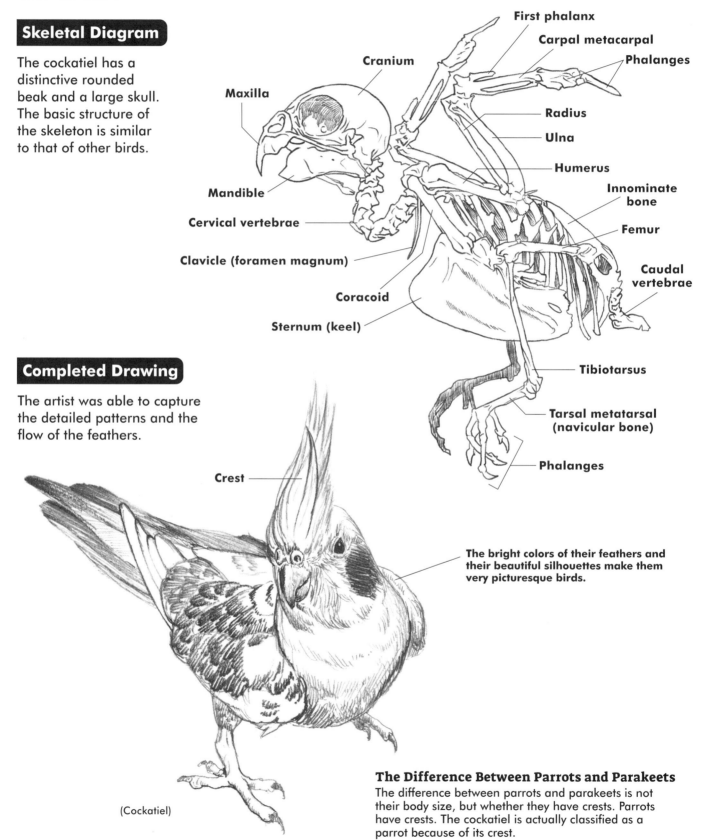

First phalanx
Carpal metacarpal
Phalanges
Cranium
Radius
Maxilla
Ulna
Humerus
Innominate bone
Mandible
Femur
Cervical vertebrae
Caudal vertebrae
Clavicle (foramen magnum)
Coracoid
Sternum (keel)
Tibiotarsus
Tarsal metatarsal (navicular bone)
Phalanges

Completed Drawing

The artist was able to capture the detailed patterns and the flow of the feathers.

Crest

The bright colors of their feathers and their beautiful silhouettes make them very picturesque birds.

(Cockatiel)

The Difference Between Parrots and Parakeets

The difference between parrots and parakeets is not their body size, but whether they have crests. Parrots have crests. The cockatiel is actually classified as a parrot because of its crest.

Try to draw the dynamic moment when the cockatiel takes flight.

Observe Carefully

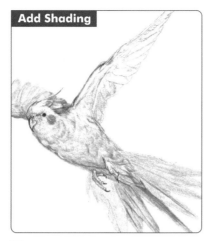

Add Shading

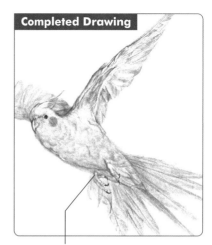

Completed Drawing

1 Trace the outline of the body

If you are drawing from a photograph, you should still observe a live cockatiel carefully before you start, if you can. First, trace the outline of the silhouette, and pay attention to the spatial balance and how the composition will fit on the paper.

2 Layers on tones and add shading

Add shading. Squint, look for dark areas, and layer the pencil tones from there. Even after capturing the shape, correct any deviations in it as you discover them.

It is flying with its wings spread. The legs are retracted.

Variations The crest, which looks like a mohawk hairstyle, changes shape depending on the bird's mood.

Crest

The orange circle on the cheek is an adorable feature of the cockatiel.

The softness of the feathers is expressed by aligning the pencil side by side.

Cockatiel dropping

Note

The feathers are captured in clusters

The feathers are outlined as a whole, and then each feather and pattern is drawn in detail. Capture the rhythm in the rows of feathers.

Key Point

The key points are the position of the beak, the base of the wings, the base of the legs and the crest. The feathers in the foreground should be drawn more clearly than those in the background. The feet perched on the branch are also key points.

Bat

(Animalia/Chordata/Vertebrata/Mammalia/Laurasiatheria/Chiroptera)

Bats are flying mammals that are found throughout the world. Unlike birds, their wings are not comprised of feathers; they are elastic flight membranes stretched over elongated finger bones, which they spread and flap.

Skeletal Diagram

The bat's forelimb bones have a characteristic shape that makes up its wings. The long, thin humerus and forearm bones spread and the elongated bones of the third through fifth fingers support the flight membranes.

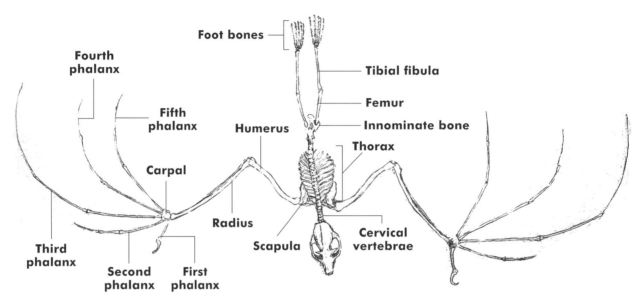

Foot bones

Fourth phalanx

Fifth phalanx

Humerus

Tibial fibula

Femur

Innominate bone

Thorax

Carpal

Third phalanx

Radius

Second phalanx

First phalanx

Scapula

Cervical vertebrae

Completed Drawing

There are many species of bats, and they form the second largest order after Rodentia (rodents). The two main categories are fruit bats and insect bats.

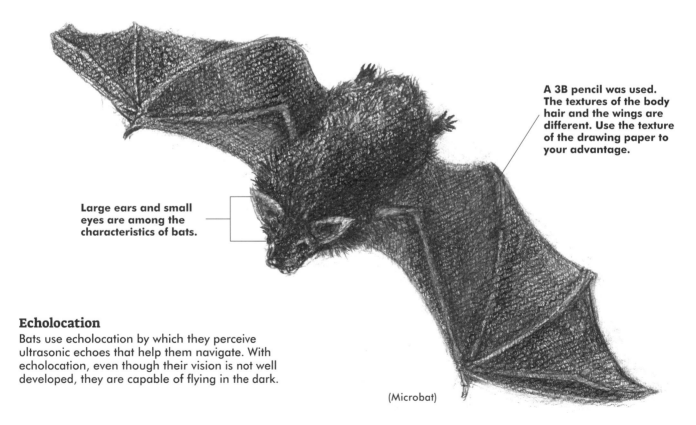

A 3B pencil was used. The textures of the body hair and the wings are different. Use the texture of the drawing paper to your advantage.

Large ears and small eyes are among the characteristics of bats.

Echolocation

Bats use echolocation by which they perceive ultrasonic echoes that help them navigate. With echolocation, even though their vision is not well developed, they are capable of flying in the dark.

(Microbat)

Drawing Procedure

Bats have different textures on their forelimbs (flight membranes) and on the fuzzy parts of their bodies. Using the skeleton as a reference, try to draw a bat while envisioning the stowed wings.

Capture the Overall Shape

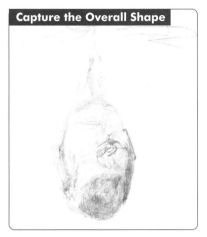

Trace the Shadows

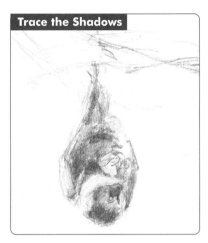

Be Conscious of the Texture

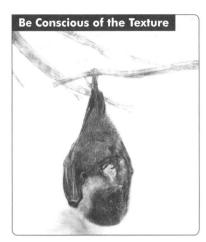

1 See the whole and capture the overall shape

The overall image is captured by considering how the shape is placed on the paper and its relationship to the space around it. As you become accustomed to drawing you will naturally develop a sense of scale and balance, but at the beginning, start by drawing the outline with light, sketchy lines. In addition, measure the proportions as you capture the shape.

2 Layer the tones and add shading

Squint to find dark areas, trace the areas to define them, and then gradually build the tones up with pencil. Compare the object with your drawing, looking for dark areas one after another, and then layer on more pencil strokes.

3 Differentiate textures in areas with and without hair

The texture of the animal's hair should be differentiated from that of the flight membranes, which have no hair. The bright areas are made light using a kneaded eraser, but the areas where the kneaded eraser is used are always augmented with pencil to preserve their relationship with their surroundings.

Note

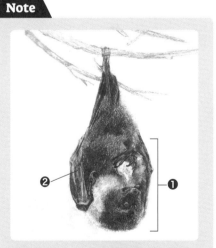

Concentrate on the area you want to emphasize

❶ The detail of the upside-down face of the megabat and the slender fingers of the foot grasping the fruit are key points of interest.

❷ Draw the differences in the textures of the hair and the flight membrane. The eyes of the megabat, which has excellent vision, should be clearly drawn.

Completed Drawing

(Megabat or Flying Fox)

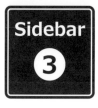

An Animal's Vision and Expressions

Sidebar 3

The placement of eyes on animal faces differs between predator and prey. This affects our perception of an animal's personality and facial expression.

Stereoscopic Predators and Prey With No Blind Spots

Although the human eyes are aligned almost directly next to each other at the front of the face, the combined left and right visual field is about 190°, of which the binocular field is 120°. The blind spot of a human is about 170° behind the head. The cat's eyes are also located almost directly in front. Their binocular field of vision is as wide as that of humans. Similarly, the eyes of owls are located on the front.

In fact, this is an eye arrangement unique to predators. Eyes aligned at the front of the face and a wide binocular field of vision means that *stereopsis* is possible. Stereopsis is the process of having a three-dimensional perspective by seeing an object with both eyes at the same time. In other words, predators use stereopsis to measure the distance between them and their prey so they can deftly close the gap between them.

On the other hand, let's take a look at the animals that are prey to these predators.

Pigeons have a wide field of view of about 350°, but their binocular field of view is only about 8°. The rabbit's eyes protrude slightly outward, giving it a field of view of 360°. Their 3D field of view is about 10° both in front and behind, leaving no blind spots at all. Rabbits and pigeons flee at once when they see a predator. Prey have adapted a wide field of vision at the expense of stereoscopic vision.

This arrangement of the eyes on the face seems to be naturally connected to the character and expression we perceive in animals. An wide distance between the two eyes may give the impression of timidity or a mildly comical look. On the other hand, if the space between the eyes is narrow, we may perceive intelligence, shrewdness, or a human-like impression.

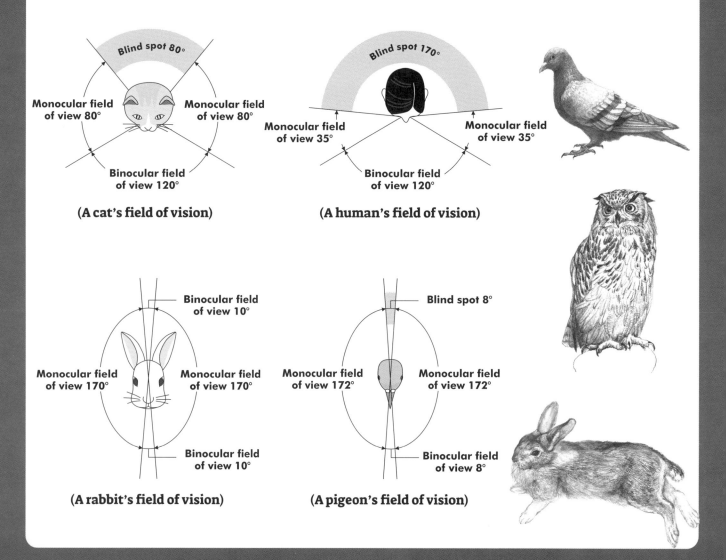

Blind spot 80°

Monocular field of view 80° Monocular field of view 80°

Binocular field of view 120°

(A cat's field of vision)

Blind spot 170°

Monocular field of view 35° Monocular field of view 35°

Binocular field of view 120°

(A human's field of vision)

Binocular field of view 10°

Monocular field of view 170° Monocular field of view 170°

Binocular field of view 10°

(A rabbit's field of vision)

Blind spot 8°

Monocular field of view 172° Monocular field of view 172°

Binocular field of view 8°

(A pigeon's field of vision)

Insects & Arthropods

Rhinoceros Beetle and Stag Beetle

(Animalia/Arthropoda/Insecta/Coleoptera/Scarabaeidae/Dynastinae/
Trypoxylus)
(Animalia/Arthropoda/Insecta/Coleoptera/Scarabaeoidea/Dynastinae/
Lucanidae)

The male rhinoceros beetle is a large insect so named because of its large horns, which resemble a samurai helmet, and a stag beetle got its name because of the shape of its large jaws, which resemble antlers.

Drawing Procedure (Rhinoceros Beetle)

The body structure of the beetle is very clear. Six legs protrude from the chest. Observe carefully and follow carefully.

Capture the Overall Shape

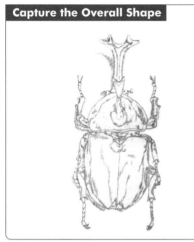

1 Draw the basic structure

This is drawn from a specimen. The outline should be drawn with the vertical and horizontal proportions of the horns, head, thorax and abdomen in mind.

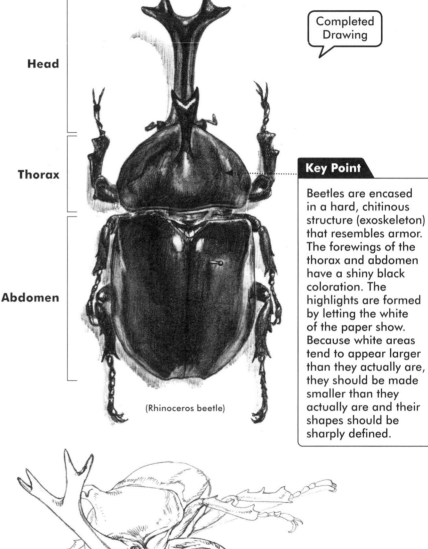

Completed Drawing

Head

Thorax

Abdomen

(Rhinoceros beetle)

Key Point

Beetles are encased in a hard, chitinous structure (exoskeleton) that resembles armor. The forewings of the thorax and abdomen have a shiny black coloration. The highlights are formed by letting the white of the paper show. Because white areas tend to appear larger than they actually are, they should be made smaller than they actually are and their shapes should be sharply defined.

Draw Each Part

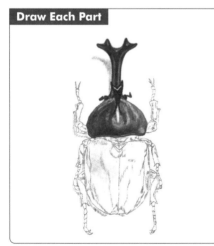

2 Add tone to each part

Once the overall shape was captured, in this case, one part was completed and the levels of shading were determined. Then, the shading was applied to the other parts in sequence.

Notes

Various perspectives and expressions

Beetles can be dynamically expressed simply by looking at them from angles other than directly above. Lift the beetle up to your eye level and try to draw it from the beetle's point of view. Also, do not neglect the details of the insect. The more details you show, the more realistic it becomes. The horns and legs also have thickness and mass.

Completed Drawing (Stag Beetle)

The Cyclommatus imperator, shown below, is a species with large mandibles relative to its body, and is found in Indonesia and Papua New Guinea. The ratio of the mandibles to body length is approximately 1:1.

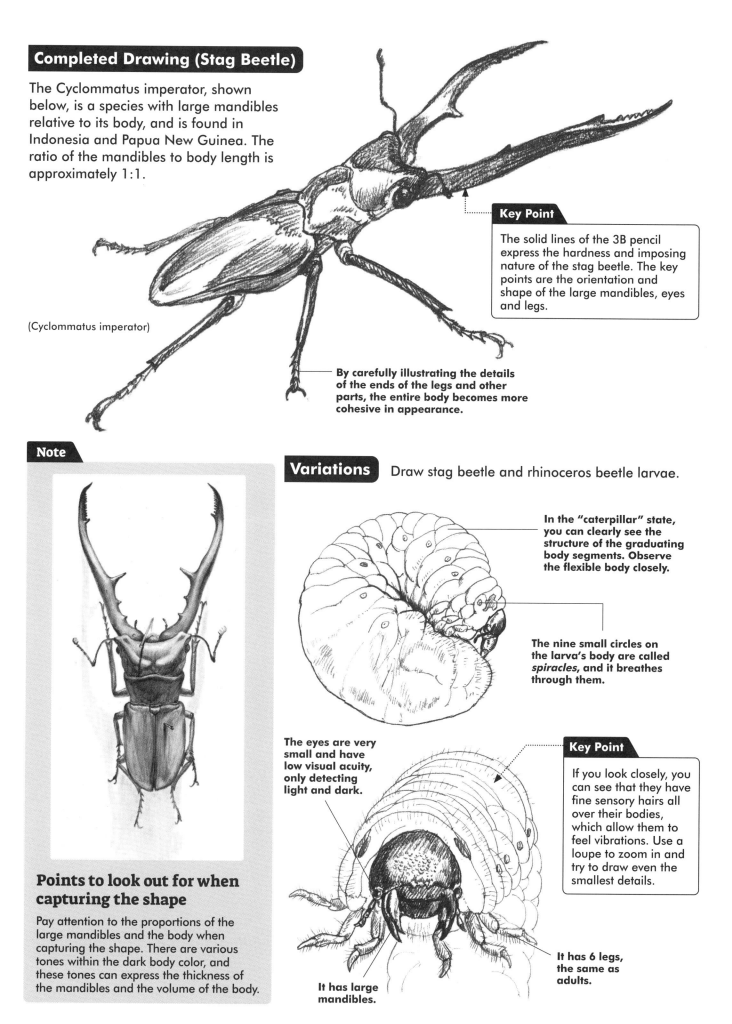

(Cyclommatus imperator)

Key Point

The solid lines of the 3B pencil express the hardness and imposing nature of the stag beetle. The key points are the orientation and shape of the large mandibles, eyes and legs.

By carefully illustrating the details of the ends of the legs and other parts, the entire body becomes more cohesive in appearance.

Note

Points to look out for when capturing the shape

Pay attention to the proportions of the large mandibles and the body when capturing the shape. There are various tones within the dark body color, and these tones can express the thickness of the mandibles and the volume of the body.

Variations Draw stag beetle and rhinoceros beetle larvae.

In the "caterpillar" state, you can clearly see the structure of the graduating body segments. Observe the flexible body closely.

The nine small circles on the larva's body are called *spiracles*, and it breathes through them.

The eyes are very small and have low visual acuity, only detecting light and dark.

Key Point

If you look closely, you can see that they have fine sensory hairs all over their bodies, which allow them to feel vibrations. Use a loupe to zoom in and try to draw even the smallest details.

It has large mandibles.

It has 6 legs, the same as adults.

Lesson

5-2

Insects & Arthropods

Ant

(Animalia/Arthropoda/Insecta/Hymenoptera/Formicidae)

Ants are found all over the world. Their nests are built around a single queen, and they protect their nest as a group. Although small, they are carnivorous and can be aggressive, attacking small insects in groups.

Completed Drawing

Japan's largest ant, the black carpenter ant, is distributed throughout almost all of the country. Its body length is 1/4 to 1/2 inch (7 to 12 mm). Here, it is scaled up 6 to 10 times and represented as a line drawing. We are looking at this specimen as if through a magnifying glass, carefully observing the thickness of even the very thin legs and the hair on their abdomens.

Ants are Social Animals

Ants are close relatives of bees. They nest in groups with a queen, and have sterile workers, soldiers and other individuals specialized for their specific roles. Such animals are called "eusocial animals."

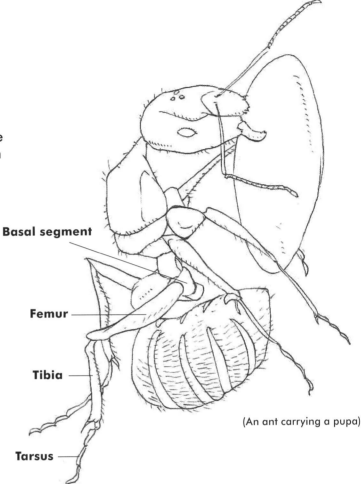

Basal segment

Femur

Tibia

Tarsus

(An ant carrying a pupa)

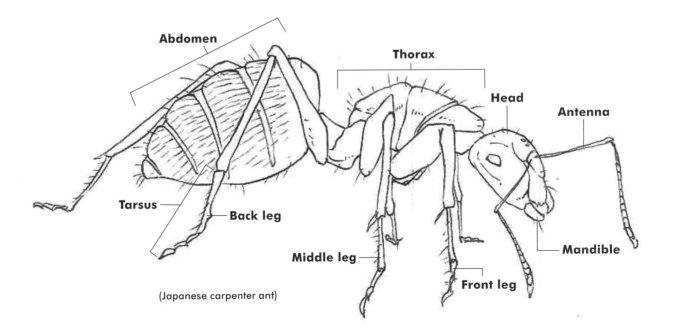

Abdomen

Thorax

Head

Antenna

Tarsus

Back leg

Middle leg

Front leg

Mandible

(Japanese carpenter ant)

Variations

The key points of the sketch are the indentations between the head, thorax and abdomen, the shape of the antennae, and the three pairs of legs that emerge from the thorax. Depict the connecting parts carefully.

Key Point

Be careful not to mistake the direction in which the insect's leg joints flex or misjudge the proportion or length of the antennae, as this can cause a sense of incongruity.

(Japanese carpenter ant)

Key Point

The farther you go toward the ends of the legs, the thinner they become. Carefully draw the characteristic parts in detail. In addition, by drawing the abdomen pattern you can express its roundness and volume.

Key Point

The ant's heads is large in relation to its body proportions. This makes it a suitable animal for anthropomorphic expression. The orientation of the face and the direction in which the antennae point can be used to approximate facial expressions.

Live specimens move quickly, but try to carefully observe the poses and draw them.

From May to November, you may see a swarm of winged ants setting out to establish a new nest.

The two ants are exchanging information. They use pheromones to mark the location of their prey and notify their companions.

(Winged ant)

(Japanese carpenter ant)

Praying Mantis

(Animalia/Arthropoda/Insecta/Mantodea)

The mantis is a carnivorous insect that preys on small animals with its large sickle-shaped forelegs. It is widely found in fields and mountains from late summer to fall.

Completed Drawing

Draw the near side boldly and the far side faintly.

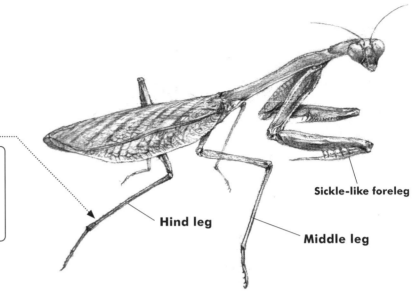

Key Point

These insects have smallish, slender bodies. The body is supported by the long, slender middle and hind legs. The legs should be carefully drawn in relationship to the ground so that the body does not look like it's floating.

Sickle-like foreleg

Hind leg

Middle leg

Drawing Procedure

Note the proportions of the head, thorax, and abdomen, the gradual thinning of the legs and feet, and the directions in which they flex.

Draw the Shape

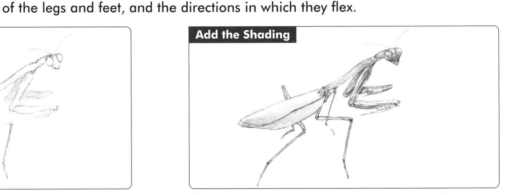

❶ Capture the shape of the praying mantis

Observing the common poses of the praying mantis, draw the shapes while finding the right balance of how to feature them in the drawing. Measure the proportions, and correct any deviations accordingly.

Add the Shading

❷ Add shading with three-dimensionality in mind

Once the shapes are in place, add tones lightly. Draw from the darker areas, paying attention to the sense of three-dimensionality. The joints of the body segments and each leg should be crisply drawn.

Draw the Patterns on the Body Surface

❸ Draw the detailed body surface patterns

Observe the head, sickle forelegs and other key points carefully, and do not to let the shading cross over the lines defining each part.

Draw the Fine Textures

❹ Draw the fine textures and make them crisp

Place more tones to create a look that is unique to the mantis. Once the overall tone is in place, draw in the wing patterns and detailed textures.

The mantis often assumes a fighting pose. When they spread their wings, they look surprisingly large. Observe the various stances.

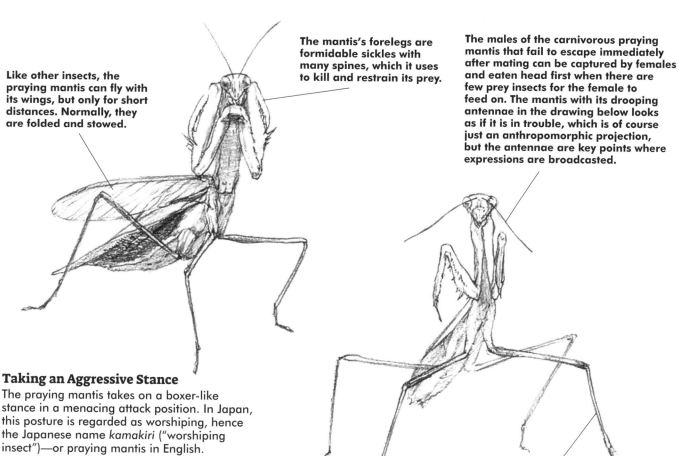

Like other insects, the praying mantis can fly with its wings, but only for short distances. Normally, they are folded and stowed.

The mantis's forelegs are formidable sickles with many spines, which it uses to kill and restrain its prey.

The males of the carnivorous praying mantis that fail to escape immediately after mating can be captured by females and eaten head first when there are few prey insects for the female to feed on. The mantis with its drooping antennae in the drawing below looks as if it is in trouble, which is of course just an anthropomorphic projection, but the antennae are key points where expressions are broadcasted.

Taking an Aggressive Stance

The praying mantis takes on a boxer-like stance in a menacing attack position. In Japan, this posture is regarded as worshiping, hence the Japanese name *kamakiri* ("worshiping insect")—or praying mantis in English.

Long, thin limbs support the body. Observe the details, such as the spines and claws on the tips.

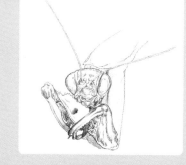

Inverted triangular head with large compound eyes

The eyes of the praying mantis are attached to the corners of its inverted triangular face, and are large and vertically oval. You can see a black dot in the compound eye, but this is a false pupil and the insect does not actually see with these. But when drawing, it's an important feature that makes the viewer really feel the gaze. The compound eyes of insects are composed of many long, thin, hexagonal individual eyes, which are grouped together to capture shapes and movement.

The mantis has two pairs of wings: forewings and hind wings. The tips are thin and slightly translucent. The fine network of leaf-vein-like channels are called the wing veins. Drawing the wings in the foreground in greater detail conveys a sense of perspective.

Ladybug

(Animalia/Arthropoda/Insecta/Coleoptera/Coccinellidae)

There are about 5,000 species of these small beetles in the world. The body pattern is brightly colored and characterized by red, yellow and black spots.

Completed Drawing

This was drawn with an awareness of the luster of the body and the transparency of the wings. The posture of the contracted legs also expresses the dynamism of the ladybug's flight.

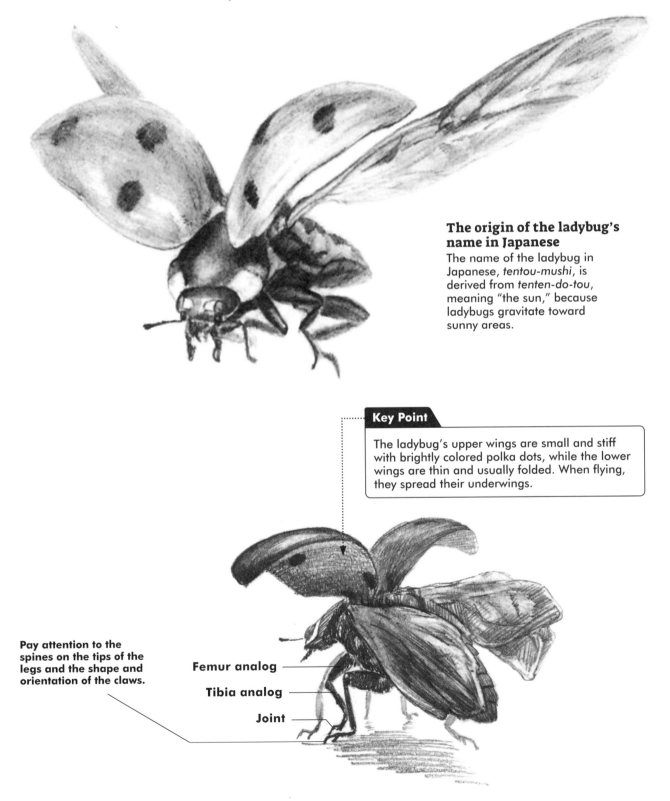

The origin of the ladybug's name in Japanese

The name of the ladybug in Japanese, *tentou-mushi*, is derived from *tenten-do-tou*, meaning "the sun," because ladybugs gravitate toward sunny areas.

Key Point

The ladybug's upper wings are small and stiff with brightly colored polka dots, while the lower wings are thin and usually folded. When flying, they spread their underwings.

Pay attention to the spines on the tips of the legs and the shape and orientation of the claws.

Femur analog

Tibia analog

Joint

Drawing Procedure Less than 1/3-inch (1-cm) long, the wings beat too fast to be observed by the naked eye. It has been drawn from a photograph this time.

Capture the Shape

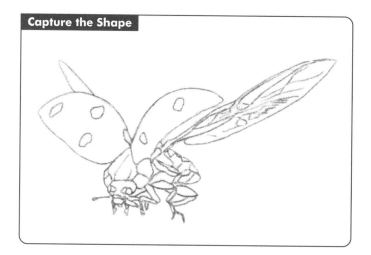

1 Draw the shape faintly

Start by capturing the shape. After measuring the proportions while carefully observing the relationship between the whole and its parts, draw the shape lightly with an HB pencil.

Add the Colors

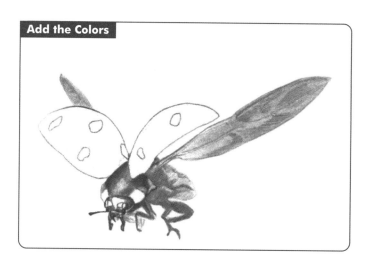

2 Apply shading starting from the darker areas

Apply shading to each part. Be aware of the difference in texture between the smooth upper wings and the translucent lower wings, as well as the texture of the body.

Draw the Details

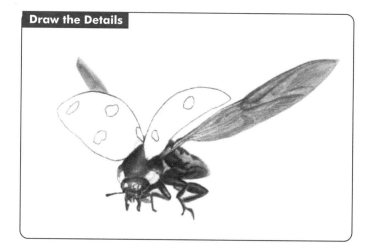

3 Draw the different textures

Use a 2B pencil to draw the detailed parts of the head and legs that are in the foreground. Be sure to capture the difference in the texture between the upper and lower wings. Differences in brightness are ascertained by squinting occasionally at the subject. If you apply the shading firmly without overshooting the outlines, a crisp quality will be expressed.

Live insects assume a variety of poses. If you observe carefully and understand the structure of the body, you will be able to draw various scenes even from non-living specimens.

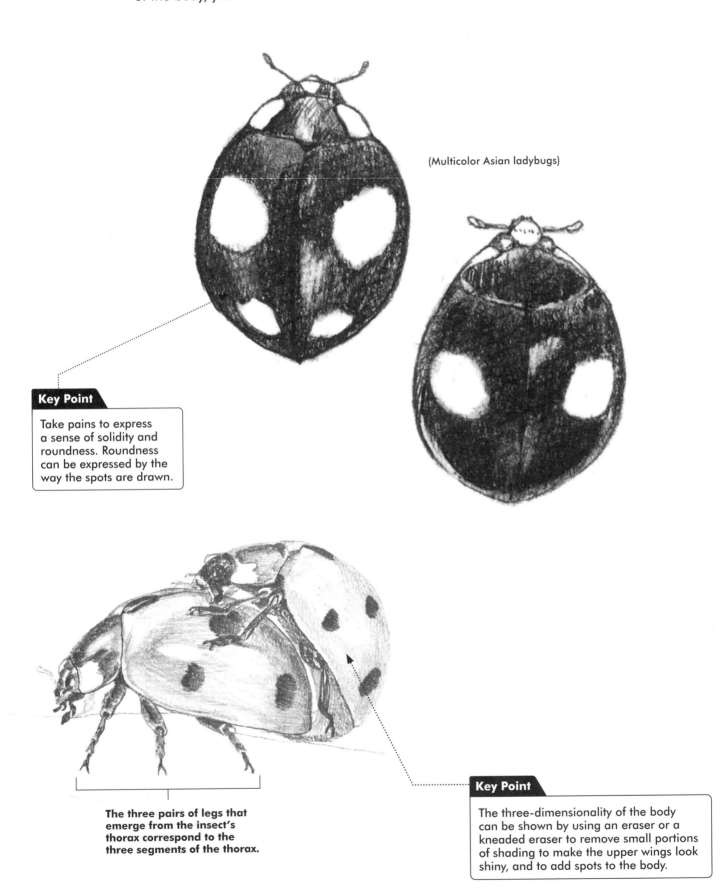

(Multicolor Asian ladybugs)

Key Point

Take pains to express a sense of solidity and roundness. Roundness can be expressed by the way the spots are drawn.

The three pairs of legs that emerge from the insect's thorax correspond to the three segments of the thorax.

Key Point

The three-dimensionality of the body can be shown by using an eraser or a kneaded eraser to remove small portions of shading to make the upper wings look shiny, and to add spots to the body.

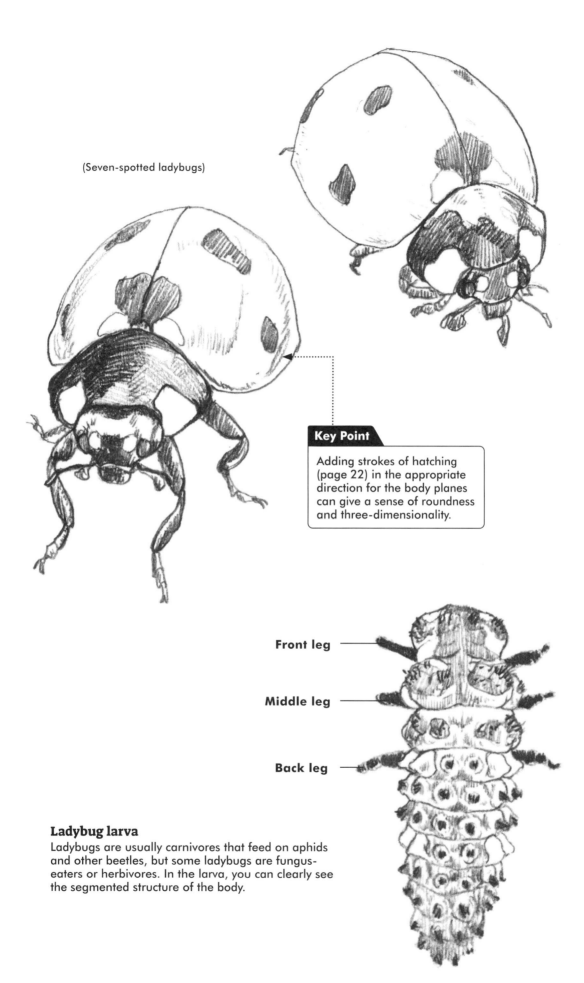

(Seven-spotted ladybugs)

Front leg

Middle leg

Back leg

Ladybug larva

Ladybugs are usually carnivores that feed on aphids and other beetles, but some ladybugs are fungus-eaters or herbivores. In the larva, you can clearly see the segmented structure of the body.

Butterfly
(Animalia/Arthropoda/Insecta/Lepidoptera)
Butterflies are found on land all over the world. Many species have colorful patterns on their wings and are often collected by insect collectors.

Drawing Procedure Successfully capturing the beautiful and delicate wing patterns covered with scales and hairs is the best part about drawing butterflies. This is drawn from a photograph.

Draw the Entire Outline

1 Compose and sketch the entire composition
Observe the butterfly closely and follow its silhouette and body outlines.

Draw the Patterns With Lines

2 Draw in the wing patterns
Draw the detailed patterns of the wings.

Add Shading

3 Add tones to each part
Apply colors in order from the darkest to the lightest areas.

Draw the Patterns

4 Draw the pattern on the entire surface
Use H to HB pencils for the lighter areas and B to 2B pencils for the darker areas. Draw the pattern over the entire surface.

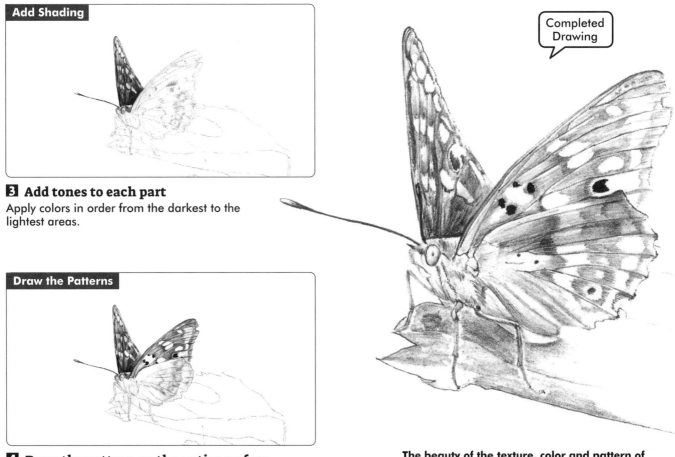

Completed
Drawing

The beauty of the texture, color and pattern of the wings is expressed while also providing a sense of depth. The butterfly's wings are rather plain on the underside and showy and beautifully colored and patterned on the top.

Variations

Butterflies become butterflies through the process of "complete metamorphosis," from egg to larva to pupa to adult. This is distinguished from "incomplete metamorphosis," which does not include the pupal stage.

The Growth of a Butterfly

The larva feeds on leaves and other plant matter, and eventually pupates after repeatedly shedding its skin. Inside the pupal shell, the tissues decompose, and cell division and differentiation* occur, resulting in the adult butterfly.

* Differentiation: the division of a single thing into two or more dissimilar or more complex things

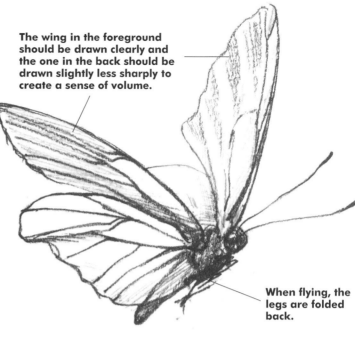

The wing in the foreground should be drawn clearly and the one in the back should be drawn slightly less sharply to create a sense of volume.

When flying, the legs are folded back.

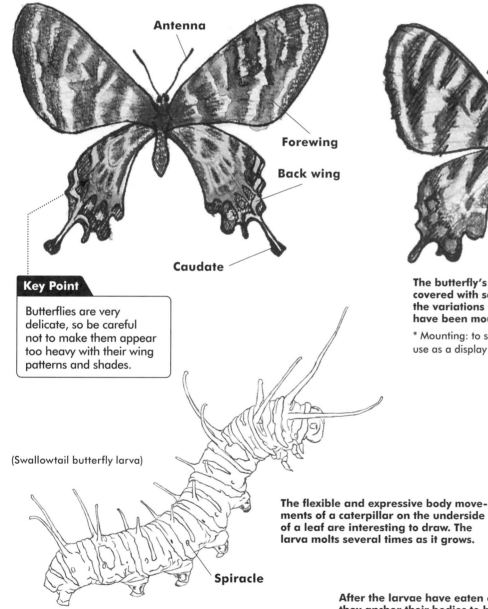

Antenna

Forewing

Back wing

Caudate

Key Point

Butterflies are very delicate, so be careful not to make them appear too heavy with their wing patterns and shades.

(Swallowtail butterfly larva)

Spiracle

The butterfly's two pairs of wings are thin and covered with scales. It's a good idea to observe the variations in the butterfly specimens that have been mounted.*

* Mounting: to spread the wings of an insect for use as a display specimen.

The flexible and expressive body movements of a caterpillar on the underside of a leaf are interesting to draw. The larva molts several times as it grows.

Cremaster

After the larvae have eaten enough food, they anchor their bodies to branches by spinning a strong anchoring tethers called *cremasters*, and then they pupate.

Spider

(Animalia/Arthropoda/Chelicerata/Arachnida/Araneae)

Most spiders feed on prey with snare in their webs. They are distinct from insects; they are instead rather closely related to horseshoe crabs, shrimps and crabs. They have 8 legs without a distinction between the head and thorax, and no antennae.

Completed Drawing

The spider's body is basically symmetrical, but in fact the left and right sides are slightly different. Try to depict the slightly asymmetrical eye positions, leg shapes, and so on.

Pedipalp

Cephalothorax

Abdomen

Key Point

Four pairs of legs emerge from the cephalothorax. The orientation of the legs can be used to express the spider's state of alertness or arousal.

Depict Three-dimensionality on the Legs

To create the tubular three-dimensionality of the thin legs, draw the joints carefully. Pay attention to the number of nodes and the orientation of the tips of the legs. Spiders have two or three claws at the end of each leg.

Variations

There are a variety of actions spiders take which cause the legs to move in various directions. Spider webs are another motif you may want to draw. Observe them well and draw them carefully.

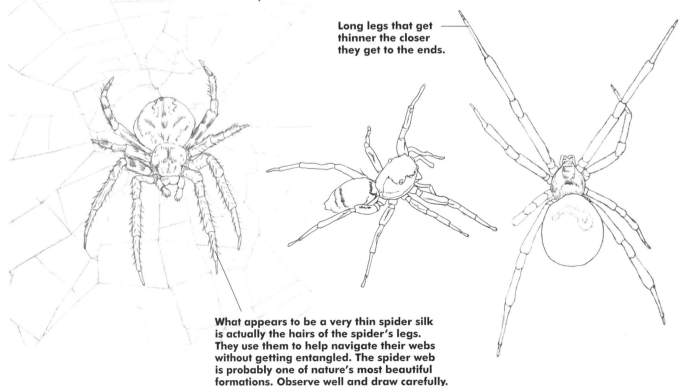

Long legs that get thinner the closer they get to the ends.

What appears to be a very thin spider silk is actually the hairs of the spider's legs. They use them to help navigate their webs without getting entangled. The spider web is probably one of nature's most beautiful formations. Observe well and draw carefully.

Drawing Procedure

This spider has a an abdomen with a complex shape. Also, pay attention to the detailed patterns on the body and the texturing of the body, along with drawing in the head and legs.

Draw the Outline

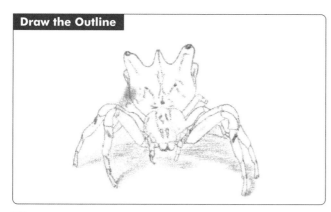

1 Outline with faint lines
After you understand the overall structure, draw an outline. The head is drawn from the front vantage point.

Add Shadows

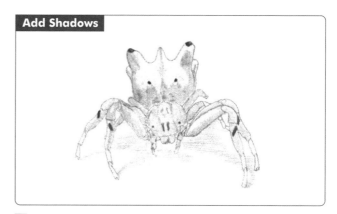

2 Add tones and shading
The dark tones are applied to dark areas and key points, and the shading is used to create three-dimensionality.

Draw in the Fine Details

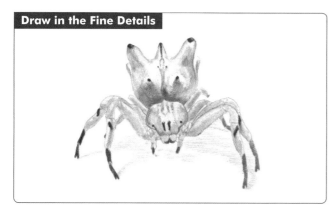

3 Draw details while creating a three-dimensional effect
Shade in overall, and then draw in details such as the tips of the claws.

Layer On More Tonality

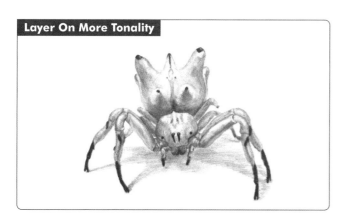

4 Add darker tone to the strongly shaded areas
Each leg now has a rounded, three-dimensional feel. Note the number of joints and the orientations of the tips. Together with the shading, the shadows below the spider are also drawn.

Completed Drawing

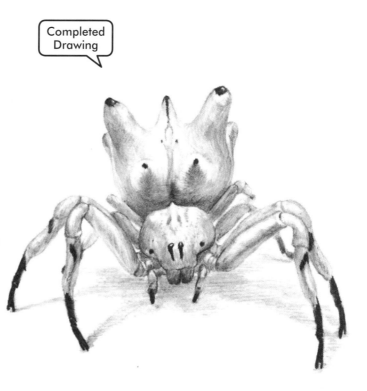

The illustration above shows slight natural asymmetries in the positions of the eyes and the humps on the back. The surface where the legs meet the ground should also be carefully observed. The joints between the segments are similar to those of a crab's legs.

Dragonfly
(Animalia/Arthropoda/Insecta/Odonata)
Dragonflies are found all over the world. Their large eyes have a field of view that spans approximately 270°. They fly on two pairs of long, transparent wings and can hover in mid-air.

Variations Dragonflies are beautiful insects with large glossy eyes and semi-transparent wings. The eyes, the base of the legs, and the body segments visible on the belly are the key points to observe. When enlarged with a magnifying lens, another level of detail opens up.

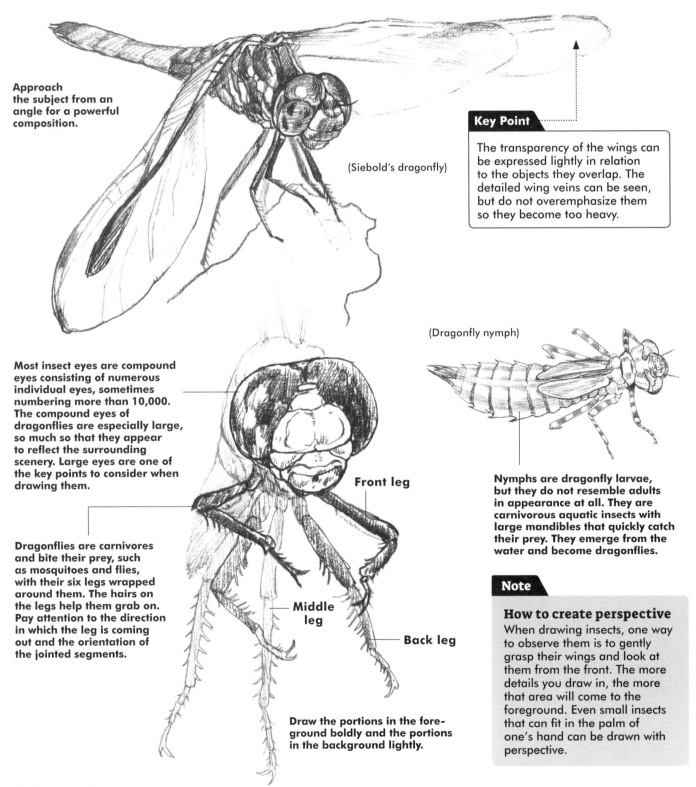

Approach
the subject from an angle for a powerful composition.

(Siebold's dragonfly)

Key Point

The transparency of the wings can be expressed lightly in relation to the objects they overlap. The detailed wing veins can be seen, but do not overemphasize them so they become too heavy.

Most insect eyes are compound eyes consisting of numerous individual eyes, sometimes numbering more than 10,000. The compound eyes of dragonflies are especially large, so much so that they appear to reflect the surrounding scenery. Large eyes are one of the key points to consider when drawing them.

Dragonflies are carnivores and bite their prey, such as mosquitoes and flies, with their six legs wrapped around them. The hairs on the legs help them grab on. Pay attention to the direction in which the leg is coming out and the orientation of the jointed segments.

Front leg

Middle leg

Back leg

Draw the portions in the fore-ground boldly and the portions in the background lightly.

(Dragonfly nymph)

Nymphs are dragonfly larvae, but they do not resemble adults in appearance at all. They are carnivorous aquatic insects with large mandibles that quickly catch their prey. They emerge from the water and become dragonflies.

Note

How to create perspective
When drawing insects, one way to observe them is to gently grasp their wings and look at them from the front. The more details you draw in, the more that area will come to the foreground. Even small insects that can fit in the palm of one's hand can be drawn with perspective.

Drawing Procedure

The long abdomen has a body-node structure like the nodes of a bamboo stalk. Note the beautiful eyes and wings, as well as the orientation and shape of the three pairs of legs that emerge from the thorax.

Trace the Outlines

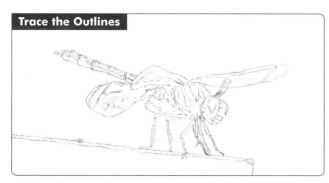

1 Trace the outlines of the body

In this example, the artist drew the image while looking at both a photograph and a specimen. Observe carefully and trace the body's outlines.

Draw the Abdomen

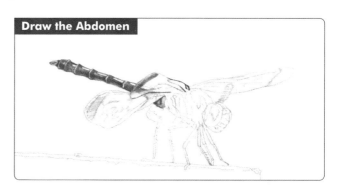

2 Draw the cylindrically shaped abdomen

Even the thin abdomen is rounded. Draw it as you would a cylinder. The major nodes are divided in regular sections, but the lengths of the sections vary. If the shape is not right, do not hesitate to correct it.

Layer On Shading

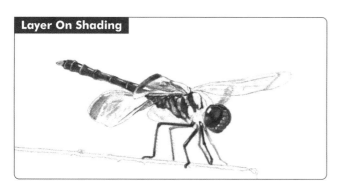

3 Darken the dark areas

Just use a pencil to lightly trace the shapes of the wings, and gradually darken the darker areas of the abdomen and head. Squinting, find the darkest area, then the next darkest, and layer the colors one on top of the other.

Draw the Fine Details

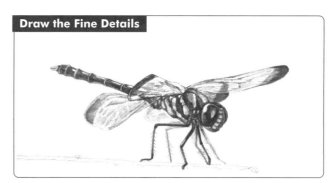

4 Complete the details, alternately comparing the whole and the parts

Where the wings and legs attach to the thorax, use a magnifying lens to carefully check the structure of the specimen dragonfly while drawing. The way the tips of the legs are drawn gives the impression that the dragonfly is perched on the end of a twig.

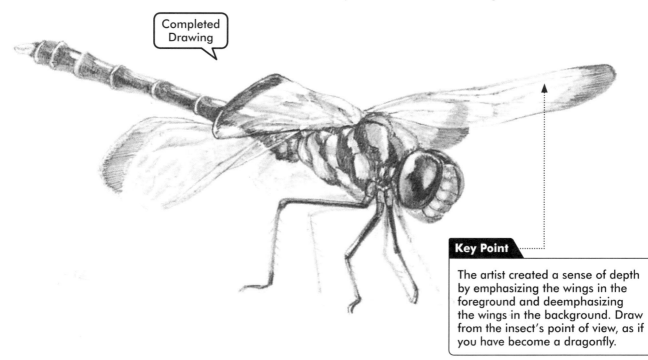

Completed Drawing

Key Point

The artist created a sense of depth by emphasizing the wings in the foreground and deemphasizing the wings in the background. Draw from the insect's point of view, as if you have become a dragonfly.

Bibliography

Barral. *Muséum National d'histoire naturelle Evolution*. Xavier Éditions, Paris, 2007.

Ellenberger, Wilhelm. *An Atlas of Animal Anatomy*. Dover Publications, New York,1949.

Hamm, Jack. *How to Draw Animals*. 1969.

Inuzuka, Norihisa. *Human Shape 500 Million Years*. Terapeia, 2001.

Kingdon, Jonathan. *East African Mammals*, Vol. I, IIA, IIB, IIIA, IIIB, IIIC, IIID. The University of Chicago Press, Chicago, 1979

Manabe, Makoto and Imaizumi, Tadaaki. *Bone and Muscle Large Drawing Book 1~4*. Gakken Education Publishing, 2012.

Miki, Shigeo. *Human Body: A Biological Historical Study*. Ubusuna Shoin, 1997.

Muybridge, Eadweard. *Horses and Other Animals in Motion*. Dover Publications, New York, 1985.

Nakao, Yoshiyasu. *Observation of Living Organisms*. Medical Friend, 1981.

Osborne, Roger, Benton, M.J., Gould, Stephen Jay. *The Viking Atlas of Evolution*. Viking, London and New York, 1996.

Schmid, Elisabeth. *Atlas of Animal Bones For Prehistorians, Archaeologists and Quaternary Geologists*. Elsevier Publishing Company, Amsterdam-London-New York, 1972.

Seton, Ernest Thompson. *Art Anatomy of Animals*. Macmillan,1896. *Art Anatomy of Animals*. Dover Publications, 2006.

Suzuki, Mari. *How to Draw the Animals that Veterinarians Draw*. Graphic, 2009.

Toscani, Oliviero. *Cacas: The Encyclopedia of Poo*. Taschen, 2000.

Ueda, Kozo. *The Most Helpful Watercolor Textbook*. Shinsei Shuppansha, 2009.

Zimmer, Carl. *The Tangled Bank: An Introduction to Evolution*. Roberts and Co., Greenwood Village, CO, 2010.

Zoller, Manfred. *Gestalt und Anatomie*. Dietrich Reimer Varlag, 2011.

List of Artists Whose Drawings Appear in This Book

Haruki Iwai	110, 118
Kozo Ueda	8–9
Ryota Kanno	56, 57, 112
Yugo Kohrogi	50, 108, 109
Maki Sakano	102, 103
Yoshikage Sasaki	104, 105, 170, 171
Ai Sano	10–11, 74,75, 76, 77, 91, 92, 93, 94, 95
Sanami Shimada	46, 47
Saeko Shirafuji	118
Yoko Sekiguchi	146, 147
Shinako Takahashi	66, 67, 78, 79, 96, 97, 98, 99, 122, 123, 154, 156, 158, 159
Marin Takeda	80, 81, 144, 145
Saori Chiba	120, 121, 142, 143, 150, 151
Yukiharu Nagao	138, 139, 144, 145
Momoko Nakamura	72, 73, 106, 107
Daiki Nishiyama	76, 77, 79
Yo Hayakawa	134, 135, 136, 137
Yoshikazu Hiramatsu	42, 43, 44, 45, 48, 49, 55, 57, 69, 71, 73, 78, 79, 81, 83, 90, 91, 92, 110, 111, 115, 116, 123, 124, 126, 127, 128, 129, 139, 143, 145, 152, 153, 155, 156, 157, 159, 160, 161, 162, 163, 168, 169, 173, 174, 175, 176, 177, 178, 179, 180, 181, 182, 183, 184, 185
Tomoka Hiruma	114, 115, 116, 117, 164, 165
Marimo Hirota	68, 69, 70, 71, 112, 113, 130, 132, 133, 155, 180
Michiyo Miyanaga	55, 56, 90, 94, 120, 128, 142, 148, 150
Juri Miyamoto	59, 61, 82, 83, 124, 125, 129, 155, 172, 173
Yuhka Murao	14, 50, 51, 52,53, 54, 88, 89, 100, 101, 140, 141
Yuka Yoshida	12–13, 58, 59, 60, 61, 62, 63, 64, 65, 84, 85, 86, 87
Tomoko Wada	42, 43, 44, 45
Nana Watanabe	114, 164

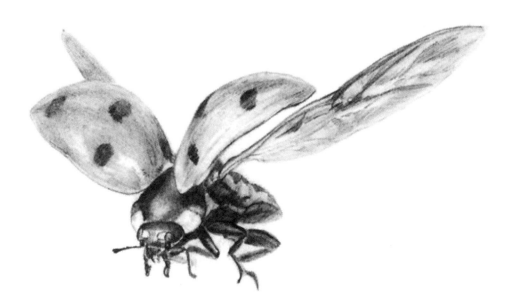

Michiyo Miyanaga is an assistant professor in the Graduate School of Art Education (Art Anatomy II) at Tokyo University of the Arts. She is also a part-time lecturer at the Joshibi University of Art and Design. She is on the board of directors for the Japanese Society of Artistic Anatomy, and Japanese Academy of Facial Studies. Miyanaga has a Ph.D. (Medicine), and she is a guest researcher at the Tokyo National Museum and Tokyo Medical University.

Miyanaga was born in Kobe, Japan. She holds a Master of Fine Arts degree (Art Anatomy) from the Tokyo University of the Arts. She also participated in the Art graduate program in the Graduate School of Art and Design at the same university. Later, she was a research student at the Department of Anthropology, Faculty of Science at the University of Tokyo. She has been a part-time lecturer at Musashino Art University, Iwamizawa School of Hokkaido University of Education, Okinawa Prefectural University of Arts, Tokyo Medical and Dental University, and other institutions. She is the author of the Japanese books *"Art Anatomy Atlas"* and *"Theory of Human Functions"* (Nanzando), and *"Skeleton of Beauty"* (Seishun Publishing). She is the translator and editor of the Japanese editions of *Classic Human Anatomy* and *Classic Human Anatomy in Motion* (both by Valerie L. Winslow), *Rey's Anatomy* by Rey Bustos and Eliot Goldfinger (Maar-sha Publishing) and others.

Published by Tuttle Publishing, an imprint of Periplus Editions (HK) Ltd.

www.tuttlepublishing.com

ISBN 978-0-8048-5611-9

ZERO KARA MANABU PRO NO GIHO DOBUTSU DESSIN NO KISO TO KOTSU
Copyright © Michiyo Miyanaga 2020
English translation rights arranged with Sotechsha Co., Ltd.
through Japan UNI Agency, Inc., Tokyo

English translation © 2023 Periplus Editions (HK) Ltd
Translated from Japanese by Makiko Itoh

Printed in Singapore 2303MP
27 26 25 24 23 10 9 8 7 6 5 4 3 2 1

Distributed by:
North America, Latin America & Europe
Tuttle Publishing
364 Innovation Drive
North Clarendon
VT 05759-9436 U.S.A.
Tel: (802) 773-8930; Fax: (802) 773-6993
info@tuttlepublishing.com; www.tuttlepublishing.com

Japan
Tuttle Publishing
Yaekari Building 3rd Floor
5-4-12 Osaki Shinagawa-ku
Tokyo 141 0032
Tel: (81) 3 5437-0171; Fax: (81) 3 5437-0755
sales@tuttle.co.jp; www.tuttle.co.jp

Asia Pacific
Berkeley Books Pte. Ltd.
3 Kallang Sector, #04-01
Singapore 349278
Tel: (65) 6741-2178; Fax: (65) 6741-2179
inquiries@periplus.com.sg; www.tuttlepublishing.com

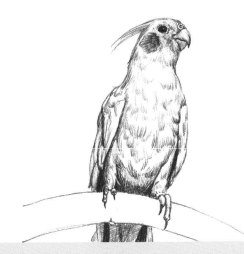